three
six
five ®

London
THE PHOTOGUIDE 2017

threesixfive is a city guide bringing you a comprehensive best of the city, striking a balance between content, design and functionality.

365 items form the foundation and the focus of the book. The book sections are tabulated allowing quick access to city information by area, category, cuisine or price.

The guides enable city discovery through rich photography and content covering architecture, art & design, culture, entertainment, food & drink, history, leisure & nature and shopping.

Design is modern, clean and well spaced to maximize the impact of local photography, whilst allowing for interesting and useful information about items.

Items are linked by number enabling you to put them in context and explore further. The photos not only show you the city before you go, enabling you to plan and prioritize, but are also intended to be a memento of your trip to share with others.

A notes section enables you to record thoughts, make sketches or simply write down practical information, allowing you to personalize your trip and your book.

Multiple maps show districts and item locations in a clean, modern and functional style.

The useful section contains information about the city such as transport information and language.

There is also an itineraries section showing you the best of the city in 24 hours, 48 hours and 5 days, designed to fit with your schedule. The book contains postcards of some of the best city items to enable you to share your trip with others.

threesixfive city guides are designed to be interactive, intuitive and personal, and used to plan, navigate, explore, discover and share.

Please consider giving us your feedback at:

www.threesixfivecity.com

Enjoy!

BT Tower

Westminster
Abbey

London Eye

St Paul's
Cathedral

30 St
Mary Axe

three six five

London
THE PHOTOGUIDE 2017

threesixfivecity.com

The Shard

Battersea Power
Station

Palace of
Westminster

Tower Bridge

Routemaster
Bus

threesixfive **London**

Contents

This second edition published in 2017 by:

Threesixfive Content Ltd
71-75 Shelton Street
London
WC2H 9JQ

First published in the United Kingdom in 2016.

ISBN 978-0-9932852-6-4
Series ID: 01-003-01-02

Designed in the United Kingdom.
Printed in China.

www.threesixfivecity.com

ISBN 9780993285264

9 780993 285264

How to Use

NORTH

Highgate **Hampstead** Primrose Hill St John's Wood Regent's Park Camden King's Cross Islington

Hampstead

Known as Hampstead Village, this residential area surrounds Hampstead Heath, London's largest ancient parkland. Larger than Highgate, Hampstead has a similar mix of wealthy residents. The area has many pubs, shops and cafes with pavement seating as well as typical village amenities such as butchers and florists. The area is filled with impressive Georgian and Victorian architecture. Hampstead is a popular destination on weekends for relaxation and recreation.

004

Kenwood House

Architecture

Kenwood House is a former stately home in Hampstead. The house is open to the public and is notable for its architecture and paintings. The collection includes art by Vermeer, Rembrandt, Gainsborough, Reynolds, Van Dyck, Turner and many more. The gardens also contain sculptures by Henry Moore and Barbara Hepworth. This incredible collection was put together by Edward Guinness, 1st Earl of Iveagh, of the Guinness brewing family in the late 19th century. Guinness bought Kenwood in 1925 and left it to the nation on his death in 1927. The house is surrounded by ancient woodlands and connects with Hampstead Heath #006 to the south.

Hampstead Lane
NW3 7JR
Tube: Hampstead
+44 (0)370 333 1181
english-heritage.org.uk
Map B-C3

005

Spaniard's Inn

Food & Drink

The Spaniard's Inn is a pub in the Hampstead area that is steeped in history. Built in the 16th century, the pub appeared in Charles Dickens' *The Pickwick Papers* and Bram Stoker's *Dracula*. Highwaymen are thought to have used the Inn to watch the road for wealthy travellers going to or coming from London and Dick Turpin was apparently a regular. Joshua Reynolds, the artist, frequented the pub, as well as the poets Byron and Shelley. Some say that Keats wrote *Ode to a Nightingale* in the garden of the inn, while others claim it was written in the garden of Keat's House #011. The name 'Spaniard's' is thought to come from the Spanish Ambassador having lived in the building. Apart from the history, the pub has award-winning food and an extensive garden.

Spaniards Road
NW3 7JJ
Tube: Hampstead
+44 (0)20 8731 8406
thespaniardshampstead.co.uk
Map B-C3

006

Hampstead Heath

Leisure & Nature

Hampstead Heath is one of the largest areas of common land in London. Major attractions on the heath include Kenwood House #004, the view over London from Parliament Hill, Parliament Hill Lido and Hampstead Bathing Ponds. The terrain is hilly and the heath includes lots of woodland. The heath is used for all sorts of sporting activity, including dog walking. There is an athletics track and a petanque pitch. Every Saturday there is a 5km run on the heath, organised by the Parkrun organisation.

NW3 1TH
Tube: Hampstead
Map B-C3

1 Tabs

threesixfive is divided by tabs. In the main part of the book, the tabs denote a compass point within the city. Each tab is then broken down into local areas.

2 Section Header

Local areas within the city are denoted on a section header within each tab. Each main area of the city (eg.North) is split into sub-areas which are listed on the header on each page in order.

3 Item Number

threesixfive is laid out with 365 city items and photos in walking order and coloured by category (see category key).

4 Category

Each item is categorized into one of 8 categories, which have 8 colours, in order to enable easy access to items by type.

Eg. if you are looking for restaurants in particular, go to the categories tab and view 'Food & Drink' to see all listed city options in one place.

You can also search by cuisine or related sub-category depending on the item.

5 Logistical Information

Address, tube station, phone, website and map reference are listed below each item. The map reference links with the area map on the maps tab. There are 17 maps in total.

Categories

Architecture	*Food & Drink*
Art & Design	*History*
Culture	*Leisure & Nature*
Entertainment	*Shopping*

Maps

Maps are arranged in tab and number order starting with north / item 001. There are 17 maps covering 001-347. 348-365 are items in the suburbs and are off-map.

Useful

The useful section contains information on language, transport, 24hr, 48hr & 5-day itineraries and a notes section.

Index

The index lists all items alphabetically and includes categories, map references and a checklist for planning and recording.

City Timeline

Population

AD 0	500	1000	1100	1300	1600
15,000	15,000	25,000	20,000	100,000	200,000

43
Londinium settled by the Romans

2nd Century
Londinium replaces Colchester as capital

225
London Wall constructed

410
Roman occupation of Britain ends

6th Century
Anglo Saxons settle in the city calling it Lundenwic

675
Church of All-Hallows-by-the-Tower founded

842
London is sacked following a Viking invasion

960
Westminster Abbey is constructed

1042
Edward the Confessor is crowned King and the government moves from The City to Westminster

1066
William the Conqueror is crowned King of England at Westminster Abbey following King Harold's death at the Battle of Hastings

1209
Old London Bridge completed

1215
The Magna Carta is agreed by King John at Runnymede. The charter offered certain rights and protections to English citizens

1265
Covent Garden Market established

1349
The Black Death wipes out half of the city population

1534
Henry VIII breaks with the Catholic Church

1576
The original Globe Theatre is constructed in Shoreditch. William Shakespeare performed plays here in the 1580s

1642
The English Civil War between Royalists and Paliamentarians erupts. London is fortified against Royalist attacks using funds from The City

1649
Charles I is convicted of being a traitor against his own people and executed on a scaffold outside Banqueting House

Monarchs

1066 William I	1307 Edward II	1483 Edward V	1625 Charles I	1760 George III
1087 William II	1327 Edward III	1483 Richard III	1649 Interregnum*	1820 George IV
1100 Henry I	1377 Richard II	1485 Henry VII	1660 Charles II	1830 William IV
1135 Stephen	1399 Henry IV	1509 Henry VIII	1685 James II	1837 Victoria
1154 Henry II	1413 Henry V	1547 Edward VI	1689 Mary II	1901 Edward VII
1189 Richard I	1422 Henry VI	1553 Mary I	1689 William III	1910 George V
1199 John	1461 Edward IV	1554 Phillip	1702 Anne	1936 Edward VIII
1216 Henry III	1470 Henry VI	1558 Elizabeth I	1714 George I	1936 George VI
1272 Edward I	1471 Edward IV	1603 James I	1727 George II	1952 Elizabeth II

*The Interregnum saw the dissolution of the monarchy and the establishment of the Commonwealth of England with Oliver Cromwell as Lord Protector.

1650	1700	1800	1900	1950	2000
400,000	600,000	1m	6.5m	8.1m	7.3m

1653
Oliver Cromwell becomes Lord Protector with power of rule over England, Scotland, Wales and Ireland

1661
Charles II is crowned King at Westminster Abbey following the restoration of the monarchy

1666
Great Fire of London destroys over half of the city

1707
The Act of Union is passed and Great Britain is formed of England, Scotland and Wales

1708
St Paul's Cathedral rebuilt by Sir Christopher Wren

1755
Samuel Johnson completes *A Dictionary of the English Language*

1762
George III acquires Buckingham House from the Duke of Buckingham

1837
Charles Dickens pubishes his first novel, *The Pickwick Papers*

1851
The Great Exhibition takes place in Hyde Park Organised by Prince Albert

1863
London Underground opens

1888
A series of gruesome murders in Whitechapel terrifies the local population. The perpetrator is nicknamed 'Jack the Ripper' and is never caught

1914-18
London is bombed by German zeppelins during the First World War

1939
The United Kingdom declares war on Germany

1940
London is bombed by Germany in what came to be known as 'The Blitz'

1948
London hosts the Olympics for the second time

1953
Queen Elizabeth II is crowned at Westminster Abbey

1966
England win the football world cup against Germany at Wembley Stadium

1979
Margaret Thatcher becomes the United Kingdom's first female prime minister

2000
London celebrates the millennium with the O2, the Millenium Bridge and the London Eye

2012
The Shard is completed becoming the tallest building in Europe

London hosts the Olympics for the third time

2013
Andy Murray becomes the first Briton to win the men's singles championship at Wimbledon for 77 years

2016
London's population reaches 8.7m with over 300 languages spoken, more than any other city

City Calendar

London has a jam-packed calendar of events throughout the year. Here is a selection of the biggest and best.

Month

01	02	03	04	05	06
New Year's Eve Fireworks	Six Nations Rugby Tournament	Oxford and Cambridge Boat Race	London Marathon	Chelsea Flower Show	Wimbledon Tennis Championships >
New Year's Day Parade	London Fashion Week >		London Book Fair	FA Cup Final	The Summer Exhibition: Royal Academy >>
			Queen's Birthday ^	State Opening of Parliament ^	Trooping the Colour
				Queen's Club Tennis Championships	London Festival of Architecture

Average Temperature [C F]*
Average Rainfall [mm]

8 46	8 46	10 50	12 54	16 62	20 70
18	24	27	21	12	10

*Highest Recorded Temperature: 37C/104F (2015) Lowest Recorded Temperature: -21C/-5.8F (1795)

07	08	09	10	11	12
< Wimbledon Tennis Championships	Notting Hill Carnival	London Open House Weekend	London Film Festival	Lord Mayor's Show	Ice Skating: Somerset House
< The Summer Exhibition: Royal Academy >	<< The Summer Exhibition: Royal Academy	< London Fashion Week		Bonfire Night	Christmas Lights: Oxford Street
The Proms >>	< The Proms >	<< The Proms			
Hampton Court Palace Flower Show		London Design Festival		^ On special occasions, The King's Troop Royal Artillery fire a 41 gun salute, usually in Hyde Park or Green Park.	

23	76	22	74	18	66	15	60	10	50	7	44
10		20		20		26		27		15	

London

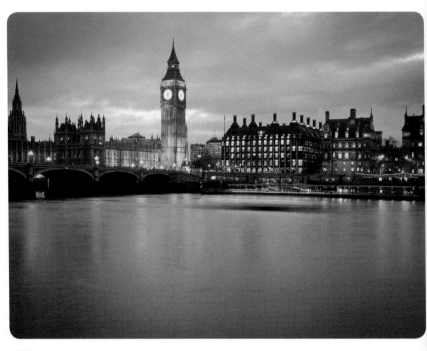

280

'When a man is tired of London, he is tired of life.'
Samuel Johnson

London is currently the number one most visited city in the world and it is easy to see why. It is the home of the British Monarchy, the British Government and a global centre of finance, arts, fashion and education. The city's long history and relative stability, since the Great Fire of London at least, mean that planners have been able to build, rebuild and improve the city, creating a fascinating mix of architectural styles and a large number of beautiful landscaped green spaces.

Settled by the Romans in the 1st Century, London developed on trade and became a magnet for rich and powerful merchants. The global insurance industry was effectively born here in the 16th century in a coffeehouse in the city. The global banking system takes its lead from the Bank of England, set up in the 18th century to raise finance for war with France. The shipping industry was born out of the iron and steel production of the Industrial Revolution and thrived on the demand for exotic goods among the aristocratic classes.

London was also a hotbed of artistic and literary talent as early as the 16th century, when Shakespeare lived in the city and this demand for and investment in the arts in the city is stronger today than ever. London's cultural scene is frenetic. There are hundreds of theatres, cinemas, bookshops, live music venues, museums, art galleries and public libraries.

Britain moved away from poor quality food long ago and now boasts over 150 Michelin stars nationwide. Many of these belong to British chefs in the capital. In recent years, there has been a strong focus on provenance and quality and many London restaurants are creating updated classic British dishes with seasonal British produce, executed to the highest standards. London is also a magnet for international chefs and you can find cuisine from almost any country. The British people have a particular affinity for Indian food and Brick Lane offers an astounding choice of dishes from the region.

During the prohibition era in the United States, bartenders came to London to ply their trade and the city's connection with the cocktail has remained ever since. A large number of high-end hotels and bars mean that the city explorer can enjoy some of the most decorated drinks on the planet here.

London is also a shopping destination. Oxford Street is the busiest shopping street in Europe and Bond Street is a global centre of luxury fashion retail. Some of the oldest shops here are over three hundred years old and continue to provide hand-made products using techniques developed centuries ago. Bespoke suits and shoes are two items for which London is particularly famous.

London's population stands at over 8 million and in 2015 over 30 million people visited the city. This high demand provides the incentive for the city to continue growing and reinventing itself, which will surely mean that London's long list of exciting things to eat, drink, see and do will continue to evolve for the benefit of visitors and residents alike.

NB. London is a city, but within London is The City of London. This refers to the original area of land in which London was situated. Today this area is London's business district. Throughout the book, 'The City' is used to refer to the City of London, whereas 'the city' means all of London.

001

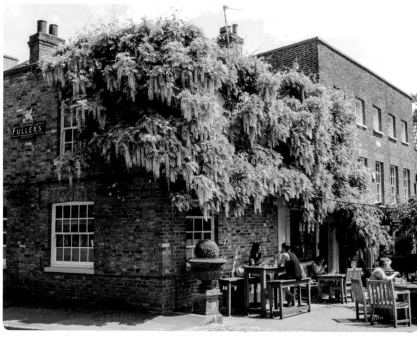

002

003

Highgate

Highgate is a village sitting above Hampstead Heath on one of the highest points in London. The village dates back to the 14th century and some buildings on the high street and surrounding areas are hundreds of years old. The village is home of several landmarks including Highgate Cemetery and Highpoint, the modernist apartment building designed by Berthold Lubetkin. Highgate is one of the most expensive residential areas in London and home of financiers and movie stars, but the village vibe is down-to-earth and there are lots of pubs and shops to keep the visitor busy.

001
The Pavilion Café

Food & Drink

Housed in a former cricket pavilion, this no frills café is located inside Highgate Wood. There is a small indoor space, but the real draw is the large terrace surrounded by trees and flowers. The café serves teas, coffees, cakes and a selection of cooked food including burgers and breakfasts. Dogs have their own area and this comes in useful considering the number being walked in Highgate Wood. The wood itself is thousands of years old and is a nature reserve, full of wildlife.

Muswell Hill Road
N10 3JN
Tube: Highgate
+44 (0)20 8444 4777
Map M01 | D1

002
The Flask

Food & Drink

The Flask dates from the 17th century and its name comes from the tradition of selling flasks from the pub, which people used to collect spring water from Hampstead Heath #006 and around Highgate. The pub was frequented by many notable historic figures including the artist, William Hogarth. Samuel Taylor Coleridge lived opposite the pub for many years and visitors included Byron, Shelley and Keats. The Committee Room, a room within the pub is said to have been the site of one of the first autopsies. The pub serves British classics such as roast Hampshire topside beef and sticky toffee pudding and offers a variety of real cask ales and an extensive wine list. It is located not far from Highgate Cemetery #003.

77 Highgate West Hill
N6 6BU
Tube: Highgate
+44 (0)20 8348 7346
theflaskhighgate.com
Map M01 | D2

003
Highgate Cemetery

History

Opened in 1839, Highgate Cemetery contains some of Britain's finest funerary architecture and many prominent figures are buried here. The most famous is perhaps Karl Marx, whose tomb is Grade I listed. Famous sections of the cemetery include the Circle of Lebanon, an impressive row of vaults topped by a Lebanese cedar tree; and Egyptian Avenue. The cemetery is split between east and west. The east side contains Marx's tomb and is open to the public. Admission is £4 for adults. Visitors must pay to join a tour in order to see the most interesting parts of the cemetery in the west side, and tours run daily.

Swain's Lane
N6 6PJ
Tube: Archway
+44 (0)20 8340 1834
highgatecemetery.org
Map M01 | D3

Hampstead

Known as Hampstead Village, this residential area surrounds Hampstead Heath, London's largest ancient parkland. Larger than Highgate, Hampstead has a similar mix of wealthy residents. The area has many pubs, shops and cafes with pavement seating as well as typical village amenities such as butchers and florists. The area is filled with impressive Georgian and Victorian architecture. Hampstead is a popular destination on weekends for relaxation and recreation.

004
Kenwood House

Architecture

Kenwood House is a former stately home in Hampstead. The house is open to the public and is notable for its architecture and paintings. The collection includes art by Vermeer, Rembrandt, Gainsborough, Reynolds, Van Dyck, Turner and many more. The gardens also contain sculptures by Henry Moore and Barbara Hepworth. This incredible collection was put together by Edward Guinness, 1st Earl of Iveagh, of the Guinness brewing family in the late 19th century. Guinness bought Kenwood in 1925 and left it to the nation on his death in 1927. The house is surrounded by ancient woodlands and connects with Hampstead Heath #006 to the south.

Hampstead Lane
NW3 7JR
Tube: Hampstead
+44 (0)370 333 1181
english-heritage.org.uk
Map M01 | B2

005
Spaniard's Inn

Food & Drink

The Spaniard's Inn is a pub in the Hampstead area that is steeped in history. Built in the 16th century, the pub appeared in Charles Dickens' *The Pickwick Papers* and Bram Stoker's *Dracula*. Highwaymen are thought to have used the Inn to watch the road for wealthy travellers going to or coming from London and Dick Turpin was apparently a regular. Joshua Reynolds, the artist, frequented the pub, as well as the poets Byron and Shelley. Some say that Keats wrote *Ode to a Nightingale* in the garden of the inn, while others claim it was written in the garden of Keat's House #011. The name 'Spaniard's' is thought to come from the Spanish Ambassador having lived in the building. Apart from the history, the pub has award-winning food and an extensive garden.

Spaniards Road
NW3 7JJ
Tube: Hampstead
+44 (0)20 8731 8406
thespaniardshampstead.co.uk
Map M01 | B2

006
Hampstead Heath

Leisure & Nature

Hampstead Heath is one of the largest areas of common land in London. Major attractions on the heath include Kenwood House #004, the view over London from Parliament Hill, Parliament Hill Lido and Hampstead Bathing Ponds. The terrain is hilly and the heath includes lots of woodland. The heath is used for all sorts of sporting activity, including dog walking. There is an athletics track and a petanque pitch. Every Saturday there is a 5km run on the heath, organised by the Parkrun organisation.

NW3 1TH
Tube: Hampstead
Map M01 | C3

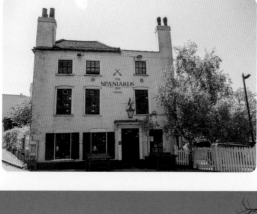

005

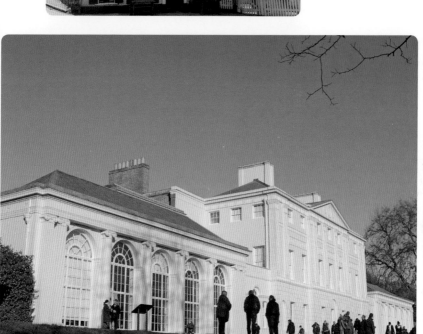

004

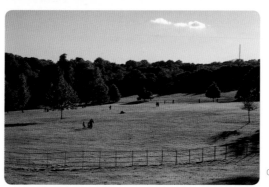

006

007

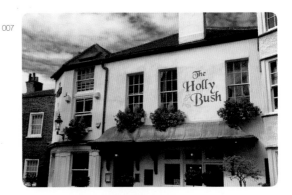

009

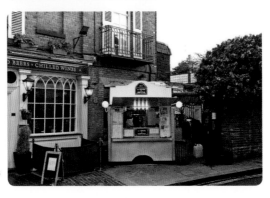

008

007
The Holly Bush

Food & Drink

008
The Hampstead Creperie

Food & Drink

009
Camden Arts Centre

Art & Design

This local Hampstead pub is over 200 years old and is decorated in the original style with a log fire. Dishes on offer include slow cooked beef cheek pie, salmon ceviche, wild boar terrine and whole roasted mallard. The pub's location is full of character and charm at the top of a set of steps off Hampstead High Street. Extremely popular with locals, booking in advance for a meal is a must.

22 Holly Mount
NW3 6SG
Tube: Hampstead
+44 (0)20 7435 2892
hollybushhampstead.co.uk
Map M01 | A4

Tucked away in a corner, in front of a pub on Hampstead High Street is this tiny street food stall serving sweet and savoury crepes. The stall has been in this location for over three decades and is wildly popular with visitors and residents. Crepes on offer include banana and Belgian chocolate and ham and cheese. At weekends, people queue patiently around the block. After indulging yourself, you can walk it off around the corner on Hampstead Heath #006.

77A Hampstead High Street
NW3 1RE
Tube: Hampstead
+44 (0)20 7445 6767
Map M01 | B5

Camden Arts Centre organises contemporary art exhibitions and residencies, film screenings and live art performances in a Grade II listed building that used to house the Hampstead Central Library. The centre's objectives include getting the public involved in the art, and they run courses in ceramics, drawing and performance. The centre includes galleries, a bookshop, a café serving healthy, fresh food and a garden. A beautiful place to relax on a sunny day.

Arkwright Road
NW3 6DG
Tube: Finchley Road
+44 (0)20 7472 5500
camdenartscentre.org
Map M01 | A5

"Dishes on offer include slow cooked beef cheek pie, salmon ceviche, wild boar terrine and whole roasted mallard."

NORTH

010
2 Willow Road
Architecture

011
Keats House
Culture

Designed by Erno Goldfinger, 2 Willow Terrace is an important example of modernist, terraced housing. Completed in 1939 for the architect and his family, it is now a National Trust property. The author Ian Fleming lived in the neighbourhood and due to disputes over construction of the new property, it is claimed that Fleming used Goldfinger as his inspiration for the villain Auric Goldfinger in his James Bond novels. The house contains artworks by Marcel Duchamp and Henry Moore and furniture designed by Goldfinger himself. Visiting is arranged by guided tour on a first-come, first-served basis.

2 Willow Road
NW3 1TH
Tube: Hampstead
+44 (0)20 7332 3868
nationaltrust.org.uk/2-willow-road
Map M01 | B4

John Keats a well-known English poet, considered be one of the greatest influences of the Romantic period along with Lord Byron and Percy Bysshe Shelley. Although, Keats died at the young age of 25, he grew to become one of the nation's most loved and respected poets after his death. He lived and wrote poetry at Keats House in Hampstead and some claim that he wrote one of his most famous poems, 'Ode to a Nightingale', in the garden. Other sources claim that it was written in the garden of the Spaniard's Inn #005. The house and garden are now a museum, showing some of Keats' personal items and hosting various activities and events throughout the year.

10 Keats Grove
NW3 2RR
Tube: Hampstead
+44 (0)20 7332 3868
Map M01 | C4

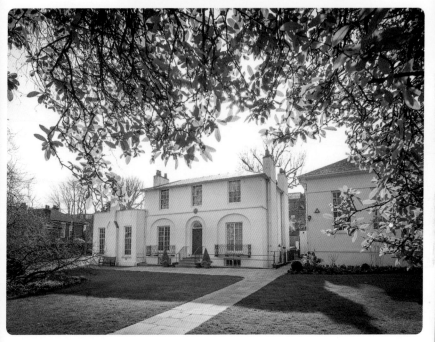

"...it is claimed that Fleming used Goldfinger as his inspiration for the villain, Auric Goldfinger in his James Bond novels."

"Minimalist in design, the building also became note-worthy for its famous residents and visitors including Henry Moore, Agatha Christie, Barbara Hepworth, Sir James Frazer Stirling and Walter Gropius."

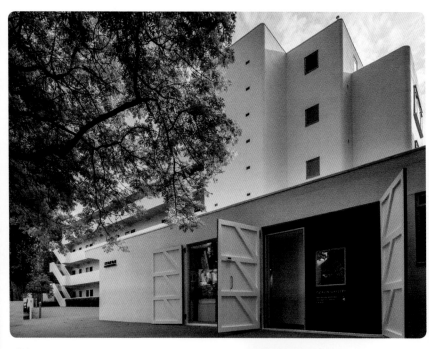

012

013

012
Isokon Gallery

Architecture

013
Little Green Street

Architecture

The Isokon Gallery tells the story of the Isokon Building, an experiment in modern living, completed in 1934 and designed by Wells Coates. Minimalist in design, the building also became noteworthy for its famous residents and visitors including Henry Moore, Agatha Christie, Barbara Hepworth, Sir James Frazer Stirling and Walter Gropius. The building featured communal kitchens and service areas. There is a public gallery documenting the history of the building on the ground floor. The building remains residential, and Grade I listed status makes it one of the most architecturally important buildings in the United Kingdom.

Lawn Road
NW3 2XD
Tube: Belsize Park
isokongallery.co.uk
Map M01 | C5

Little Green Street is London's last remaining intact Georgian street. Featuring eight houses on one side and just two on the other, the small street is a window into 18th century London. Constructed in the 1780s, the buildings used to house shops and are now used for residential purposes. With so much development going on nearby, the street's future is now guaranteed by a Grade II listing. Although a bit of a detour, this unique street will be fascinating for the London history buff.

NW5 1BL
Tube: Tufnell Park
Map M01 | E4

"Featuring eight houses on one side and just two on the other, the small street is a window into 18th century London."

Primrose Hill

Located just to the north of Regent's Park, Primrose Hill is the name of the small park from which the city skyline can be viewed. The hill used to be part of a deer park created by Henry VIII. Today, the area consists of a small number of streets filled with colourful, terraced housing and a handful of cafes and shops running along the high street. The area is fashionable and many famous people live in or have lived in the area. These have included Friedrich Engels and Sylvia Plath.

014
Greenberry

Food & Drink

015
The Lansdowne

Food & Drink

016
Primrose Bakery

Food & Drink

Greenberry is an informal restaurant offering all-day dining. Foods include salads, seafood, charcuterie, soups, noodles, burgers, cheese, homemade ice creams, cakes and teas. Breakfast offerings include eggs Florentine, granola and porridge. The cuisine is international and broad with dishes from Japan and South America sitting comfortably next to each other on the menu. The café features outdoor seating on Primrose Hill high street and lunchtimes get very busy.

101 Regents Park Road
NW1 8UR
Tube: Chalk Farm
+44 (0)20 7483 3765
greenberrycafe.co.uk
Map M01 | D6

The Lansdowne Pub and Dining Room is a gastropub serving seasonal food in a residential area, a short walk from Primrose Hill. The pub features large wooden tables, large windows and high ceilings giving it a traditional feel. The menu features British and Mediterranean cuisine including stone-baked pizzas, salt cod croquettes, wild boar meatballs, baked aubergine and puy lentils and apple and rhubarb crumble. A local favourite for over twenty years, The Lansdowne continues to draw the crowds from Primrose Hill and much further afield.

90 Gloucester Avenue
NW1 8HX
Tube: Chalk Farm
+44 (0)20 7483 0409
thelansdownepub.co.uk
Map M01 | D6

Primrose Bakery is a London bakery that makes cupcakes, loaves, layer cakes, biscuits, slices and croissants. With stores in Primrose Hill, Covent Garden and Kensington, these beautifully crafted cupcakes are in high demand. Flavours include matcha green tea, chai latte, chocolate cheesecake, ginger fudge, salted caramel, pink lemonade, cookies and cream, apple crumble, bubblegum, cherry cola and lemon meringue. The stores also sell gift-wrapped boxes of cupcakes, so there is no excuse for not taking something for your next host.

69 Gloucester Avenue
NW1 8LD
Tube: Camden Town
+44 (0)20 7483 4222
primrose-bakery.co.uk
Map M01 | D7

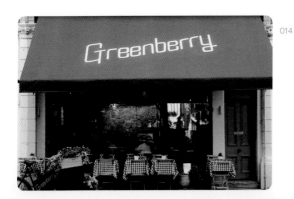

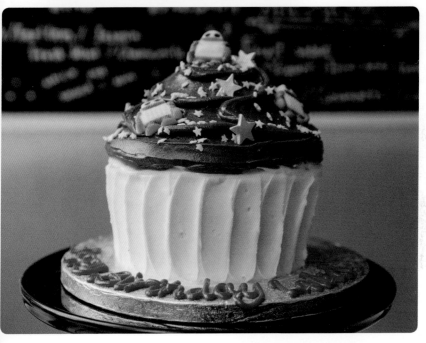

016

015

017

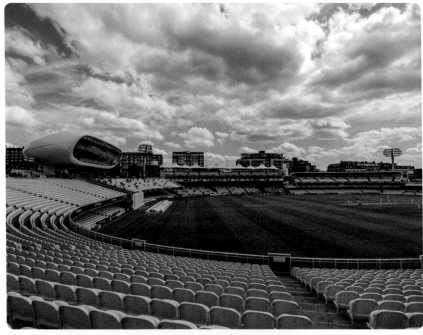

018

019

St John's Wood

Another wealthy neighbourhood in north London, St John's Wood was once part of a great forest. The area is located to the north and west of Regent's Park and there are many substantial houses in the area. The area has a vibrant high street with shops, restaurants and pubs. Many visitors to the area come for the cricket at Lord's and to visit Abbey Road. Famous residents have included Richard Branson, Kate Moss and Sir John Major.

017
Abbey Road Studios

Culture

Abbey Road Studios is the most famous recording studio in the world. The Beatles recorded much of their music here in the 1960s and named their 1969 album *Abbey Road*. The album cover features the Fab Four on the crossing outside the studios and this has now become a must-have photograph for visitors to London. As well as The Beatles, the studios have played host to Cliff Richard and The Drifters, Pink Floyd and others. The studios were saved from redevelopment in 2010 by being granted Grade II listed status by the government. The studios are located in St John's Wood, an affluent area in north London, home to established musicians and actors.

3 Abbey Road
NW8 9AY
Tube: St. John's Wood
+44 (0)20 7266 7000
abbeyroad.com
Map M01 | B8

018
Lord's Cricket Ground

Entertainment

Known as the home of cricket, Lord's was established in 1814 and is located on the northern edge of Regent's Park. The Lord's Museum is the oldest sports museum in the world and houses the Ashes urn, the most famous trophy in cricket. The urn is reported to contain the ashes of a burnt cricket bail and was presented to the England team by the Australian team in 1883. Each time England play Australia, they are competing for 'The Ashes'. The ground is home to Middlesex County Cricket Club and regular matches take place at Lord's, both domestic and international.

St. John's Wood Road
NW8 8QN
Tube: St. John's Wood
+44 (0)20 7616 8500
lords.org
Map M01 | B8

019
Harry Morgan

Food & Drink

This New York-style delicatessen sits in the middle of St John's Wood High Street and is famous for their kosher specialities. They were established in 1948. The menu includes salt beef, smoked salmon, bagels, potato latkes, chicken noodle soup, gefilte fish and a selection of strudels, pies and cheesecakes, to name a few. The prices are reasonable considering the location. They have outdoor seating on the high street and the restaurant is packed at meal times.

29-31 St. John's Wood High Street
NW8 7NH
+44 (0)20 7722 1869
harryms.co.uk
Map M01 | B8

Regent's Park

The Regent's Park was formerly a piece of land used by Henry VIII for hunting. In the 19th century, the Prince Regent, later King George IV, commissioned John Nash to design a new palace for him. The designs included a park, a lake, 56 villas and several terraces. The design was part of a scheme that ran up from St James's and included Regent Street and Portland Place. The palace was never built and only 8 villas and the terraces were constructed. At the centre of the park are the beautiful Queen Mary's Gardens that contain over 12,000 roses of 400 varieties. There is also a boating lake, a public tennis centre, and an open-air theatre.

020
Regent's Park Open Air Theatre

Entertainment

This theatre is located inside Queen Mary's Gardens in Regent's Park. It can hold over 1200 people and opened in 1932. Every summer, the theatre sees a whole host of theatrical productions usually including works by Shakespeare. The surrounding parkland and trees provide a magical backdrop for such performances. The theatre is completely open air and contains a bar and outdoor seating for food and drinks. A unique experience in London, the theatre is a treat for visitors to London in the summer months.

Inner Circle
Regent's Park
NW1 4NU
Tube: Baker Street
+44 (0) 844 375 3460
openairtheatre.com
Map M01 | D8

021
Park Crescent

Architecture

Park Crescent is a semicircle of terraced houses built in the early 19th century and designed by the architect John Nash. Nash's grand buildings were designed to connect central London all the way from The Mall #254 to Regent's Park, via Regent Street. The buildings on the crescent are used for residential and office space and there is a small private garden facing the facades. In the park is a statue of Queen Victoria's father, Prince Edward and a nursemaid's tunnel which connects the gardens to Park Square on the other side of Marylebone Road. These private gardens contain a grass tennis court for resident's use. The architectural design is replicated in some of the other buildings standing nearby on Regent's Park.

W1B 1PE
Tube: Great Portland Street
Map M11 | E1

"In the park is a statue of Queen Victoria's father, Prince Edward and a nursemaid's tunnel which connects the gardens to Park Square on the other side of Marylebone Road."

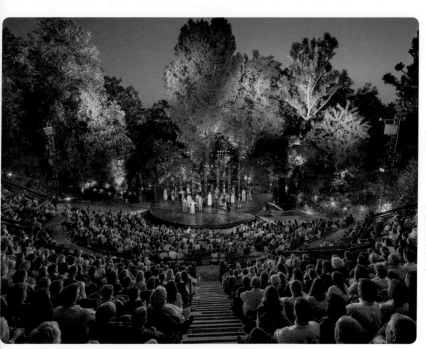

020

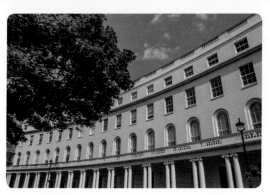

021

"The buildings have served as private residences, a hospital during the First World War, home of various institutes and are once again in private hands."

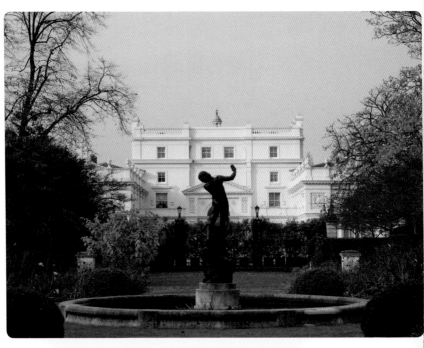

022

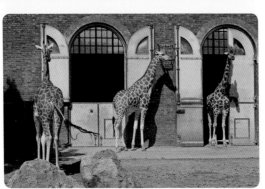

023

022
St John's Lodge Gardens

Leisure & Nature

023
London Zoo

Leisure & Nature

St John's Lodge was one of only 8 villas built in Regent's Park out of an original design for 56. The villa was completed in 1818 and is one of only two of the original 8 remaining. The buildings have served as private residences, a hospital during the First World War, home of various institutes and are once again in private hands. The gardens were laid out in 1889 and are open to the public. They were intended to be gardens fit for meditation and contain beautiful landscaping, stonework and sculpture.

London Zoo is the world's oldest scientific zoo and opened in 1828. Located in Regent's Park, it is also known as Regent's Zoo. The zoo contains over 17,000 animals including mammals, birds, reptiles, monkeys, fish and invertebrates. There are giraffes, gorillas, tigers, lions and two Komodo dragons at the zoo. The zoo was home to a quagga in the 1860s, a type of South African zebra that became extinct in 1883. The Grant Museum of Zoology #185 has one of only seven quagga skeletons left, making it the rarest skeleton in the world.

Regent's Park
NW1 4RY
Tube: Regent's Park
royalparks.org.uk
Map M01 | D8

Regent's Park
NW1 4RY
Tube: Mornington Crescent
+44 (0)20 7449 6200
zsl.org
Map M01 | D7

"The zoo was home to a quagga in the 1860s, a type of South African zebra that became extinct in 1883."

024

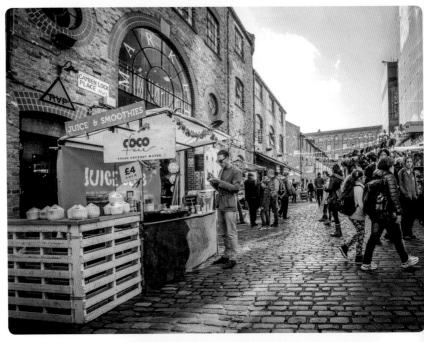

025

026

Camden

Camden Town is an area of north London located to the north-east of Regent's Park and south of Hampstead. The area is well known for Camden Market, which is the cultural centre and welcomes tens of thousands of visitors each weekend. Camden Town is relatively more laid back and down-to-earth than some other London areas and is filled with live music venues making it a destination for amateur musicians and revellers. The Regent's Canal dissects the area at Camden Lock and played a major role in the area's development through trade and migration.

024
Jazz Café

Entertainment

The Jazz Café is a live music venue featuring jazz, soul, blues, hip-hop and reggae performers. It moved to Camden Town in 1990. Former performers at the venue include De La Soul, Don Cherry, Lee Scratch Perry, Kym Mazelle and Maceo Parker. The venue includes the Jazz Café Kitchen, which offers mezzanine seating with a view of the live performance. Dishes include: asparagus, deep fried egg and absinthe hollandaise; braised beef short rib, sticky rice and ssamjang sauce, lettuce wrap; and cornflake ice-cream, bourbon and espresso affogato.

5 Parkway
NW1 7PG
Tube: Camden Town
+44 (0)20 7485 6834
thejazzcafelondon.com
Map M01 | E7

025
Camden Market

Shopping

Camden Market is the collective term for a number of retail markets in the area of Camden Lock on the Regent's Canal #040. The market is a major visitor attraction and counts around 100,000 visitors each weekend. The area is packed with stalls selling clothing, jewellery, books, vinyl records, art, antiques and food. Due to the vast numbers of visitors, the area has become a major food destination at weekends with many canal-side pubs and restaurants in addition to the street food stalls.

56 Camden Lock Place
NW1 8AF
Tube: Camden Town
+44 (0)20 3763 9900
camdenmarket.com
Map M01 | D7

026
Koko

Entertainment

Koko is a concert venue located in the former Camden Palace Theatre. The Rolling Stones played the venue in 1964. Other well-known performers have included Prince, Red Hot Chili Peppers, Madonna, Christina Aguilera, Coldplay, Oasis, Bruno Mars, Thom Yorke, Amy Winehouse, La Roux, Skrillex, Lady Gaga, The Killers, Kanye West, Katy Perry, Lily Allen, Demi Lovato, Usher, Noel Gallagher, Swedish House Mafia and Skepta. Koko runs a full schedule of live performances and club nights throughout the week.

1A Camden High Street
NW1 7JE
Tube: Mornington Crescent
+44 (0)20 7388 3222
koko.uk.com
Map M01 | E7

King's Cross

King's Cross's reputation precedes it. Known in the 1980's for being a run-down area of drugs and prostitution, the area has undergone a massive transformation thanks to significant investment. Large swathes of former railway yard have been developed into modern office and residential spaces. King's Cross Railway Station has also had a facelift and along with the new St Pancras Station next door, makes for an architecturally impressive international transport hub. The area now features art, music, culture and international cuisine. It is also becoming a creative area with Thomas Heatherwick and Anthony Gormley setting up studios in the area. King's Cross Station is also the location of Platform 9 3/4 from which Harry Potter boards the train for Hogwarts.

027
St Pancras Renaissance Hotel

Architecture

This hotel started life in 1873 as The Midland Grand Hotel and held the record for the tallest building in the United Kingdom for 42 years (excluding churches). It was designed by Sir George Gilbert Scott, who based the Italian Gothic design on Kelham Hall, a work he completed several years earlier. Scott was one of Britain's most accomplished architects and was responsible for the Albert Memorial #320 and the Foreign and Commonwealth Office #280, amongst many others. He believed that gothic architecture should not be reserved for ec- clesiastical buildings only. The building was granted protected status in the 20th Century and reopened in 2004, following a full renovation. The building contains stunning metal- work, gold leaf ceilings and a grand staircase that evoke the original designs of the 19th century. The Gilbert Scott bar is open to the public for drinks.

Euston Road
NW1 2AR
Tube: King's Cross
+44 (0)20 7841 3540
marriott.com
Map M02 | A4

028
Plum + Spilt Milk

Food & Drink

Plum + Spilt Milk gets its name from the livery of the train cars that The Flying Scotsman first pulled out of King's Cross Station. It is a modern British restau- rant by Mark Sargeant, a well-known British chef and protégé of Gordon Ramsay. Offering breakfast, all-day a la carte dining and sunday roasts, dishes include: cream of Jerusalem artichoke soup, chestnuts, shaved Berkswell and oyster mushrooms; corn- fed chicken, leek and Perigord truffle terrine, truffle mayon- naise; and pan-fried fillets of John Dory, Shetland mussels, smoked bacon and sea beet. The restaurant is located in the Great Northern Hotel at the recently redeveloped King's Cross Station.

Great Northern Hotel
Pancras Road
N1C 4TB
Tube: King's Cross
+44 (0)20 8600 3600
plumandspiltmilk.com
Map M02 | B4

"It was designed by Sir George Gilbert Scott, who based his Italian Gothic designs on a work he completed several years earlier, Kelham Hall. "

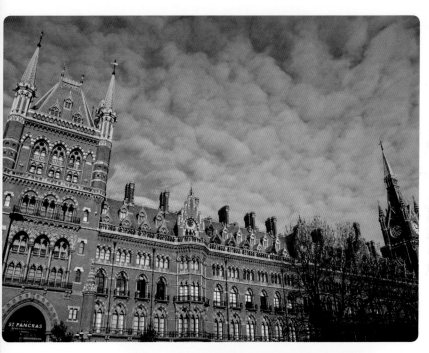

027

028

029

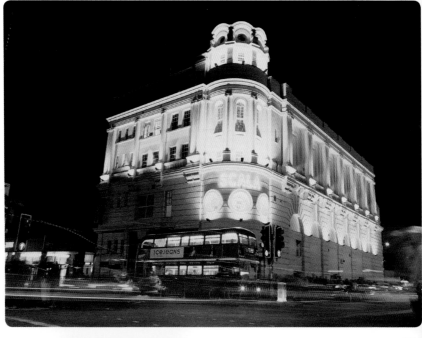

031

030

029
Granary Square

Culture

030
King's Place

Entertainment

031
Scala

Entertainment

Granary Square is a new public space on the banks of the Regent's Canal #040 in the heart of King's Cross. The square contains over 1,000 choreographed fountains, individually controlled and lit. On warm days, the square becomes a playground and the surrounding area is filled with eating and drinking options. The grass-covered terrace overlooking the canal attracts a laid-back crowd on weekends and the area plays host to food markets, music concerts and film screenings. The square is also the home of the world-famous art school, Central Saint Martins.

1 Granary Square
N1C 4AA
Tube: King's Cross
kingscross.co.uk
Map M02 | A3

King's Place is a modern, purpose-built music and art venue with two large concert halls and several art galleries. A wide range of musical, arts and educational activities are organised here including classical, contemporary, jazz and folk music performances as well as comedy events and talks. The venue includes a café and restaurant.

90 York Way
N1 9AG
Tube: King's Cross
+44 (0)20 7520 1490
kingsplace.co.uk
Map M02 | B3

Scala is a large live music venue located in a beautiful former cinema building near King's Cross Station. The venue run club nights at the weekend and host live performers on weekdays. Performers who have played at the club include Tiesto, Bastille, Ed Sheeran, Killers, Nine Inch Nails, Bombay Bicycle Club, Snarky Puppy, Rival Sons, Kaiser Chiefs, Run DMC, J Mascis, Sonic Youth, Rita Ora, Rhianna, Jessie J, Die Antwood, Taylor Hawkins, Carl Barat, First Aid Kit, New York Dolls, Lana Del Ray and Foo Fighters.

275 Pentonville Road
N1 9NL
Tube: King's Cross
+44 (0)20 7833 2022
scala.co.uk
Map M02 | B4

"The square contains over 1,000 choreographed fountains, individually controlled and lit."

NORTH

Islington

Islington is a primarily residential area in north-east London that was still relatively rural in the 16th century. The area's agricultural roots partly stemmed from its role as a stop-off for farmers driving their cattle to Smithfield Market in the City. As with many centrally located areas in London, Islington has developed significantly in the last twenty years to become a prime real estate area and home of many professionals who work nearby in the City of London. As such, house prices are high and the area is filled with markets, restaurants, pubs and other entertainment options.

032
The Albion
Food & Drink

The Albion is an award-winning gastropub set in a beautiful old Georgian building with a large walled garden. Recipient of many awards including best sunday roast and one of the best pubs in the UK, the pub is clad in beautiful wisteria and the stunning garden is one of the major draws. The all-day menu is British and seasonal. In the summer, all sorts of meat and fish are cooked outside on a grill. Example dishes include poached eggs on toasted sourdough, avocado and baby spinach; fish and chips, mushy peas, tartare sauce; whole roast suckling pig; and English puddings and cheeses.

10 Thornhill Road
N1 1HW
Tube: Angel
+44 (0)20 7607 7450
the-albion.co.uk
Map M02 | C2

033
Duncan Terrace Garden
Leisure & Nature

This public garden in Islington features lawns, herbaceous borders and plane trees and is a popular local spot for lunch and relaxation. The gardens measure just over an acre in size. As part of the 'Secret Gardens Project', sculptures were placed in the gardens, designed to create a new habitat for birds and insects. The design inspiration was the local Georgian terraces and 1960s housing nearby. The piece is called 'spontaneous city in the tree of heaven' in reference to the rare, Chinese trees in which the sculptures were placed.

London N1 8AG
Tube: Angel
Map M02 | D3

034
69 Colebrook Row
Food & Drink

Located in Islington, 69 Colebrook Row (officially called 'the bar with no name') is a small cocktail bar set up by Tony Conigliaro, a well-known London mixologist and protégé of Dick Bradsell, who revolutionised the London cocktail scene in the 1980s and invented the espresso martini. Conigliaro also set up Drink Factory, a laboratory focused on experimentation with ingredients for use in cocktails. Drinks here are based on classic cocktails, usually with an updated twist and executed to the highest standards.

69 Colebrooke Row
N1 8AA
Tube: Angel
+44 (0)75 4052 8593
69colebrookerow.com
Map M02 | E3

032

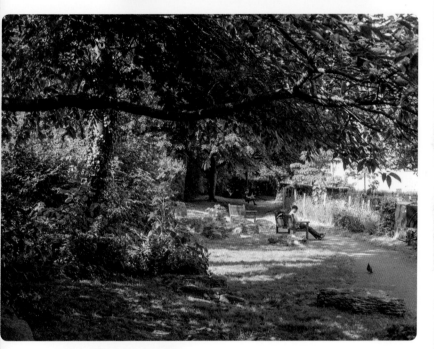

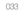

033

034

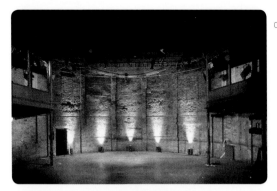

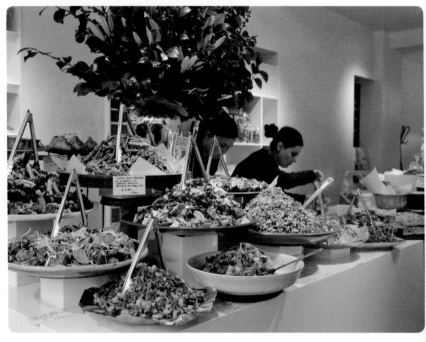

"...dishes include: eggs, peppers and tomatoes served with labneh and grilled focaccia; turkey and courgette koftas with spring onion, cumin and sumac yoghurt..."

035
Almeida Theatre

Entertainment

036
Ottolenghi

Food & Drink

An international theatre that opened in 1980, the Almeida is a place for young and emerging theatrical talent who typically find it difficult to access the larger theatres. Many productions that have started here have gone on to success in the West End. The theatre has played host to some of stage's most well-known stars including Ralph Fiennes as Hamlet; Kevin Spacey in *The Iceman Cometh*; and Juliette Binoche in *Naked*. The theatre has been able to pay for renovation and expansion projects due to funding from the Arts Council of England.

Almeida Street
N1 1TA
Tube: Angel
+44 (0)20 7359 4404
almeida.co.uk
Map M02 | D2

Yotam Ottolenghi is an award-winning cookery writer and restaurateur originally from Jerusalem. His delicatessens serve primarily Mediterranean food, but there are global influences as well, particularly from Asian cuisines. He is known for championing vegetarian dishes, while at the same time enjoying fish and meat. The Islington deli opened in 2004. Ottolenghi serves breakfast, lunch and dinner and example dishes include: eggs, peppers and tomatoes served with labneh and grilled focaccia; turkey and courgette koftas with spring onion, cumin and sumac yoghurt; za'atar basmati and wild rice with roasted chestnut mushrooms, mixed nuts and fried shallots; and grilled mixed peppers with labneh, sundried tomato, olive and caper salsa.

287 Upper Street
N1 2TZ
Tube: Highbury & Islington
+44 (0)20 7288 1454
ottolenghi.co.uk
Map M02 | E2

038

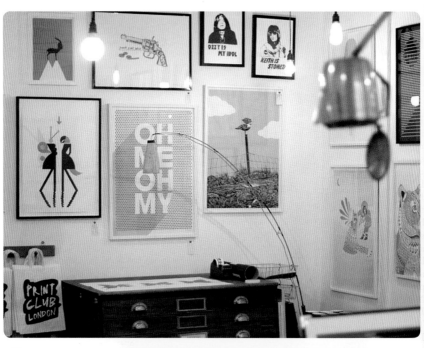

037

039

Dalston

Dalston is a bustling area in the north-east of London filled with vintage shops, entertainment venues and cafes that reflect the area's multicultural heritage. Dalston is located outside the centre of the city but is still well connected, a feature that has traditionally led to affordable housing and a diverse mix of people. Gentrification is now catching up with the area demonstrated by recent sharp house price increases. The local population are resolute however that it will not change the exciting and creative dynamic unique to the area. The area is excellent for exploring different global cuisines.

EAST

037
Print Club

Shopping

038
Kristina Records

Shopping

039
Vortex Jazz Club

Entertainment

Print Club is a screenprinting studio, gallery and shop rolled into one. The studio run screenprinting workshops and classes and offer affordable, limited edition screenprints. Print Club offer studio time to qualified printmakers, who bring their own ink, paper, screens and emulsion. They also organise one of the UK's largest poster shows, 'Blisters', as well as working on major projects for clients that include Nike, Sony, Selfridges #209, Disney, Stella McCartney, Tate Modern #115, Havanna Rum and Puma.

3, 10-28 Miller's Avenue
E8 2DS
Overground: Dalston Kingsland
+44 (0)20 7254 9028
printclublondon.com
Map M03 | C1

Specialising in new and second-hand vinyl across a wide range of musical genres, Kristina Records is an independent shop that attracts customers from across London and further afield. The shop also deals in rare records, books and various other musical accessories.

44 Stoke Newington Road
N16 7XJ
Overground: Dalston Kingsland
+44 (0)20 7254 2130
kristinarecords.com
Map M03 | C1

Vortex is a volunteer-led, not-for-profit, world-famous jazz venue in North London. Hosting around 400 concerts per year, the club has been serving as a platform for jazz, improvised and experimental music for over 25 years. The Vortex has been instrumental in the launch of up and coming artists' careers, such as Mercury-nominated bands including Polar Bear and Portico Quartet. The Vortex's mission is "To support 'jazz' in some of its various forms, bringing the music to a wider audience while nurturing new and emerging talent through innovative programming that recognises the continuity as well as development of the art form."

11 Gillett Street
N16 8AZ
Overground: Dalston Kingsland
+44 (0)20 7254 4097
vortexjazz.co.uk
Map M03 | B2

Haggerston

EAST

Haggerston is an area in east London nestled amongst some more well-known and more gentrified neighbours. The major draw to the area for visitors is Broadway Market, which is particularly busy at weekends. There are also artisan shops and cafes dotted around the place making the area worth exploring on foot. Dalston lies to the north and Shoreditch and Bethnal Green to the south.

040
Regent's Canal
Leisure & Nature

041
The Geffrye Museum of the Home
Art & Design

042
Broadway Market
Culture

The Regent's Canal was part of the design for Regent's Park in the early 19th Century. It connects with the Grand Union Canal in north-west London. The Canal runs to the north of Regent's Park and was used to transport commodities. Commercial use was taken over by railways and road and its use ceased completely by the 1960s. Today it is used as a cycle route for commuters and for pedestrians. The canal runs from Maida Vale and Little Venice to Camden Town, passing Camden Market #025 on the north side then on to King's Cross and eastwards towards Broadway Market #042. The canal passes many significant attractions including London Zoo #023 and Lord's Cricket Ground #018 and narrow boat tours can be arranged between Little Venice and Camden Town.

The Geffrye Museum is an exploration of how we live, documenting how homes have been furnished over the last 400 years. It is named after Sir Robert Geffrye, a former Lord Mayor of London and Master of the Ironmonger's Company. The museum is set within a series of almshouses; small, charitable housing provided to retired workers of the company. A procession of rooms display interior design from the 17th century, the Georgian and Victorian periods and the 20th century. There are also four gardens that provide a snapshot of garden design from four different centuries.

136 Kingsland Road
E2 8EA
Overground: Hoxton
+44 (0)20 7739 9893
geffrye-museum.org.uk
Map M03 | B6

Broadway Market is a street filled with shops, pubs, restaurants, cafes and stalls selling fresh produce and street food as well as fashions and design. Historically, the street was used by farmers to drive sheep to market at Smithfield in the City of London. Fred Cooke started selling jellied eels to the farmers in 1900 and the restaurant F.Cooke still sell them today, alongside pies and mash. The market is open on saturdays and attracts hundreds of visitors to its 135 stalls. The local community strongly oppose the type of gentrification that has occurred in areas such as Shoreditch and the area is filled with local, independent shops.

E8 4QJ
Tube: Bethnal Green
Map M03 | D5

Map M03 | B5

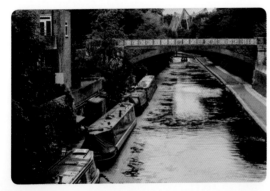

040

041

042

044

043

045

Bethnal Green

Bethnal Green is a former working class area of east London that has seen recent investment in transport infrastructure and construction projects. The area is now a culturally diverse mix of people and full of interesting shops, restaurants, cafes and pubs. The V & A Museum of Childhood is a draw for visitors as is the area's proximity to other interesting east London areas.

043
V & A Museum of Childhood

History

This museum was designed to be a second Victoria and Albert Museum #318 in the east and opened as the Bethnal Green Museum in 1872. It used to exhibit items from the V & A and the Wallace Collection #198, but in the early 20th century it became a museum of childhood. Queen Mary was a supporter of the project and donated many of her own toys. The museum contains toys, clothing, doll's houses, furniture, games, paintings and educational toys. The extensive range of objects document the history of childhood in many different ways and is considered to be one of the finest collections of its type.

Cambridge Heath Road
E2 9PA
Tube: Bethnal Green
+44 (0)20 8983 5200
vam.ac.uk/moc
Map M03 | E7

044
Sager + Wilde

Food & Drink

Sager + Wilde is an award-winning wine bar. They hold regular wine tastings here and also run a bi-weekly cocktail workshop. Although the focus is strongly on wine, they also have a selection of bar snacks and a fixed, four-course menu available at lunch and dinner. Example items from the bar menu include: chicken liver, black sesame and apple; Jerusalem artichoke and caramelised yoghurt; langoustine, millet and rice porridge; and apple ice cream, hazelnut cake and creme fraiche. The wine list is extensive and is made up of wines from all over the globe with offerings by the bottle or the glass.

Arch 250 Paradise Row
E2 9LE
Tube: Bethnal Green
+44 (0) 20 7613 0478
sagerandwilde.com
Map M03 | E7

045
Columbia Road Flower Market

Shopping

This small street holds a flower market on sundays, selling plants, trees and all sorts of other garden-related products. As well as the plants, the street is home to around 60 independent shops. Small art galleries sit next to cupcake shops, vintage clothes stores, English and Italian delicatessens, garden and antique shops. There are also pubs, cafés and restaurants. The street is bustling with vendors and visitors, and is a sunday destination for eating, drinking and socialising.

Columbia Road
E2 7RG
Overground: Hoxton
columbiaroad.info
Map M03 | C6

Shoreditch

Shoreditch is located to the north of the City of London in the east of London. The area was previously run-down but has become one of the main examples of gentrification in the city. This is a process by which the presence of low-cost housing attracts a mix of artists, students and creative talents; which in turn creates a draw for professionals resulting in large-scale property and infrastructure investment. This causes the original residents to move out because housing is no longer affordable. The early presence of certain institutions can accelerate the process. For example Saatchi Gallery, which was located in nearby Hoxton Square for many years was seen as a central component of the area's gentrification. Shoreditch is an exciting area that still attracts creative people to work and socialise and the area now has a growing number of high-end shops and restaurants.

046
Beigel Bake
Food & Drink

Beigel Bake is a 24-hour bakery on Brick Lane famous for its Jewish-style beigels filled with hot salt beef and mustard; or smoked salmon and cream cheese. The bakery is a no-frills affair producing thousands of beigels each day. Plain beigels cost 25p each whether you buy one or six dozen. A cup of tea is 50p, which makes a very refreshing change from the prices charged on the high street. The bakery is very popular with locals and late-night revellers.

159 Brick Lane
E1 6SB
Overground: Shoreditch High Street
+44 (0)20 7729 0616
Map M03 | C8

047
Hostem
Shopping

Hostem is an upmarket fashion retail store featuring contemporary brands in a modern space. The store's interior design is as much a feature as the clothes themselves, with modern art hanging on the walls and contemporary furniture, lighting and glass employed in the design. Labels include Commes des Garcons, Junya Watanabe, Raf Simons and Thom Browne. All together around thirty designer labels are available.

41-43 Redchurch Street
E2 7DJ
Tube: Liverpool Street
+44 (0)20 7739 9733
hostem.co.uk
Map M03 | B7

048
Lyle's
Food & Drink

Opened by a former head chef of St John Restaurant #093, the dining room has a similar modern, light and white design. The food is British and aims to be simple, focusing on a handful of ingredients so as not to overcomplicate the flavour of the dish. Lunch offers an a la carte selection of dishes including monkfish liver and blood orange; smoked eel, beetroot and horseradish; and treacle tart and raw milk ice cream. Dinner is restricted to a fixed, four-course vegetarian or non-vegetarian menu for £44. A cheese option featuring Neal's Yard cheeses is extra.

Tea Building
56 Shoreditch High Street
E1 6JJ
Overground: Shoreditch High Street
+44 (0)20 3011 5911
lyleslondon.com
Map M03 | B8

046

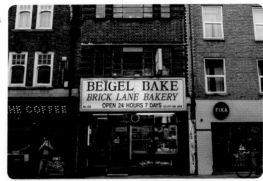

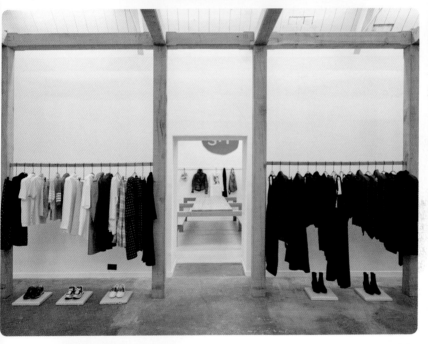

047

048

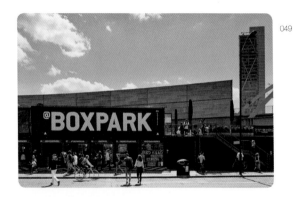

049

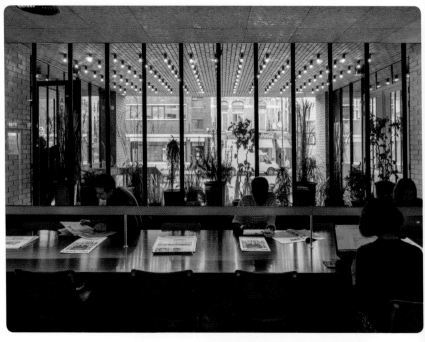

050

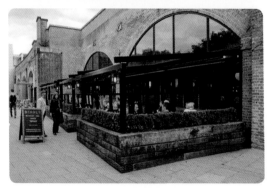

051

049
Boxpark
Shopping

050
Ace Hotel
Art & Design

051
Beagle
Food & Drink

Boxpark is a retail space in Shoreditch focused on fashion, lifestyle, food and drink. Stores are housed in renovated shipping containers and products available here include cosmetics, candles, hair products, clothes, homewares, shoes, wine and headphones. The 'Park' also offers outlets selling soups, burgers, salads, meze boxes, coffee, rum cocktails, doughnuts, milk tea, pork ribs, sushi and more. Located at the end of Shoreditch High Street, the Boxpark is popular with local residents and visitors looking to absorb a bit of the area's creative buzz.

This famous boutique hotel has a lobby space with worktables and beanbags, an art gallery, juice bar, brasserie and a live music bar. During the day, the public spaces are buzzing with local creative types hard at work on their Macbooks. The hotel is located in Shoreditch, an area of east London that has developed substantially over the last 15 years to become a hotbed of artistic and creative talent. There are lots of things to do here, not least grabbing a coffee, a pastry and a beanbag and getting a feel for one of London's most hip and fashionable areas.

The Beagle is a multi-concept eatery located in a large space under a railway arch serving coffee, brunch, lunch and dinner. Brunch menu items include: salt cod, potato, and green pepper omelette; breaded ox tongue, fried egg, anchovy and green sauce; and roast longhorn rump and smoked bone marrow butter sandwich. Dinner dishes include: braised pork belly, peas, bobby beans and pickled mustard seeds; pig's cheek, butterhead, pickles and salad; and braised Swaledale lamb shoulder, spelt and rainbow chard. The restaurant is popular with locals and gets very full on weekends.

2-10 Bethnal Green Road
E1 6GY
Tube: Liverpool Street
+44 (0)20 7033 2899
boxpark.co.uk
Map M03 | B8

100 Shoreditch High Street
E1 6JQ
Overground: Shoreditch High Street
+44 (0)20 7613 9800
acehotel.com/london
Map M03 | B7

397-400 Geffrye Street
E2 8HZ
Overground: Hoxton
+44 (0)20 7613 2967
beaglelondon.co.uk
Map M03 | B6

"The hotel is located in Shoreditch, an area of east London that has developed substantially over the last 15 years to become a hotbed of artistic and creative talent."

EAST

052
Hoxton Square

Culture

053
Clove Club

Food & Drink

054
Cargo

Entertainment

Existing since 1683, Hoxton Square is one of the oldest squares in London. It became popular in the 1990s and 2000s as the centre for a growing arts and creative hub in the East End. White Cube Gallery #129 was located here until 2012 and their exhibitions, which included sculptures in the square's garden, added to the vibrancy of the area. Home to arts and media organisations, the square and surrounding areas are now a destination for eating, drinking and entertainment.

N1 6NU
Overground: Hoxton
Map M03 | B7

Located in Shoreditch Town Hall, the Clove Club offers a la carte and tasting menus crafted from often overlooked British produce. The building itself was built in 1865 and provides a light and airy space with large windows for lunch or dinner. Sample dishes include: flamed Cornish mackerel, English mustard and cucumber; Scottish blood pudding, Braeburn apple and radicchio; crisp Tamworth pork belly, spinach, anchovy and mint; roast black salsify, smoked apple and chanterelles.

Shoreditch Town Hall
380 Old Street
EC1V 9LT
Tube: Old Street
+44 (0)20 7729 6496
thecloveclub.com
Map M03 | B7

Cargo is a club in Shoreditch showcasing live bands and DJs. The club is located in a former railway yard and plays various music genres including R&B, hip-hop, disco, funk, soul and house. The club serves food and has several spaces including an outdoor terrace that features works of art by Banksy and Shepherd Fairey. The area in which it is located is a lively and exciting area for going out, full of restaurants, bars and clubs.

83 Rivington Street
EC2A 3AY
Tube: Liverpool Street
+44 (0)20 7739 3440
cargo-london.com
Map M03 | B7

"Sample dishes include: flamed cornish mackerel, English mustard and cucumber; Scottish blood pudding, Braeburn apple and radicchio; crisp Tamworth pork belly, spinach, anchovy and mint; roast black salsify, smoked apple and chanterelles."

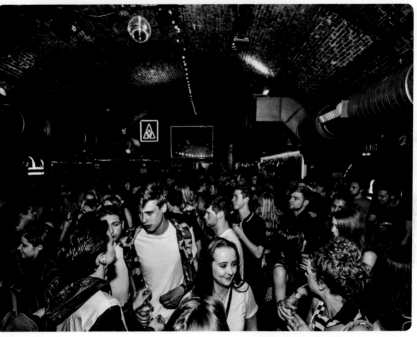

054

053

055

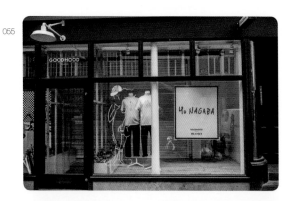

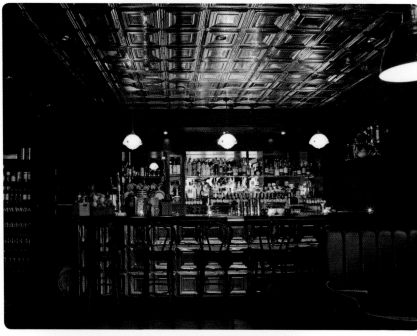

056

057

055
Goodhood Store
Shopping

056
Nightjar
Food & Drink

057
Worship Street Whistling Shop
Food & Drink

This award-winning independent retail store features men's and women's fashions, homeware, lighting, furnishings, jewellery and beauty products. Stocking over 200 brands, products on offer include Japanese porcelain; tables by Hay; products by Nomess of Copenhagen; clothes by Norse Projects, C.E and Adidas; and cosmetics by Aesop. They also sell books and magazines. Both the store design and the range of products are simple and clean in their designs.

151 Curtain Road
EC2A 3QE
Overground: Shoreditch High Street
+44 (0)20 7729 3600
goodhoodstore.com
Map M03 | B7

Nightjar is an award-winning cocktail bar featuring a cocktail list organised by period. Pre-prohibition era drinks include the 'Aged Hong Kong Punch' - Appleton Reserve Blend, Hennessy Fine de Cognac, Ceylon tea liqueur, Hong Kong Baidu, cherry heering, grape molasses, fresh pineapple and yuzu soda. Prohibition era drinks include the 'Charlie Chaplin' - Tanqueray Ten, Bael Fruit Infusion, Akashi Tai Umeshu, Madeira, grenadine, fresh lime, aronia berries and peach bark. Post-War drinks include the 'London Mule' - Tanqueray Gin, apple and rhubarb, Kamm & Sons, lime, honey, galangal beer and stout bitters. Nightjar regularly hosts live jazz and swing acts to ensure your night goes off with a bang.

129 City Road
EC1V 1JB
Tube: Old Street
+44 (0)20 7253 4101
barnightjar.com
Map M03 | A7

This Victorian-inspired cocktail bar features in the World's 50 best bars list. The menu consists of regularly updated original creations using ingredients such as goat's cheese distilled vodka; duck fat cider; coffee and lime zest soda; and yuzu. The bar features bare brick walls and leather sofas. As well as cocktails there are wines, beers and a broad range of spirits on offer as well as food including popcorn, pork scratchings, charcuterie and cheese platters. Two example cocktails are Camelia Spritz made with Tanqueray gin, celery, cold brew green tea, kaffir fruit acid and kombu sake; and Undyed Bloodshed made with Machu pisco, ninos aymara, champagne, acid gomme, xanthan and Fever Tree lemonade.

63 Worship Street
EC2A 2DU
Tube: Liverpool Street
+44 (0)20 7247 0015
whistlingshop.com
Map M03 | A8

"Stocking over 200 brands, products on offer include Japanese porcelain; tables by Hay; products by Nomess of Copenhagen; clothes by Norse Projects, C.E and Adidas; and cosmetics by Aesop. "

058
Galvin La Chapelle

Food & Drink

059
Dennis Severs' House

History

Owned and run by chef brothers, Chris and Jeff Galvin, La Chapelle is a one Michelin starred French restaurant in the City of London. The restaurant is located in the stunning St Botolph's Hall, a former Victorian chapel with high, vaulted ceilings, and features dishes such as lasagne of Dorset crab, tagine of Bresse pigeon and roast Chateaubriand of Cumbrian beef. The Galvin empire continues to expand with Bistro de Luxe on Baker Street, Windows at the Hilton on Park Lane and other restaurants in Edinburgh and London earning the English brothers a growing collection of accolades.

35 Spital Square
E1 6DY
Tube: Liverpool Street
+44 (0)20 7299 0400
galvinrestaurants.com
Map M03 | B8

This Grade II listed, Georgian house contains ten rooms, each of which is designed to evoke a different historical period between 1724-1914. The house contains period paintings, furnishings, fabrics, ornaments, fireplaces and many other historical objects. The guided tour includes the kitchen, cellar, dining room, smoking room and several bedrooms upstairs. The tours are conducted in silence and designed to make the visitor feel like they are viewing an inhabited house, the occupants of which may walk back in at any moment.

18 Folgate Street
E1 6BX
Tube: Liverpool Street
+44 (0)20 7247 4013
dennissevershouse.co.uk
Map M03 | B8

"The restaurant is located in the stunning St Botolph's Hall, a former Victorian chapel with high, vaulted ceilings and features dishes such as lasagne of Dorset crab, tagine of Bresse pigeon and roast Chateaubriand of Cumbrian beef."

"*The tours are conducted in silence and designed to make the visitor feel like they are viewing an inhabited house, the occupants of which may walk back in at any time.*"

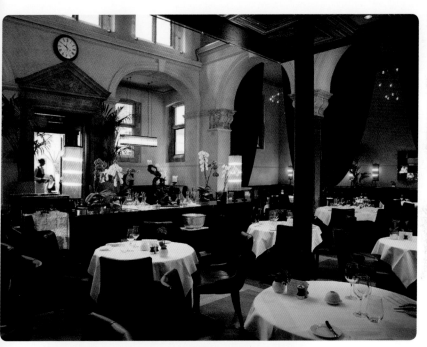

058

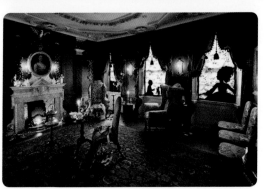

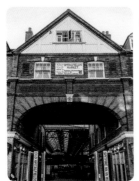

060

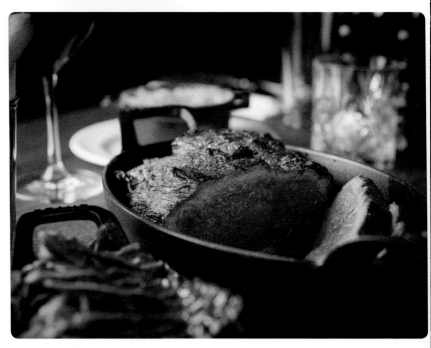

061

"*The cocktail list is based on the creations of Harry Craddock, bartender at the American Bar #165 at the Savoy in the 1920s, and include his famous corpse reviver #2.*"

Whitechapel

Whitechapel's proximity to the Docklands meant that historically, it was a draw for immigrants and labourers aiming to get work in the area. The over-supply of labour led to overcrowding, crime and poor living conditions. Such conditions in the 18th and 19th century were the subject of many of Charles Dickens' books. Whitechapel was famously the location for the Whitechapel Murders, attributed to Jack the Ripper and unsolved for over a century. Today, Whitechapel is a major centre for London's Asian communities and Brick Lane is a destination for Asian cuisine.

EAST

060
Old Spitalfields Market

Shopping

061
Hawksmoor

Food & Drink

This covered market in Spital-fields in east London has been the site of a market for over 350 years. Historically, it was a meat and vegetable market designed to supply produce to the growing London popula-tion. The buildings seen today were constructed in 1887 and are Grade II listed. The market moved premises in 1991 and now the space contains restaurants and shops selling arts and crafts, fashion and food. The market is open every day but gets especially busy on weekends. There is a growing presence of large brands at Old Spitalfields catering to the city workers nearby and it is rumoured that Apple will open a large, new store at some point in the future.

Hawksmoor is a steakhouse celebrating British beef and old-school cocktails. Starting in 2006 in Spitalfields, Hawksmoor have expanded to several London locations and one in Manchester. The restaurant use longhorn cattle bred in Yorkshire by the Ginger Pig company. Steaks on offer include Chateaubri-and (pictured), porterhouse, T-bone and prime rib. Sides include triple-cooked chips, creamed spinach and roasted field mushrooms. Puddings include a sticky toffee pudding with clotted cream. The cocktail list is based on the creations of Harry Craddock, bartender at The American Bar at The Savoy #165 in the 1920s, and include his famous corpse reviver #2.

Horner Square
E1 6EW
Tube: Aldgate East
+44 (0)20 7377 1496
spitalfields.co.uk
Map M03 | B8

157A Commercial Street
E1 6BJ
Tube: Aldgate East
+44 (0)20 7426 4850
thehawksmoor.com
Map M03 | B8

062
Brick Lane
Culture

063
Tayyabs
Food & Drink

064
Whitechapel Gallery
Art & Design

Located in London's East End, Brick Lane is a long street spanning Bethnal Green, Spitalfields and Whitechapel. Although predominantly known for its Indian and Bangladeshi cuisine, Brick Lane today offers far more than just food, and has become a diverse artistic and cultural destination. Street art is popular here, and works by many artists including Banksy are visible. Shows by London art and fashion schools are frequently hosted here, at some of the numerous well-known galleries and exhibition spaces. Bars, restaurants and quirky shops round off this new and exciting hub of creativity.

Brick Lane
E1 6QR
Tube: Aldgate East
Map M03 | C8

Tayyabs is a no-frills restaurant serving Punjabi cuisine. The restaurant is famous for serving good value, high-quality food. Although they do not serve alcohol, you are allowed to bring your own, which leads to a huge amount of business for the supermarket at the end of the road. The restaurant is always extremely busy and there are often queues down the street. Authentic dishes include karahi, gosht, keema, saag aloo, chana, urid dhal and haleem. This is one place you will want to book ahead.

83-89 Fieldgate Street
E1 1JU
Tube: Aldgate East
+44 (0)20 7247 9543
tayyabs.co.uk
Map M04 | C2

Situated to the east of the City of London, this was one of the first publicly funded galleries for temporary exhibitions, opening in 1901. The gallery has hosted internationally renowned artists including David Hockney, Lucian Freud, Mark Rothko, Jackson Pollock and Pablo Picasso. The space is an important part of east London's program of cultural activities and has well-established educational programs aimed at developing the local community. Whitechapel Gallery is open year round and has significant exhibition space, a café and a bookshop.

77-82 Whitechapel High Street
E1 7QX
Tube: Aldgate East
+44 (0)20 7522 7888
whitechapelgallery.org
Map M04 | B2

"Authentic dishes include karahi, gosht, keema, saag aloo, chana, urid dhal and haleem. This is one place you will want to book ahead."

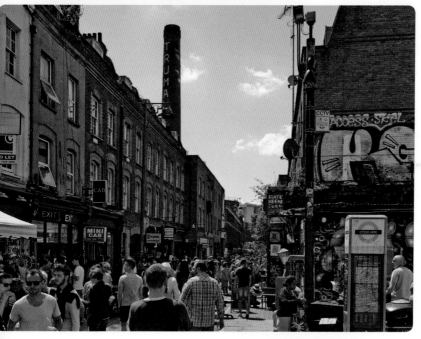

062

064

065

066

"*The halls grew out of public houses and in contrast to
the more formal theatre experience, the music hall was
designed for drinking and eating at the same time as
the performances.*"

065
Jack the Ripper Tour

History

066
Wilton's Music Hall

Entertainment

Jack the Ripper is the name given to a suspected serial killer in the East End of London in the late 19th Century. Five murders in 1888 were attributed to the ripper and it is perhaps the world's most famous, unsolved criminal case. The victims were all prostitutes, and their bodies were mutilated, with some organ removal by the attacker, leading some to conclude that the ripper had detailed knowledge of the human anatomy. Over the years ripper suspects have included surgeons, artists and even the Prince of Wales. Although investigative techniques, including DNA profiling, have advanced immeasurably since the period in which the crimes were committed, the surviving forensic evidence is too contaminated to offer any meaningful assistance to the investigation. The tour covers the locations of the crimes and other interesting places, including a working pub, which two of the victims are said to have frequented.

9 The Shrubberies, George Lane
E18 1BD
Tube: Aldgate East
+44 (0)20 8530 8443
jack-the-ripper-tour.com
Map M04 | B2

The British 'music hall' was a space for a type of variety show, or theatrical entertainment with various different acts ranging from the comedic to the acrobatic. Music Halls were extremely popular during the Victorian era. The halls grew out of public houses and in contrast to the more formal theatre experience, the music hall was designed for drinking and eating at the same time as the performances. Wilton's developed in the same way, from alehouse to saloon to music hall, the latter opening in 1859. The venue is also known as The Mahogany Bar based on the bar installed in 1826. Wilton's has a full program of dance, theatre, music and other activities, such as swing dance classes.

1 Graces Alley
E1 8JB
Tube: Tower Hill
+44 (0)20 7702 2789
wiltons.org.uk
Map M04 | C4

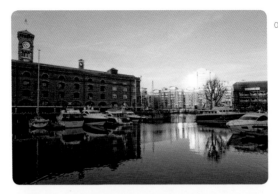

067

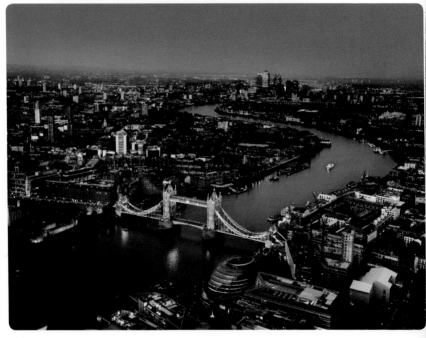

068

"The bridge was designed to alleviate increased traffic in the East End resulting from rising populations and trade in the 19th century, whilst allowing ships to continue to dock at the port upstream."

Tower Hill

Tower Hill is a small area just outside the City of London. Site of a Roman settlement, the area is one of London's oldest and home to the Tower of London (1078) and All-Hallows-by-The-Tower (625). The hill itself was the site of numerous public executions over the course of several centuries including Sir Thomas More, ex-Lord Chancellor to Henry VIII; George Boleyn, brother of Anne Boleyn; and Edward Seymour who commissioned the building of Somerset House and was the brother-in-law of King Henry VIII. The site of the executions is marked by a plaque and the area also contains a memorial to members of the merchant navy who fought in both world wars.

CITY

067
St Katharine Docks

Culture

St Katharine Docks were formerly a commercial dock on the banks of the Thames near Tower Bridge and have been completely redeveloped into a marina with offices, shops, bars, restaurants and homes. The marina is the only one in Central London. Views from the renovated warehouses look out over the river and Tower Bridge. The development offers quayside dining, a cooking school, a Friday food market and plenty of other events and things to see and do.

50 St. Katharine's Way
E1W 1LA
Tube: Tower Hill
+44 (0)20 7264 5312
skdocks.co.uk
Map M05 | I8

068
Tower Bridge

Architecture

Tower Bridge is a mix of architectural styles being both a suspension bridge and a bascule bridge. The two bascules open and elevate in order to allow ships to pass through. The bridge was designed to alleviate increased traffic in the East End resulting from rising populations and trade in the 19th century, whilst allowing ships to continue to dock at the port upstream. The lower deck is both a road and pedestrian bridge. The towers and high-level walkways contain an exhibition showing the original steam engines and have a vertigo-inducing glass floor.

SE1 2UP
Tube: Tower Hill
+44 (0)20 7403 3761
towerbridge.org.uk
Map M05 | I8

CITY

069
Tower of London

History

070
London Wall

History

071
All-Hallows-by-the-Tower

Culture

Founded towards the end of 1066 as part of the Norman Conquest of England, the Tower of London is one of Britain's oldest and most important castles. The Tower was a Royal Palace and the main tower was built by William the Conqueror in 1078. The castle was used as a prison and prisoners entered the castle by boat at Traitor's Gate. In 1483, following the death of the King, Edward IV, his sons, Prince Edward and Prince Richard were accommodated in the Tower awaiting Edward's coronation as King Edward V. The princes disappeared and Edward's uncle, Richard, Duke of Gloucester, who was charged with their safety, took the throne. It is assumed that Richard had the princes murdered so that he could become King. Elizabeth I was held here as a prisoner by her sister Queen Mary in the 16th Century. Mary, a Catholic saw Elizabeth, a Protestant as a challenge to her power. The tower is the home of the crown jewels and the Yeoman Warders (Beefeaters) were traditionally charged with guarding them. Today it is a ceremonial duty and the Beefeaters act more as tour guides.

The London Wall was built by the Romans around 200AD and was intended to be a defensive measure to protect the city, which was then known as Londinium. Saxon pirates regularly carried out raids on the city. Remaining parts of the wall are near Barbican Centre #088 and Museum of London #087 and the museum run a London Wall walk that traces the original route of the wall, passing by many of the surviving sections. In front of one section at Tower Hill is a statue of the Emperor Trajan, deemed by the Roman Senate to be the greatest Emperor and who led the Roman Empire to its greatest amount of territory.

Tower Hill
EC2Y 5AJ
Tube: Tower Hill
+44 (0)370 333 1181
english-heritage.org.uk
Map M05 | H7

Founded in 675 AD, All Hallows is the oldest church in the City of London. Situated close to the Tower of London, the church was used for temporary burial of persons executed at the tower, including Sir Thomas More, Catholic statesman and Lord Chancellor to Henry VIII. Thomas was executed for his refusal to accept Henry as head of the Church of England. The Undercroft Museum situated in the church's crypt contains parts of a Roman pavement and church records, including the marriage of US President John Quincy Adams.

Byward Street
EC3R 5BJ
Tube: Tower Hill
+44 (0)20 7481 2928
allhallowsbythetower.org.uk
Map M05 | H7

EC3N 4AB
Tube: Tower Hill
hrp.org.uk/toweroflondon
Map M05 | I8

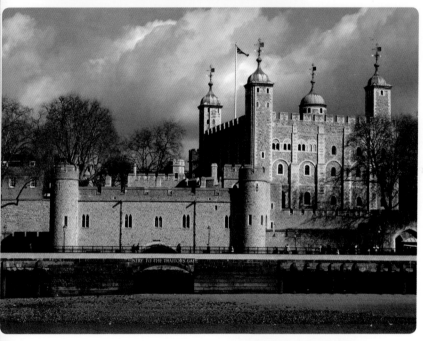

070

069

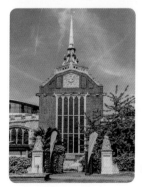

071

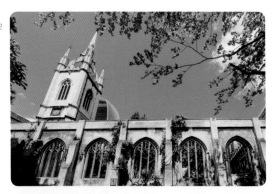

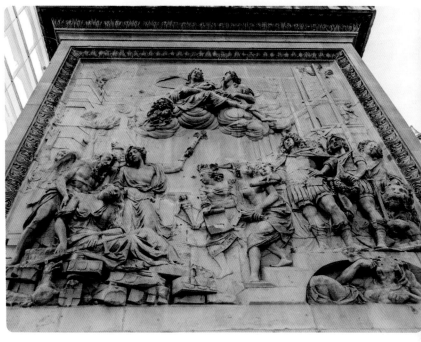

"It started in a bakery on Pudding Lane in the City of London and destroyed over 13,000 houses, over 80 churches and St Paul's Cathedral."

City of London

The City of London is the site of the original Roman settlement of Londinium. Also known as 'the square mile' based on the approximate historical boundaries, it was here that the Great Fire of London occurred in 1666. As the monarch and the governing institutions moved westwards, the city remained an area of business and trade and is today the major business and financial centre in the United Kingdom. It is home to London's insurance industry located in and around the Lloyds Building. During the week, the City is an energetic and lively throng of pinstripe suits but weekends are much quieter, allowing visitors to explore some of the fascinating history that lies within.

072
St-Dunstan-in-the-East

Culture

073
Monument to the Great Fire of London

History

This city garden contains the ruins of the church of St Dunstan, built in the early 12th century. The church was severely damaged in the Great Fire of London, after which Sir Christopher Wren added a steeple and tower. The church was again damaged during The Blitz in The Second World War, but Wren's additions survived. The ruin is Grade I listed and trees and plants wind their way around it, making it a local destination for a pleasant walk or sit-down.

St. Dunstan's Hill
EC3R 5DD
Tube: Tower Hill
cityoflondon.gov.uk
Map M05 | G7

The Great Fire of London in 1666 was one of the most devastating events in the city's history. It started in a bakery on Pudding Lane in the City of London and destroyed over 13,000 houses, over 80 churches and St Paul's Cathedral #086. The fires burned for three days and were only brought under control by the deliberate demolition of buildings in the fire's path. The majority of the city within the London Wall #070 was destroyed. The scale of the destruction was compounded by the state of overcrowding in the city, which led to many illegal buildings made of wood and thatch being constructed in close proximity. The monument, completed in 1677, stands close to the spot where the fire started and another monument, The Golden Boy of Pye Corner #091 commemorates the spot where the fire was stopped. The Monument was designed by Sir Christopher Wren and consists of a single column topped by a gilded urn of fire. There is a viewing platform at the top, which offers visitors views across the City of London.

Fish Street Hill
EC3R 8AH
Tube: Monument
themonument.info
Map M05 | G7

CITY

074
Sky Garden
Leisure & Nature

075
Leadenhall Market
Shopping

076
Lloyd's Building
Architecture

20 Fenchurch Street is a 160m skyscraper in the city. The building's design is top-heavy, increasing the floor space in the upper floors beyond the building's footprint area. This has given rise to the nickname, 'The Walkie Talkie'. In the top of the building is a public garden with an outdoor terrace. A condition of the building's approval, the sky garden offers plants and panoramic views across London. Visitors can pre-book through the website and admission is free. The sky garden contains restaurants and a café serving food, drinks and cocktails.

20 Fenchurch Street
EC3M 8AF
Tube: Monument
+44 (0)20 7332 1523
skygarden.london
Map M05 | G7

Located in the City of London, Leadenhall Market dates from the 14th century and is one of the oldest markets in London. The market is covered and the building structure features ornate Victorian, cast iron and glass with Corinthian columns, gables and turrets. Traders include butchers, florists, cheesemongers and there are also several clothes shops, pubs and restaurants. The Lloyds Building #076 is next door and at lunchtimes the market fills with suited members of the insurance industry negotiating deals over a pint of beer and a sandwich.

EC3V 1LT
Tube: Monument
+44 (0)20 7332 1523
cityoflondon.gov.uk
Map M05 | G6

The Lloyd's Building is a world-famous example of 'bowelism' architecture in which the service elements of the building, such as the pipes, ducts, staircases and even lifts are located outside of the building so as to maximize the internal usage space. The building houses Lloyd's of London, the international insurance market, founded in a coffee house in 1688. The building's architect is Richard Rogers, who also designed the Pompidou Centre in Paris along with Renzo Piano. Inside, the building reveals a huge, cathedral-like space rising 60m to a glass roof. The building also contains the Lutine Bell, recovered from HMS Lutine, a Royal Navy frigate that sank in 1799. The bell is used for ceremonial purposes.

1 Lime Street
EC3M
Tube: Monument
Map M05 | G6

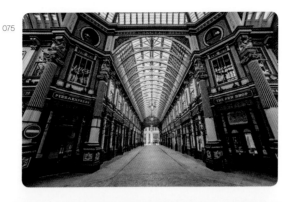

075

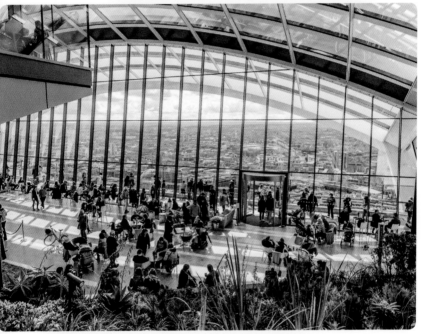

074

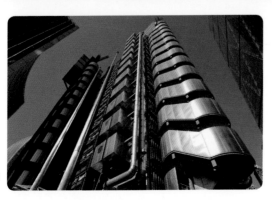

076

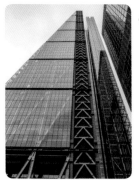

077

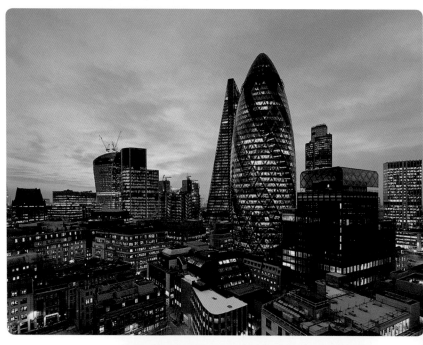

078

079

077
The Leadenhall Building

Architecture

078
30 St Mary Axe

Architecture

079
The Mayor of Scaredy Cat Town

Food & Drink

Known locally as 'The Cheesegrater', the Leadenhall Building was designed by the architecture firm of Richard Rogers, the architect behind the Lloyd's Building #076, which stands next door. The building is shaped like a wedge and was designed to allow for protected views of St Paul's Cathedral #086. The building's glass facade shows elements of the steel frame underneath and other mechanical elements such as lift shafts are painted in bright colours to make them more visible, similar to the Lloyd's Building. The Leadenhall Building is in an area of the city, primarily occupied by the insurance industry.

122 Leadenhall Street
EC3V
Tube: Aldgate East
theleadenhallbuilding.com
Map M05 | G6

Standing on the former site of the Baltic Exchange, 30 St Mary Axe, better known as "The Gherkin", is a modern skyscraper in the heart of the city. The building was designed by celebrated British architect Norman Foster and is one of the most well known and iconic of London's modern buildings. The building opened in 2004 and Foster was awarded the prestigious RIBA Stirling Prize later that year. The building stands 180m tall and has 41 floors. Formerly owned by reinsurance giant Swiss Re, the building has changed ownership several times since its completion. One previous transaction made this the most expensive office building in the United Kingdom.

30 St. Mary Axe
EC3A 8EP
Tube: Liverpool Street
30stmaryaxe.info
Map M05 | H6

This small, dimly lit basement bar is different. For a start, the entrance is through a fridge door inside The Breakfast Club Café above and the staff take great pleasure in making patrons ask for the mayor of scaredy cat town. Cocktails have names like Berlusconi, Mezcallywag (containing mezcal) and Blood and Slander and use ingredients like pink and black peppercorn infused tequila; and chocolate, peanut and vanilla bourbon. Despite all the secrecy, this was voted London bar of the year in 2015. The focus is on drinks but they also offer sharing food such as cheeseboards, pulled pork sliders and quesadillas.

12-16 Artillery Lane
E1 7LS
Tube: Liverpool Street
+44 (0)20 7078 9639
themayorofscaredycattown.com
Map M05 | H5

080
Angler

Food & Drink

Angler is a high-end, Michelin-starred seafood restaurant celebrating seasonal, local fish and other fresh ingredients. Located in the City of London on top of a luxury hotel, the restaurant pairs city views with modern cooking. Dishes such as Cornish red mullet soup; ballotine of ray wing and crab; and roast fillet of turbot with ragout of squid offer diners the best of British seafood in a comfortable setting.

South Place Hotel
3 South Place
EC2M 2AF
Tube: Moorgate
+44 (0)20 3215 1260
anglerrestaurant.com
Map M05 | G4

081
Royal Exchange

Architecture

The Royal Exchange was opened by Queen Elizabeth I in 1571. Designed as the first, purpose-built financial exchange in the city, the building was funded by merchant, Sir Thomas Gresham who also created the foundation for Gresham College #108. The building has been rebuilt twice; once following the Great Fire of London in 1666. The building was home to the Lloyd's Insurance Market for 150 years. The current building has a grand Neoclassical facade modelled after the Pantheon in Rome and was opened by Queen Victoria in 1844. Today the Royal Exchange contains over 30 shops and several restaurants.

2 Royal Exchange Steps
EC3V 3DG
Tube: Bank
+44 (0)20 7283 8935
theroyalexchange.co.uk
Map M05 | F6

082
Bank of England

Architecture

Established in 1694 in order to raise funds from private investors for the war with France, the Bank of England moved to Threadneedle Street in 1734. This is the central bank of the United Kingdom and is nicknamed, 'The Old Lady of Threadneedle Street', which comes from a 1797 cartoon. The vaults here hold many billions of pounds of gold that form part of the United Kingdom's and other countries' national reserves. The bank has been extended, renovated, demolished and rebuilt over the course of its history; its most famous architect being Sir John Soane, who was principal architect and surveyor from 1788-1833. The museum is open between 10am and 5pm on weekdays. The bank has also been known to open on London's Open House Weekend, which takes place in September each year.

Threadneedle Street
EC2R 8AH
Tube: Bank
+44 (0)20 7601 4444
bankofengland.co.uk
Map M05 | F6

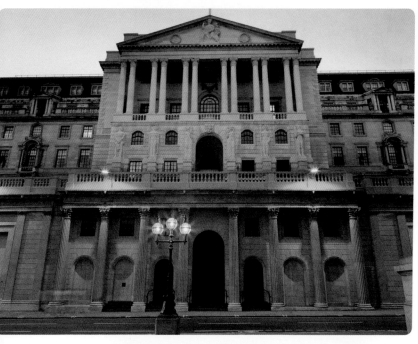

082

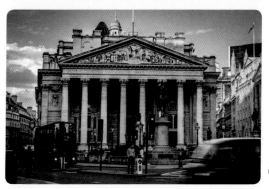

081

084

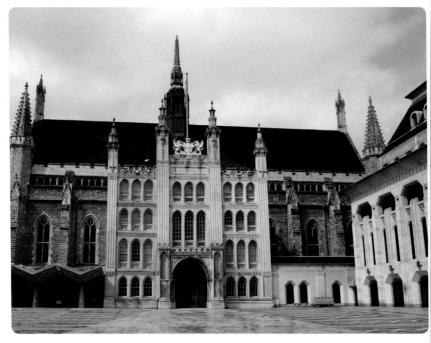

083

085

083
The Guildhall

Culture

084
St-Mary-Le-Bow

Architecture

085
Sweetings

Food & Drink

The Guildhall is the home of the City of London Corporation, which is an elected council that governs the workings of London's financial district. The building was completed in 1440 and contains a medieval crypt. Next door is The Guildhall Art Gallery, housing the City of London's art collection, as well as containing the ruins of a Roman amphitheatre in the basement. The collection includes around 4,000 artworks, many of which are by British artists and related to London. The amphitheatre is believed to have been Britain's biggest and would have held gladiatorial contests and public events. Admission to the gallery and the amphitheatre is free.

St-Mary-Le-Bow is one of the most important churches in London. It was rebuilt by Sir Christopher Wren following the Great Fire of London in 1666 and rebuilt again after being bombed in the Second World War. Located in the City of London, tradition dictates that those born within the sound of 'bow bells' (the bells of St-Mary-Le-Bow) are the only ones to be considered true cockneys (a term relating to the east end of London and a specific accent and vocabulary known as cockney English - see language section).

The original Sweetings opened in 1830 as John S. Sweetings, Fish and Oyster Merchant in Islington. The present premises have been occupied for over 100 years and the restaurant is a city institution. Still all about fish and seafood, dishes here include Lobster Thermidor, home made Gravadlax, chef's fish pie and smoked haddock with poached eggs. Home made puddings such as spotted dick and baked jam pie are also available. The restaurant is old school through and through from the black and white uniformed staff to the church pew-like seating and the daily selection of fresh fish on ice in the window. Sweetings is only open for weekday lunch and does not take reservations.

Cheapside
EC2V 6AU
Tube: Bank
+44 (0)20 7248 5139
stmarylebow.co.uk
Map M05 | E6

Guildhall Yard
EC2V 5AE
Tube: St. Paul's
+44 (0)20 7332 3700
Map M05 | F5

39 Queen Victoria Street
EC4N 4SF
Tube: Mansion House
+44 (0)20 7248 3062
sweetingsrestaurant.co.uk
Map M05 | F6

"The restaurant is old-school through and through from the black and white uniformed staff to the church pew-like seating and the daily selection of fresh fish on ice in the window."

086
St Paul's Cathedral
Architecture

087
Museum of London
History

088
Barbican Centre
Culture

Designed by Sir Christopher Wren in the 17th century and built over the course of 45 years, St Paul's is the seat of the Bishop of London and was the tallest structure in London for more than 240 years. Designed in the English Baroque style, St Paul's was only one of around 50 churches designed by Wren following the Great Fire of London in 1666. Though bombed several times during the Second World War, the cathedral survived. The cathedral was the location for the wedding of Prince Charles and Princess Diana and the funerals of Lord Nelson, the Duke of Wellington and Sir Winston Churchill. Visitors can get panoramic views of London by climbing 528 steps to the Golden Gallery that sits 85m above the cathedral floor.

This museum features artefacts from Prehistoric, Roman, Medieval and Elizabethan London all the way up to the modern day. The stories of major events in London such as the Great Plague and the Great Fire of London are told through a vast collection of historical items. Highlights include the 250-year-old Lord Mayor's Coach; 18th century fashions; Oliver Cromwell's death mask; Roman marble sculptures from the Temple of Mithras; and the prehistoric skull of an extinct auroch (wild ox).

150 London Wall
EC2Y 5HN
Tube: St. Paul's
+44 (0)20 7001 9844
museumoflondon.org.uk
Map M05 | E5

This performing arts centre in the City of London is home to the London Symphony Orchestra, the BBC Symphony Orchestra and the Royal Shakespeare Company. The Centre organises events covering music, theatre, film, dance and art. Designed to be all-purpose, fully equipped arts, culture and residential complex, the centre's brutalist architecture has consistently divided opinion. In 2001, the whole complex became a Grade II listed building, giving it protected status for the future.

Silk Street
EC2Y 8DS
Tube: Barbican
+44 (0)20 7638 4141
barbican.org.uk
Map M05 | E4

St. Paul's Churchyard
EC4M 8AD
Tube: St. Paul's
+44 (0)20 7246 8350
stpauls.co.uk
Map M05 | D6

"...built over the course of 45 years, St Paul's is the seat of the Bishop of London and was the tallest structure in London for more than 240 years."

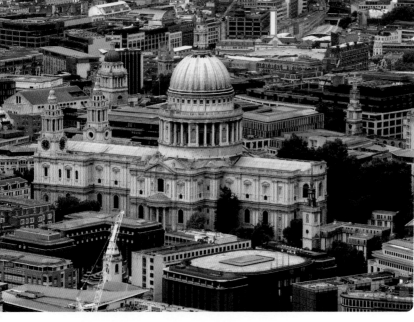

086

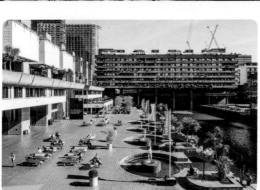

088

"The church is one of the best examples of Norman architecture in the country and inexplicably escaped damage during the Dissolution of the Monasteries under Henry VIII, the Great Fire of London and bombing raids in two world wars."

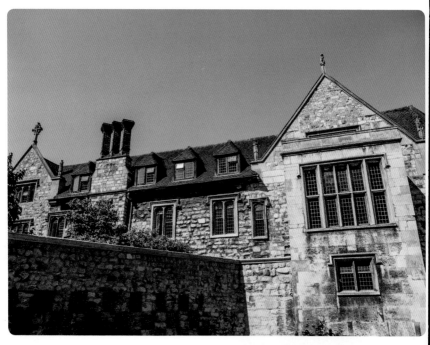

089

090

Farringdon

A historic area in the City of London, Farringdon is home to St Bartholomew's Hospital, Charterhouse Square, the Priory Church of St Bartholomew the Great and Smithfield Meat Market. The wholesale market gets going in the middle of the night and by early morning, workers are clocking off, leading to nearby pubs having some of the longest licensing hours in the city. The area also has several well-known nightclubs that keep going until the early hours. The recent Crossrail project made a gruesome discovery in the area, a plague pit from the Black Death dating to the 14th century.

CITY

089
Charterhouse Square

History

Charterhouse Monastery was founded on this square in 1371. After its dissolution in the 16th century the monastery buildings were turned into a private house and subsequently bought by Thomas Sutton and endowed as an almshouse for pensioners and a boy's school (Charterhouse School). The school moved out in the 19th century, but the almshouse remains today under the name Sutton's Hospital. The residents are known as 'brothers' in reference to the former Monastery. The area is the site of one of the city's biggest plague pits with recent excavations putting the number of victims buried here in the tens of thousands. St Bartholomew's Hospital and the Priory Church of St Bartholomew #090 are nearby, making the square a focal point for an important period of the city's history.

EC1M
Tube: Barbican
Map M05 | D4

090
The Priory Church of St Bartholemew the Great

History

London's oldest surviving church, St Bartholomew's was founded as an Augustinian Priory in 1123 and has been in continuous use ever since. The church is one of the best examples of Norman architecture in the country and inexplicably escaped damage during the Dissolution of the Monasteries under Henry VIII, the Great Fire of London and bombing raids in two world wars. The area contains St Bartholomew's Hospital, Smithfield Market and Charterhouse Square making it an important historical area in the development of the city.

West Smithfield
EC1A 9DS
Tube: Barbican
+44 (0)20 7600 0440
www.greatstbarts.com
Map M05 | D4

CITY

091
The Golden Boy of Pye Corner

History

092
Fabric

Entertainment

093
St John Restaurant

Food & Drink

This small statue was erected to commemorate the stopping of the Great Fire of London in 1666. The main inscription reads: "The boy at Pye Corner was erected to commemorate the staying of the great fire which beginning at Pudding Lane was ascribed to the sin of gluttony when not attributed to the papists as on the monument and the boy was made prodigiously fat to enforce the moral he was originally built into the front of a public-house called The Fortune of War which used to occupy this site and was pulled down in 1910."

Cock Lane and Gitspur Street
EC1
Tube: St. Paul's
Map M05 | D5

Fabric opened its doors in 1999 and is located in Farringdon. A self-styled club by clubbers for clubbers, electronic music dominates and the main focus is on drum and bass, dubstep, house and techno. The club has a capacity of 1,600 and offers more than 2,000 square metres of space across three main rooms. The major nights are Friday and Saturday, but Fabric also runs a Sunday club night featuring house and techno music until 5.30am, just to make those Mondays even harder.

77A Charterhouse Street
EC1M 6HJ
Tube: Farringdon
+44 (0)20 7336 8898
fabriclondon.com
Map M05 | D4

St John is a vegetarian's nightmare with all sorts of meats and offal available including: ox hearts, pig's cheeks, lamb tongues, roast bone marrow, pig's head and potato pie; pigeon and trotter pie; tripe and sweetbreads. The restaurant was founded in 1994 and the head chef Fergus Henderson is well known for delivering quality and consistency across the menu. The restaurant is housed in a former smoke-works and very little has been done to change the external appearance in over twenty years. Inside, the decor is clean and simple with white walls, wood and vintage lighting. The menu is British, and as well as the carnivorous delights, offers vegetable dishes, traditional puddings, cheese, and breakfasts.

26 St. John Street
EC1M 4AY
Tube: Barbican
+44 (0)20 7251 0848
stjohngroup.uk.com
Map M05 | D4

"...all sorts of meats and offal available including: ox hearts, pig's cheeks, lamb tongues, roast bone marrow, pig's head and potato pie; pigeon and trotter pie; tripe and sweetbreads."

091

093

092

094

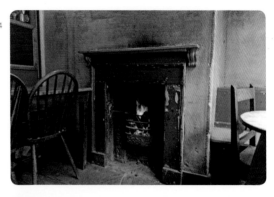

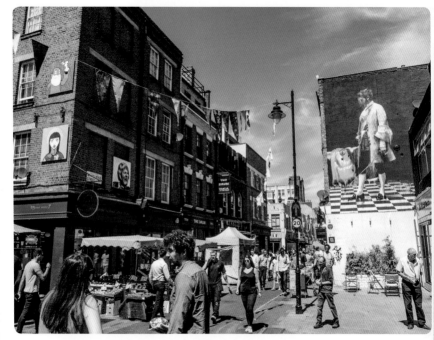

095

096

Clerkenwell

Located close to the City of London but outside the original London Wall, Clerkenwell was a notorious area of crime and prostitution in centuries past. It became a centre for clock making and printing during the Industrial Revolution and has a historical association with communism. Lenin lived in the area in the early 20th century and the Marx Memorial Library is located here. It was also the centre of the Italian community in London for a period. Centered on Clerkenwell Green, the area has a village feel with several pubs and restaurants nearby.

CITY

094
Jerusalem Tavern

Food & Drink

The Jerusalem Tavern occupied several sites from the 14th century onwards and the current buildings date from 1720. Run by the St Peter's Brewery based in Suffolk, the pub offers a broad range of real ales including whisky beer, winter ale, spelt blonde beer, old style porter and India pale ale. They also brew gluten free beer. The décor inside consists of wooden floorboards, panelling, open log fires and well-worn tables. Rated highly by the Good Pub Guide, space here is limited and there is outdoor seating on the street outside. They also serve food.

55 Britton Street
EC1M 5UQ
Tube: Chancery Lane
+44 (0)20 7490 4281
stpetersbrewery.co.uk
Map M05 | D4

095
Whitecross Street Market

Food & Drink

Whitecross Street Market is one of the oldest markets in London. The market is primarily focused on street foods including hog roasts, pies, Thai, Chinese, Vietnamese, Indian, Moroccan, French, Turkish, Italian, wild and exotic meats, crepes, cakes and sweets, delicatessens, baguettes, sandwiches and salads, teas and coffees. There are stalls selling other household and craft items as well. Popular at lunchtimes, the market is open weekdays 10am to 5pm.

Whitecross Street
EC1Y
Tube: Barbican
Map M05 | E3

096
Hula Nails

Leisure & Nature

Located on Whitecross Street in Clerkenwell, Hula Nails describes itself as 'a Vintage Tiki Beauty Parlour'. It provides manicures, pedicures, waxing, spray tans, hair extensions and more, in a funky, retro-designed space. Hula offer themed events and hen parties and their tagline is: 'Get Nailed at Hula'. Manicures start at £18, full body spray tan is £36 and there are many different treatment packages available.

203-205 Whitecross Street
EC1Y 8QP
Tube: Old Street
+44 (0)20 7253 4453
hulanails.com
Map M05 | E3

CITY

097
Ironmonger Row Baths

Leisure & Nature

098
Kennedy's of Goswell Road

Food & Drink

099
Sadler's Wells Theatre

Entertainment

Ironmonger Row Baths is one of London's oldest Turkish baths. Built in 1931 as a public washhouse, the baths were renovated extensively and reopened in 2012 as a modern public gym, swimming pool and day spa. The Victorian style Turkish bath comprises a hammam, hot rooms, and an icy cold plunge pool. The spa offers waxing, manicures, massage and facials. The spa is open to all and access is available for £26 for a three-hour session. Access to the gym and pool is priced separately.

1 Norman Street
EC1V 3AA
Tube: Old Street
+44 (0)20 3642 5520
better.org.uk
Map M05 | E2

Kennedy's has been around for about 150 years and offers British food such as fish and chips, pies and sausages at reasonable prices. They offer an eat-in or takeaway next door. The restaurant is intimate and extremely busy at lunchtimes. They have a second location on Whitecross Street, next to Whitecross Street Market #095.

184-186 Goswell Road
EC1V 7DT
Tube: Barbican
+44 (0)20 7490 2089
kennedyslondon.co.uk
Map M05 | D2

Sadler's Wells is a world-class contemporary dance venue with three performance spaces, the main one holding 1,500 people. London's second oldest theatre has adapted with the times and the competition since the first theatre opened on the site in 1683. Over the course of three centuries, the theatre has put on plays, opera, music, ballet and many other forms of entertainment. Sadler's Wells gets its name from its founder, Richard Sadler and the wells that were rediscovered nearby. Thought to have life-giving properties the water was in great demand and brought a lot of people to the area, a ready-made audience for the theatre's various entertainments.

Rosebery Avenue
EC1R 4TN
Tube: Angel
+44 (0)20 7863 8000
sadlerswells.com
Map M05 | C1

"...a world-class contemporary dance venue with three performance spaces, the main one holding 1,500 people. "

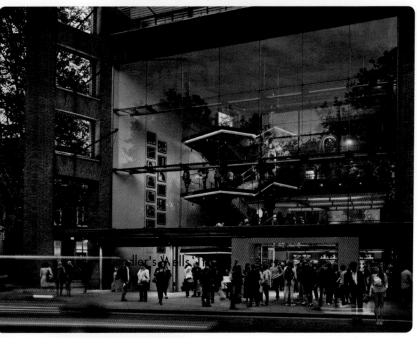

"Using a wood-burning oven and charcoal grill they create dishes such as: cuttlefish kofte with grilled red pepper, and crispy caper salad; pan fried sweetbreads with prawns, pine nuts, wild garlic leaves and oloroso."

100

101

100
Amwell Street

Culture

101
Moro

Food & Drink

Amwell Street is a quiet street in Islington with a local village atmosphere and a handful of small businesses, restaurants and pubs. In the area are Exmouth Market #102 and Sadler's Wells Theatre #099. The street has a delicatessen, coffee shop and other local amenities. The area has several green spaces and squares. Karl Marx once lived in a house nearby, which is now marked with a blue plaque.

Amwell Street
EC1R
Tube: Angel
Map M05 | C1

Moro serves a mix of Spanish, African and Middle Eastern dishes from the heart of Exmouth Market #102. Using a wood-burning oven and charcoal grill they create dishes such as: cuttlefish kofte with grilled red pepper, and crispy caper salad; pan fried sweetbreads with prawns, pine nuts, wild garlic leaves and oloroso; wood roasted pork with roasted sour plums and mash potato; and charcoal grilled lamb with roast carrots chopped with pomegranate molasses, caraway and farika. The bar menu offers tapas in the form of babaganoush; grilled chorizo; mojama with piquillo pepper; and labneh, black olives and lemon thyme to name a few. The success of such dishes allowed them to open Morito, a small tapas and mezze bar, next door.

34-36 Exmouth Market
EC1R 4QE
Tube: Farringdon
+44 (0)20 7833 8336
moro.co.uk
Map M05 | C2

"Karl Marx once lived in a house nearby, which is now marked with a blue plaque."

CITY

102
Exmouth Market

Food & Drink

103
Otto's

Food & Drink

Exmouth Market consists of a single main street in Clerkenwell and a growing area around it where restaurants, cafés, pubs and particularly street food stalls have made it a food and drink destination. The provision of outdoor seating by many establishments is also a draw. Classified as 'gentrified' areas, Clerkenwell, Shoreditch and other nearby areas were relatively run down in past decades, but have seen massive regeneration in recent years. These areas' proximity to well-paid jobs in the City of London, along with the influence of artists and designers living in such areas are two factors that seem to accelerate the process.

Exmouth Market
EC1R 4QE
Tube: Farringdon
Map M05 | C2

Otto's is a classic French restaurant. The signature dish here is canard a la presse, a dish consisting of duck breast and leg, served with a sauce made from the juices of the remaining duck, pressed at the table and mixed with cognac and duck liver. The dish dates from the beginning of the 18th century and the press here is from the 1900s. The ducks are sourced from Challans in France. Other dishes include spring pea soup and mushroom cromesquis; terrine of pork, juniper berry jelly, meaux mustard sauce and toast; roast fillet of brill, cauliflower puree, purple sprouting broccoli and sauce bonne femme; and tournedos of Scotch fillet of beef with rich truffle and Madeira sauce and potato mousseline.

182 Gray's Inn Road
WC1X 8EW
Tube: Russell Square
+44 (0)20 7713 0107
ottos-restaurant.com
Map M05 | B3

"The signature dish here is canard a la presse, a dish consisting of duck breast and leg, served with a sauce made from the juices of the remaining duck, pressed at the table and mixed with cognac and duck liver."

Canard a la Presse

NAME:_____ NO._____ DATE:_____

102

104

105

"*The collection includes paintings by Canaletto, Hogarth, J.M.W. Turner and Joshua Reynolds; 18th century Chinese ceramics; Peruvian pottery; Greek and Roman bronzes and the ancient Egyptian alabaster sarcophogus of Seti I.*"

Holborn

Holborn is an area to the west of the City of London, which has a strong connection with London's legal system, being home to Gray's Inn and Lincoln's Inn, two of the four Inns of Court. The area contains Hatton Garden, London's diamond centre; and is full of old churches and pubs. One of the grandest and most unique buildings in the area is Holborn Bars, a stunning redbrick building designed by Alfred Waterhouse for the Prudential Assurance Company in 1905.

CITY

104
Princess Louise

Food & Drink

105
Sir John Soane's Museum

History

The Princess Louise Public House was built in 1872 and retains its original Victorian décor. The interior is filled with wood panelling, booths and ornate tiling. The pub contains snob screens, a series of etched glass screens that were designed to allow middle class drinkers to see working class drinkers nearby, but not be seen by them or the bar staff. The building is Grade II listed down to the marble urinals and the pub has a range of beers, ales and food on offer.

Sir John Soane was a prominent architect in the late 18th and early 19th century and professor of architecture at the Royal Academy of Arts #224. The museum is located in his former house on Lincoln's Inn Fields #106. Soane owned two adjacent properties, leaving them to the nation by an act of parliament, which required that the buildings be maintained as close to their original state as possible. The museum houses Soane's collection of architectural drawings, models and antiquities. The collection includes paintings by Canaletto, Hogarth, J.M.W. Turner and Joshua Reynolds; 18th century Chinese ceramics; Peruvian pottery; Greek and Roman bronzes and the ancient Egyptian alabaster sarcophagus of Seti I. The architecture of the house, having been remodelled by Soane himself, is as much a part of the collection as the paintings and objects.

208 High Holborn
WC1V 7EP
Tube: High Holborn
+44 (0)20 7405 8816
princesslouisepub.co.uk
Map M05 | A5

13 Lincoln's Inn Fields
WC2A 3BP
Tube: Holborn
+44 (0)20 7405 2107
soane.org
Map M05 | A5

CITY

106
Lincoln's Inn Fields

Leisure & Nature

107
London Silver Vaults

Culture

108
Gresham College

Culture

London's largest public square was laid out in the 1630s and its grand buildings were designed by such esteemed architects as Sir Christopher Wren, Sir John Vanbrugh and Sir Edwin Lutyens. The square is home to several businesses including the law firm Farrer & Co. who have represented Kings and Queens over the 300-year period of their existence. The London School of Economics also own several buildings on the square and Sir John Soane's Museum #105 is located here. When the weather is good, the fields are extremely popular for picnics and sunbathing.

Treasury Office
WC2A 3TL
Tube: Holborn
+44 (0)20 7405 1393
lincolnsinn.org.uk
Map M05 | B5

The London Silver Vaults contain around 40 shops selling silver and it is claimed to be the world's largest retail collection of fine antique silver. The vaults were originally designed as a safe deposit, but were soon filled with shops. The building above the vaults was destroyed by bombing in The Second World War, but the vaults were undamaged. The shops here offer candlesticks, cutlery, watches, goblets, photo frames, teaware and much more, from the 16th century to the art deco period and on to modern-day designs.

53-64 Chancery Lane
WC2A 1QS
Tube: Chancery Lane
+44 (0)20 7242 3844
silvervaultslondon.com
Map M05 | B5

Gresham College was founded in 1597 by Sir Thomas Gresham, who also founded the Royal Exchange #081 to offer free public lectures. Early subjects included astronomy, law, physics and music. Lecturers included Sir Christopher Wren, who designed St Paul's Cathedral #086. The college was a forerunner of the Royal Society and still organises around 140 lectures per year, given by eminent thinkers in science, history, economics and many other fields.

Barnard's Inn Hall
EC1N 2HH
Tube: Chancery Lane
+44 (0)20 7831 0575
gresham.ac.uk
Map M05 | C5

"Early subjects included astronomy, law, physics and music. Lecturers incuded Sir Christopher Wren, who designed St Paul's Cathedral #086."





107

THE LONDON SILVER VAULTS

SHOPS

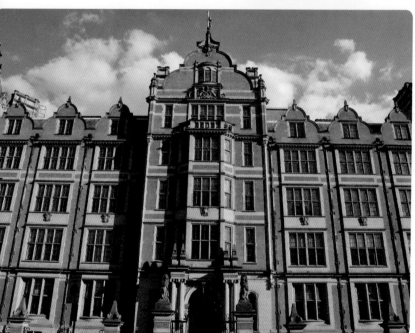

106

108

109

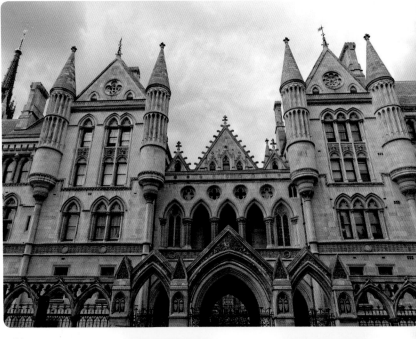

111

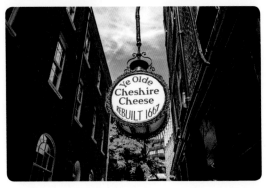

110

Temple

Temple is one of the centres of English law and home to the Inner Temple and the Middle Temple, two of the four inns of court; and the Royal Courts of Justice. The temples belonged to the Knights Templar in the 12th Century along with Temple Church. The word Inner temple derives from the fact that the inns were within the boundaries of the City of London, whereas the Outer Temple was outside. During the week, the streets are filled with members of the legal profession going to and from courts and offices.

CITY

109
Dr Johnson's House

History

Dr Johnson's House is a Georgian townhouse in the City of London, home of the famous lexicographer, Dr Samuel Johnson. Johnson was contracted to create the first comprehensive and practical dictionary of the English language, a feat that took him nine years. Published in 1755, the dictionary contained over 42,000 words, complete with definitions and uses. The work was highly praised not only for its completeness and detail but also for the fact that Johnson created it single-handedly. The house is laid out in its original style and contains many original Georgian fixtures, fittings and pieces of furniture as well as several paintings, which makes it a fascinating and valuable time capsule from the early 18th century period.

17 Gough Square
EC4A 3DE
Tube: Chancery Lane
+44 (0)20 7353 3745
drjohnsonshouse.org
Map M05 | C6

110
Ye Olde Cheshire Cheese

Food & Drink

There has been a pub on this site since 1538 and Ye Olde Cheshire Cheese was one of the public houses rebuilt after the Great Fire of London. The pub features wooden panelling and vaulted ceilings. There are many small rooms inside and not much in the way of lighting, giving it an old, possibly Victorian feel. Many literary figures frequented the pub including Mark Twain, Alfred Tennyson, Sir Arthur Conan Doyle, P.G. Wodehouse and Charles Dickens. The pub sits in a narrow alleyway off Fleet Street and is Grade II listed.

145 Fleet Street
EC4A 2BU
Tube: Chancery Lane
+44 (0)20 7353 6170
Map M05 | C6

111
Royal Courts of Justice

Architecture

The Royal Courts of Justice consist of the High Court and the Court of Appeal of England and Wales and are housed together on the Strand. Not to be confused with the Old Bailey, which is the central criminal court of England and Wales, these impressive Gothic buildings were opened by Queen Victoria in 1882. The buildings are notable for their elaborate carvings and decorative interiors including marble galleries. The buildings are open to the public and most of the trials being conducted can be watched free of charge. There are also regular tours documenting the history, architecture and art of the courts.

Strand
WC2A 2LL
Tube: Temple
+44 (0)20 7947 6000
justice.gov.uk
Map M05 | B6

CITY

112
Courtauld Gallery

Art & Design

113
Somerset House

Architecture

114
Inner Temple Gardens

Leisure & Nature

The Courtauld Gallery houses the art collection of the Courtauld Institute of Art, a college of the University of London, and is housed within Somerset House #113. This world-renowned collection contains paintings by Van Gogh, Gainsborough, Turner, Van Dyck, Rubens, Cezanne, Degas, Gauguin, Manet, Monet, Pisarro, Renoir, Modigliani, Goya and many more. The institute was founded in 1932 through the efforts of Samuel Courtauld, an industrialist and art collector. Courtauld's own extensive collection formed the foundation of the gallery.

Somerset House
WC2R 0RN
Tube: Temple
+44 (0)20 7848 2526
courtauld.ac.uk/gallery
Map M05 | A7

Somerset House is a grand, Neoclassical, former palace that was built for the Duke of Somerset in the 16th Century. The future Queen Elizabeth I lived here as a Princess. The house dates from Tudor times, but the current building was commissioned in the late 18th century. The House has had many different roles and uses over the last two hundred years. It was home to various government offices, the Royal Academy and Royal Society and currently the building is home to a variety of artistic organisations including The Courtauld Gallery #112. During winter, the courtyard is transformed into an ice skating rink and is one of London's most popular seasonal attractions.

Strand
WC2R 1LA
Tube: Temple
+44 (0)20 7845 4600
somersethouse.org.uk
Map M05 | A7

The Inner Temple is one of the four Inns of Court, which are professional legal associations to which all barristers in England must belong. The Inn was founded in the 12th century and resembles an Oxbridge college. Traditionally, the Inns of Court are where trainees and qualified barristers would work, eat and sleep. Today, they are mainly places of work. The gardens here are beautifully landscaped and extensive. Running adjacent to the river, the gardens are open to the public on weekdays from 12.30pm to 3pm and make for a picturesque place to relax.

Inner Temple
EC4Y 7HL
Tube: Temple
+44 (0)20 7797 8243
innertemple.org.uk
Map M05 | C7

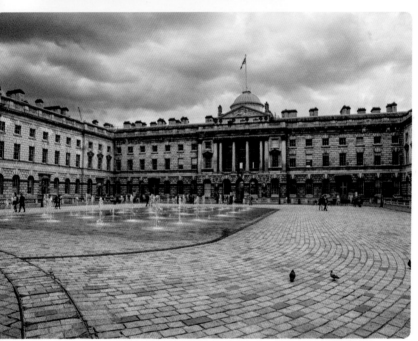

113

114

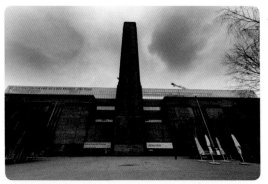

115

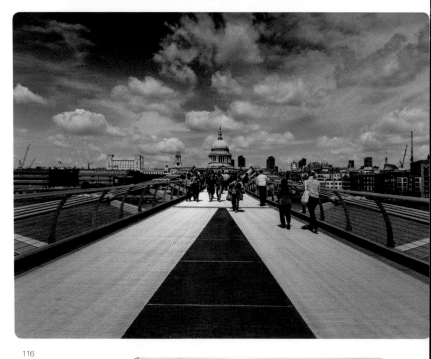

116

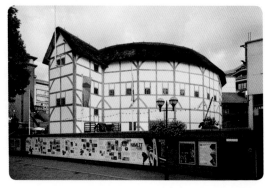

117

Southwark

Southwark is an ancient area on the south bank of the River Thames and became important in the 1st century AD after the Romans built London Bridge, connecting Southwark with the city on the north bank. Southwark Cathedral dates from the 13th century and Shakespeare's Globe Theatre is a replica of the original which stood nearby in the early 17th century. Modern Southwark is a large area extending southwards from London Bridge and containing many artistic, cultural and gastronomic activities.

115
Tate Modern
Art & Design

116
Millennium Bridge
Architecture

117
Shakespeare's Globe Theatre
Entertainment

SOUTH

Tate Modern is Britain's national museum of modern and contemporary art. Housed in the former Bankside Power Station, the building has become an icon of the city skyline. The cavernous space houses permanent and temporary collections of modern art and exhibitors have included Ai Wei Wei, Anish Kapoor, Rachel Whiteread and Damien Hirst. The museum is connected with Tate Britain #288 by high-speed boat and sits across the Millennium Bridge #116 opposite St Paul's Cathedral #086.

Bankside
SE1 9TG
Tube: Southwark
+44 (0)20 7887 8888
ate.org.uk
Map M06 | E1

The Millennium Bridge is a steel suspension bridge spanning the river thames between Tate Modern #115 and St Paul's Cathedral #086. The bridge was designed by Norman Foster and opened in 2000 for the millennium. Initially, the bridge swayed and it took engineers a further two years after opening to fix the problem. The bridge became know as 'The Wobbly Bridge' as a result. The bridge is designed to maximize views of St Paul's Cathedral #086 and the city and the suspension cable supports are lateral; as opposed to traditional vertical designs, which means that the cables mostly fall below the viewing deck level. The bridge is extremely popular with both residents and visitors.

Thames Embankment
SE1
Tube: Mansion House
Map M06 | E1

The Globe is a reconstruction of the Elizabethan playhouse built in 1599 by the Lord Chamberlain's men, a playing company to which Shakespeare belonged. The theatre is designed to be as close to the original in its design as possible and is located around 230m from the original site. The theatre's objective is to explore the works of Shakespeare through performance and education and as such the theatre puts on hundreds of performances each year, both in London and internationally. A recent global tour of Hamlet saw the play performed in every country in the world before returning to the Globe for the final time.

21 New Globe Walk
Bankside
SE1 9DT
Tube: St. Paul's
+44 (0)20 7902 1400
shakespearesglobe.com
Map M06 | E1

SOUTH

118
Imperial War Museum

History

119
Ministry of Sound

Entertainment

120
Red Cross Garden

Leisure & Nature

The Imperial War Museum is located in the former Bethlem Royal Hospital, a grand and imposing building completed in 1814. The museum tells the story of modern warfare from WWI to the present day. The permanent collections include a First World War photography exhibition; the Holocaust Exhibition; Curiosities of War, a collection of wartime objects; the Lord Ashcroft Gallery, the world's largest collection of Victoria Crosses; and Peace and Security 1945-2014. The Imperial War Museum's mandate extends to operation of the Churchill War Rooms #281 as well as three other museums in the UK.

Lambeth Road
SE1 6HZ
Tube: Lambeth North
+44 (0)20 7416 5000
iwm.org.uk
Map M06 | C5

Ministry of Sound is a global megabrand in dance music including nightclubs, a record label and events. The London nightclub opened in 1991 with the objective of creating the world's best sound system devoted to house music. Hosting the world's biggest DJs like Tiesto, Armin Van Buuren, Pete Tong, Sasha and David Guetta, the club attracts around 300,000 clubbers every year. The club calls their main room 'The Box', or 'the best room in clubland', and it features a sound system that has won numerous global awards. As the club put it, 'to DJ in The Box is to play in the Madison Square Garden of dance music.' Ministry of Sound compilation sales exceed 55m to date.

103 Gaunt Street
SE1 6DP
Tube: Borough
+44 (0)20 7740 8600
ministryofsound.com
Map M06 | E4

Opened in 1887 as a Victorian community garden, it was the brainchild of a future co-founder of the National Trust and designed to bring art and beauty to the working poor. Built on the site of a burnt-down paper factory and a derelict warehouse, the garden's meandering paths were designed to give a sense of space and a place to wander amongst the curved lawns and flowerbeds. An ornamental pond was made with a fountain to provide beauty and movement, offering a focus for contemplation. The bandstand provided for performances of music and poetry. The garden was the venue for the annual Southwark Flower Show, and many fetes and celebrations. Now fully restored, the garden hosts regular after-school clubs, poetry readings, celebrations, and events.

50 Redcross Way
SE1 1HA
Tube: Borough
+44 (0)20 7403 3393
Map M07 | A2

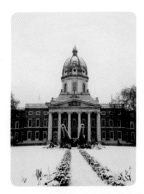

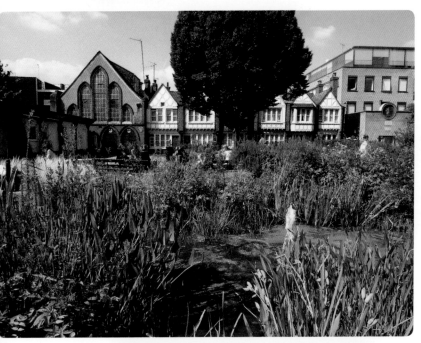

120

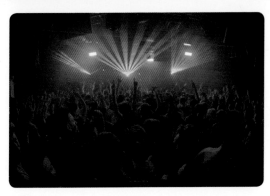

119

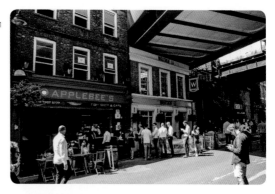

121

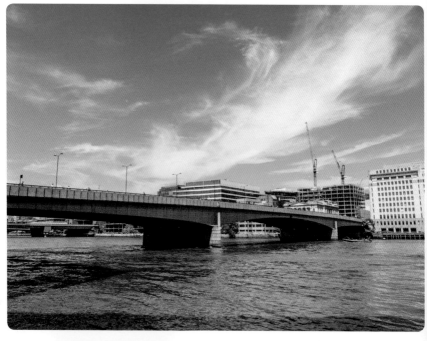

123

122

121
Borough Market

Food & Drink

122
Southwark Cathedral

History

123
London Bridge

Culture

One of the oldest food markets in London, Borough Market sells fruit, vegetables, breads, cheese, meat and game, both wholesale and retail. The market is more recently famous for street food stalls that cater to lunchtime (and all-day) visitors. On offer are wild boar tortelloni, chorizo buns, Lincolnshire sausage baps and hand-dived scallops to name a few. The queues really get going on Saturdays.

8 Southwark Street
SE1 1TL
Tube: London Bridge
+44 (0)20 7407 1002
boroughmarket.org.uk
Map M07 | B2

A former Augustinian Priory, Southwark Cathedral has served as a place of worship for over 1,000 years. The cathedral was reconstructed following a fire in the 13th century. Following the dissolution of the monasteries in 1539, it became a parish church. The original London Bridge #123 was located adjacent to the cathedral. Architectural evidence suggests that pagan worship took place on the site during Roman times. The cathedral contains a stained glass window dedicated to William Shakespeare depicting scenes from his plays and it regularly holds organ recitals and concerts.

London Bridge
SE1 9DA
Tube: London Bridge
+44 (0)20 7367 6700
cathedral.southwark.anglican.org
Map M07 | B1

London Bridge has had several incarnations over the course of the hundreds of years of its existence. The old London Bridge was completed in 1209 and was so expensive that building plots were organised in order to try and recoup some of the money spent. The bridge thus resembled the Ponte Vecchio in Florence, with hundreds of buildings and a church lining its span. At the entrance gate to the bridge, the heads of traitors recently executed were displayed on spikes to deter would-be future criminals. The bridge became famously decrepit and inspired the nursery rhyme 'London Bridge is falling down' in the 18th century. The old bridge was replaced in 1831 by a new design and became the busiest bridge in London. So busy in fact, that it started sinking and had to be replaced again. The bridge was famously sold to an American and reconstructed piece by piece in Arizona. The current London Bridge opened in 1973.

SE1 9BG
Tube: London Bridge
Map M07 | B1

SOUTH

SOUTH

124
The Shard

Architecture

125
HMS Belfast

History

126
The City Hall

Architecture

Completed in 2012, the Shard is the tallest building in the United Kingdom and the European Union. Rising to 306m, the building was designed by Italian architect Renzo Piano, a winner of the Pritzker Prize and the RIBA Gold Medal. Resembling a shard of glass, there is an observation deck at 244m on the 72nd floor, offering one of the best views of the city. To view the Shard itself, visit the Sky Garden #074 outdoor terrace. The Shard contains a Shangri-La hotel, offices and several high-end restaurants with impressive views.

32 London Bridge Street
SE1 9SG
Tube: London Bridge
the-shard.com
Map M07 | C2

HMS Belfast is a former Royal Navy ship, now a museum moored on the River Thames. Launched in 1938, she saw action in the Second World War and as part of the United Nations naval forces in the Korean War. The original ship included two catapult-launched amphibious biplanes designed to form part of her defences. Her main weaponry consisted of twelve six-inch guns capable of firing ninety-six rounds per minute. Visitors can see all nine decks of the ship, climbing up and down ladders to explore the ship's operations rooms, engines and accommodations.

The Queen's Walk
SE1 2JH
Tube: London Bridge
+44 (0)20 7940 6300
iwm.org.uk
Map M07 | D1

This egg-shaped building houses the offices of the Greater London Authority and the Mayor of London. It was designed by 'starchitect' Norman Foster and opened for use in 2002. Sitting on the South Bank, it is located close to Tate Modern #115, the National theatre #155, Shakespeare's Globe Theatre #117 and Southbank Centre #154. The building features a helical staircase that stretches from the ground to a viewing deck at the top of the building. Although the viewing deck is only open to the public as part of the London Open House Weekend, parts of the building are open daily. Visitors can walk down to the Kitchen Café, or go to the viewing gallery overlooking The Chamber, a meeting space.

The Queen's Walk
SE1 2AA
Tube: London Bridge
london.gov.uk
Map M07 | D2

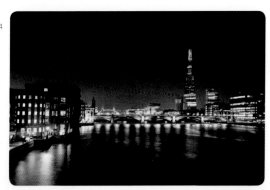

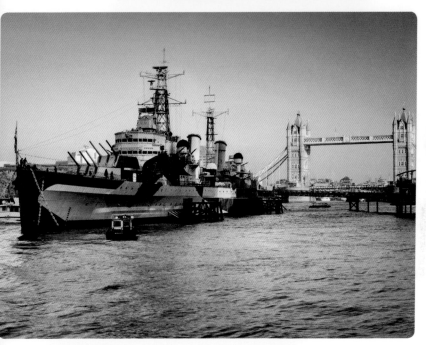

125

126

"Chapter 1: Coast - Razor, Crab; Chapter 2: Childhood - Bread and dripping, Onion and gin, Heritage potato; Chapter 3: Ocean - Scallop, Squid; Chapter 4: Land - Herdwick Lamb; Chapter 5: The End - Picnic, Chocolate and lovage, Almond and dill."

127

128

Bermondsey

Formerly home of a pleasant garden suburb in the 17th century, industrialization changed the area's demographics significantly and parts of Bermondsey became overcrowded slums. In the 19th century the area was defined by water trade and warehouses and wharves lined its length along the banks of the Thames. Due to the decline of such trade, along with significant investment, the buildings were transformed into residential and commercial properties. Butler's Wharf is one of the most famous and now contains luxury apartments and fine dining restaurants.

127
Story

Food & drink

128
Fashion and Textile Museum

History

Story gained its first Michelin star only five months after opening and the head chef, Tom Sellers, has previously worked for Tom Aikens, Thomas Keller and René Redzepi. 'The Full Story' or dinner menu consists of a foreword and several 'chapters'. Descriptions are deceptively simple. Foreword: Snacks. Chapter 1: Coast - Razor, Crab; Chapter 2: Childhood - Bread and dripping, Onion and gin, Heritage potato; Chapter 3: Ocean - Scallop, Squid; Chapter 4: Land - Herdwick Lamb; Chapter 5:

The End - Picnic, Chocolate and lovage, Almond and dill. The cooking has been compared to The Fat Duck by Heston Blumenthal (See Dinner #297) for its creativity and execution. The set lunch is £39; The lunch tasting menu is £80; and the dinner tasting menu is £100.

199 Tooley Street
SE1 2JX
Tube: London Bridge
+44 (0)20 7183 2117
restaurantstory.co.uk
Map M07 | E3

The Fashion and Textile Museum is a centre for contemporary fashion, textiles and jewellery, founded by British fashion designer Zandra Rhodes. The museum organises a full calendar of events including exhibitions, talks, workshops and courses designed to inspire and educate. The building in which the museum is housed was designed by famous Mexican architect, Ricardo Legorreta, along with Rhodes and is a popular attraction itself with its bold and vibrant colours. The museum contains an award-winning café.

83 Bermondsey Street
SE1 3XF
Tube: London Bridge
+44 (0)20 7407 8664
ftmlondon.org
Map M07 | D3

129
White Cube

Art & Design

130
Maltby Street Market

Food & drink

White Cube is an influential contemporary art gallery set up in 1993 with one small room as an exhibition space. The gallery has occupied several different spaces since its inception and today exists in two locations; Mason's Yard in St James's and Bermondsey. Together, the galleries offer a combined exhibition area of more than 6000 square metres. Artists who have previously shown at the gallery include Damien Hirst, Tracey Emin, Anthony Gormley and Marc Quinn. White Cube also has a gallery in central Hong Kong.

144-152 Bermondsey Street
SE1 3TQ
Tube: Borough
+44 (0)20 7930 5373
whitecube.com
Map M07 | D4

Maltby Street Market is held on Saturday mornings and sells artisan foods and drinks. Gastronomic offerings include peri peri pulled pork; grapefruit and orange distilled gin; waffles with dry cure bacon and maple syrup; salted caramel brownies; juniper and beechwood cold-smoked salmon; cured fish roe; jamon; breads by St John (see #093); mead; Brazilian wraps; handmade scotch eggs; handmade chocolate truffles; craft honey beer; British farmhouse cheeses; fresh basil pesto and the list goes on (for quite a long time). Parts of the market also open on Saturday afternoons and Sundays.

Ropewalk
SE1 3PA
Tube: Bermondsey
+44 (0)79 7370 5674
Map M07 | E4

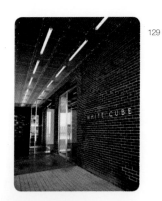

129

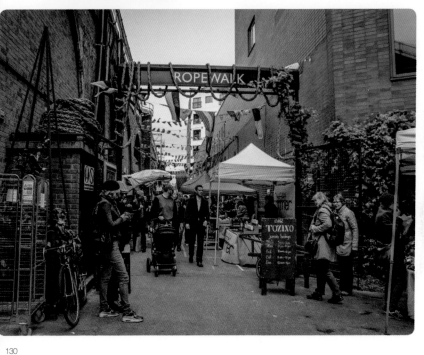

130

"Artists who have previously shown at the gallery include Damien Hirst, Tracey Emin, Anthony Gormley and Marc Quinn."

132

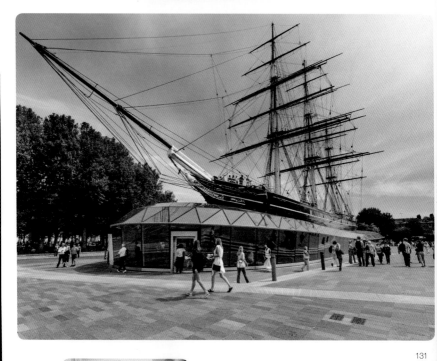

131

133

Greenwich

Greenwich is the site of a former royal palace; the Palace of Placentia; where Henry VIII and Elizabeth I were born. The site of the palace was subsequently rebuilt as the Royal Naval Hospital; and then the Royal Naval College; by Sir Christopher Wren. The whole area has strong naval connections and is home to the Cutty Sark and the National Maritime Museum. The Royal Observatory and the Greenwich Meridian are here and the area is now a UNESCO World Heritage Site. Greenwich Park is a beautiful green area surrounded by historic architecture and is a prime residential area.

131
Cutty Sark

History

The Cutty Sark is the world's sole remaining tea clipper, a fast sailing ship built in 1869 and originally used to transport tea from China. Return trips to China around the Cape of Good Hope took well over 100 days and with the development of steamships and the opening of the Suez canal, sailing ships eventually became obsolete. During her career, the Cutty Sark also made frequent trips to Australia for trade and refuelling. The ship's construction consisted of a wooden hull built around an iron frame. Various types of wood were used including teak and pine. Today the Cutty Sark is a fully functioning, permanent museum, which contains the world's largest collection of ship's figureheads.

King William Walk
SE10 9HT
DLR: Cutty Sark
+44 (0)20 8312 6608
rmg.co.uk/cuttysark
Map M08 | B8

132
Goddard's

Food & Drink

Goddard's have served up traditional pies, mash and liquor (parsley sauce) since 1890. Alternatively, people have gravy instead of liquor. Pie fillings on offer include minced beef (the traditional pie), steak and kidney, steak and ale, chicken and mushroom, chilli minced beef, and cheese and onion. For dessert there are traditional pies, crumbles and puddings. Londoners have been eating pie and mash for hundreds of years and it remains a popular tradition today.

22 King William Walk
SE10 9HU
DLR: Greenwich
+44 (0)20 8305 9612
goddardsatgreenwich.co.uk
Map M08 | B8

133
National Maritime Museum

History

The world's largest maritime museum contains artworks, maps and charts, manuscripts, ship models and other maritime memorabilia charting Britain and the world's history at sea. The collection numbers over two million items and the collections relating to Vice-Admiral Horatio Nelson and Captain James Cook are unrivalled. The museum is part of the Royal Museums Greenwich, which includes the Queen's House #135, the Cutty Sark #131 and the Royal Observatory #136. The museum is an interactive, learning experience which children and adults alike will find fascinating.

Park Row
SE10 9NF
DLR: Cutty Sark
+44 (0)20 8858 4422
rmg.co.uk
Map M08 | B8

SOUTH

134
Old Royal Naval College

Architecture

135
Queen's House, Greenwich

Architecture

This outstanding collection of buildings on the Greenwich Peninsula is a former Royal Palace, home to Henry VIII and favourite palace of his daughter, Queen Elizabeth I. The young King had grown up at Eltham Palace #364 but moved to Greenwich based on his daughter's wishes. The palace was replaced with the Royal Hospital for Seamen in 1712 much like the army equivalent, the Royal Hospital Chelsea #305. It then became the Royal Naval Academy in 1873. Designed by Sir Christopher Wren, the buildings were split in order to preserve the view of the river from the Queen's House #135. The Royal Observatory #136 overlooks the college from the hill above Greenwich Park. Today, the buildings have found use as part of the University of Greenwich and the Trinity Laban Conservatoire of Music and Dance. Both the painted hall and the chapel are open to the public and are considered to be some of the finest interiors in the United Kingdom.

Greenwich
SE10 9NN
DLR: Greenwich
+44 (0)20 8269 4799
ornc.org
Map M08 | B8

Built in the early part of the 17th Century, the Queen's House was commissioned for Anne of Denmark, the wife of King James I. The architect was Inigo Jones, who also designed Banqueting House #277 some years later. The house was the first example of classical architecture in Britain and was inspired by Jones' trips to Rome. Queen Mary II insisted that the view of the river from the house always be maintained and as such, when Sir Christopher Wren built the Greenwich Hospital next door, a gap equal in width to the Queen's House was incorporated into the design running all the way to the river. The house is now part of the National Maritime Museum #133.

Romney Road
SE10 9NF
DLR: Greenwich
+44 (0)20 8858 4422
rmg.co.uk
Map M08 | C8

"Queen Mary II insisted that the view of the river from the house always be maintained and as such, when Sir Christopher Wren built the Greenwich Hospital next door, a gap equal in width to the Queen's House was incorporated into the design running all the way to the river."

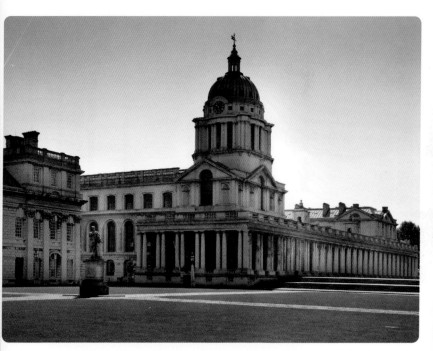

134

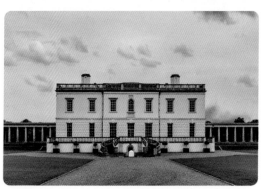

135

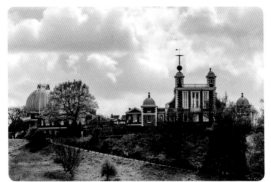

136

137

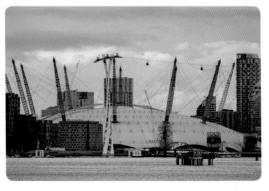

138

136
Royal Observatory Greenwich

Architecture

137
NOW Gallery

Art & Design

138
The O2 Arena

Entertainment

The Royal Observatory and the position of Astronomer Royal were commissioned by King Charles II in 1675 to facilitate a more formal study of astronomy and also for determining longitudes to perfect the art of navigation. In the late 17th and early 18th century, the problem of determining longitude at sea became extremely important for trade. In 1721, Great Britain established a prime meridian passing through the observatory in order to establish a common zero of longitude and time standard for use throughout the world. This was ratified internationally in 1884. The observatory is now a museum and sits on top of a hill above Greenwich Park, commanding exceptional views of the Queen's House #135, the Old Royal Naval College #134 and the river below.

Blackheath Avenue
SE10 8XJ
DLR: Greenwich
+44 (0)20 8858 4422
rmg.co.uk
Map M08 | C9

NOW Gallery is a public exhibition space for contemporary art and design in Greenwich. The gallery organise many events covering performing arts, music, film, dance and sculpture. The gallery invite established and emerging artists, designers and other creative talents to design exciting and exceptional installations that will transform and react to the gallery space. The gallery is permanent and free. NOW Gallery also play host to makers' markets featuring handmade ceramics, jewellery and leather goods. Installations to date have featured artists and designers such as Robert Orchardson, Phoebe English, Alex Chinneck and Morag Myerscough.

The Gateway Pavilions
Peninsula Square
SE10 0SQ
Tube: North Greenwich
+44 (0)20 3770 2212
nowgallery.co.uk
Map M08 | D3

The O2 Arena is a super-sized performance venue in Greenwich. Constructed for the millennium, the structure was called the Millennium Dome and housed the Millennium Experience, which was open to the public for one year in 2000. The venue can hold 20,000 people and is the world's busiest music arena. The venue has played host to the likes of Aerosmith, Alicia Keys, Beyonce, The Black Eyed Peas, Bon Jovi, The Eagles and Iron Maiden as well as numerous comedians and sports events such as the ATP World Tennis Tour Finals.

Peninsula Square
SE10 0DX
Tube: North Greenwich
+44 (0)20 8463 2000
theo2.co.uk
Map M08 | D2

SOUTH

Clapham

Clapham is an ancient area in south London centered on a large common. The area was popular with the upper classes in the 17th and 18th centuries and many large houses were built in the area. Clapham became a commuter town in the 19th century and a large amount of social housing was constructed. From the 1980s onwards, the area became a draw for middle-class professionals and house prices skyrocketed. Today, Clapham is a lively, social place with lots of community events and award-winning restaurants.

139
The Exhibit

Culture

140
Northcote Gallery

Art & Design

The Exhibit is an informal creative space with a restaurant, bar, cinema, studio and gallery. Open every day, the restaurant serves breakfast, brunch, lunch, dinner and Sunday roasts. The Exhibit run many different events including film nights, life-drawing classes, karaoke nights, stand up comedy and speed dating nights. The venue is also open until late on weekends featuring cocktails and music. The Exhibit is a local, social hub and self-professed 'youth club for adults'.

Northcote Gallery specialises in modern British and International contemporary paintings and sculpture. Artists represented by the gallery work with a broad range of materials to create modern art pieces including paper collages, oil paintings, screenprints, hand stitched illustrations and stone sculptures. The gallery offer a range of limited edition pieces through their website.

12 Balham Station Road
SW12 9SG
Tube: Clapham South
+44 (0)20 8772 6556
theexhibit.co.uk
Map M09 | C8

110 Northcote Road
SW11 6QP
Overground: Clapham Junction
+44 (0)20 7924 6741
www.northcotegallery.com
Map M09 | A6

140

"Artists represented by the gallery work with a broad range of materials to create modern art pieces including paper collages, oil paintings, screenprints, hand stitched illustrations and stone sculptures."

"...they grow their own herbs and vegetables on the roof, as well as having beehives to supply the 'rooftop honey' for the cheese course."

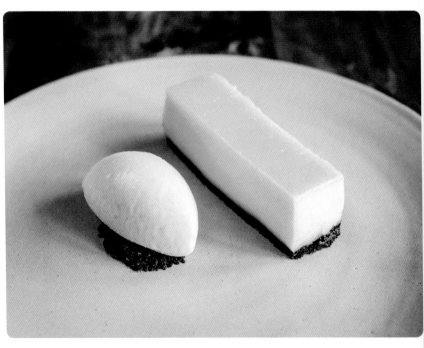

141

142

141
The Dairy

Food & Drink

142
Trinity

Food & Drink

The Dairy is a down-to-earth, modern British restaurant featuring seasonal ingredients, located on the edge of Clapham Common. The head chef has worked in some of the world's best restaurants and they grow their own herbs and vegetables on the roof, as well as having beehives to supply the 'rooftop honey' for the cheese course. The tasting menu is £48 and includes: Sourdough, smoked bone marrow butter, chicken liver mousse, cellar salumi; Misozuki monkfish, wild garlic dashi, cucumber; Julie Girl skate, Wye Valley asparagus, leek miso; Swaledale lamb, tropea onions, shepherd's pie; Truffled Baron Bigod, fig and walnut toast, rooftop honey; and Elderflower tart, rye, apple.

15 The Pavement
SW4 0HY
Tube: Clapham Common
+44 (0)20 7622 4165
the-dairy.co.uk
Map M09 | D5

Trinity is an award-winning, modern European restaurant cooking seasonal produce. Dishes include: Soused Cornish mackerel, white gazpacho, grapes, tarragon; warm Wye Valley asparagus, buttermilk beurre blanc, smoked cod's roe; pot roast Bresse pigeon, salt baked celeriac, creamed spinach, Madeira; hand rolled garganelli, mousserons, spring vegetables and pecorino cream; salt caramel custard tart; and baked Wigmore cheesecake with pear sorbet. The restaurant design is modern creating an upscale dining experience.

4 The Polygon
SW4 0JG
Tube: Clapham Common
+44 (0)20 7622 1199
trinityrestaurant.co.uk
Map M09 | D4

SOUTH

Battersea

Battersea's defining landmark is Battersea Power Station and this industrial giant and its workers defined the area in the 20th century. It will define it in the 21st century as well. The area has been redesigned as a residential, office and leisure complex including the complete renovation of the power station. The area also contains Battersea Park, one of London's largest. The area is rapidly developing artistically, culturally and culinarily.

143
Battersea Arts Centre

Art & Design

Located in the impressive former Battersea Town Hall, the Battersea Arts Centre is a creative space bringing together people of all ages to explore the arts, including mixed media art, theatre, comedy, music and dance. The centre puts on more than 600 performances per year and is a focal point for the local community. Visitors are welcome to watch early versions of shows to offer feedback and become part of the creative process.

Lavender Hill
SW11 5TN
Overground: Clapham Junction
+44 (0)20 7223 2223
bac.org.uk
Map M09 | A4

144
Santa Maria Del Sur

Food & Drink

Santa Maria Del Sur is an authentic Argentinean steakhouse with live music events. Steaks are flown in from Argentina and expertly grilled. Cuts on offer include fillet, sirloin, rib eye, flank and rump. There are a range of tasty accompaniments including grilled mushrooms with garlic dressing and melted cheese; spinach, cream and onion; and mashed potatoes with coriander, nuts or cheese. The menu also features traditional Argentine empanadas and Argentinean red wines are available. The dining room is casual, with exposed brick and wooden floorboards.

129 Queenstown Road
SW8 3RH
Overground: Wandsworth Road
+44 (0)20 7622 2088
santamariadelsur.com
Map M09 | C3

145
Albert Bridge

Architecture

Built in 1873, the Albert Bridge was designed to be a toll bridge connecting Chelsea on the north bank of the Thames with Battersea on the south bank. The bridge was commercially unsuccessful and the toll was removed, however the original tollbooths remain. The bridge displays a mixture of architectural styles due to the need to strengthen the original design. In fact, it is nicknamed, 'the trembling lady' due to vibrations occurring when large numbers of people walked over it and there is still a sign visible today requiring troops to break step when they cross.

SW11 4PL
Overground: Battersea Park
Map M09 | A1

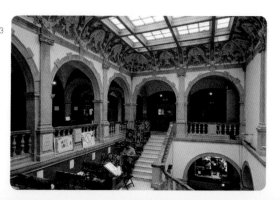

143

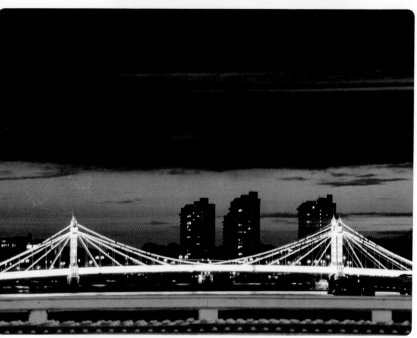

145

144

146

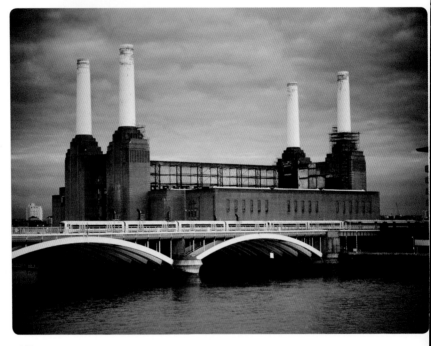

147

"Decommissioned in 1983, the building is seen as an
important piece of British history and popular culture,
its image having been used by several musical artists
and filmmakers, including The Beatles."

146
Battersea Park

Leisure & Nature

147
Battersea Power Station

Architecture

SOUTH

Opening in 1858, Battersea Park is comprised of 200 acres of land on the south bank of the River Thames, between the Albert Bridge #145 and Chelsea Bridge. This large space includes a performance arena, boating lake, children's zoo and many other things to see and do. During the Second World War, anti-aircraft guns were installed in the park to protect against enemy air raids and the park was also used to grow food for the local population. Prior to the park being created, this fertile area was home to crops including lavender, which is where the nearby Lavender Hill gets its name. It was also a site of numerous duels including one involving the Duke of Wellington at which both parties allegedly deliberately missed each other.

SW11 4NJ
Overground: Battersea Park
Map M09 | B1

Designed by Sir Giles Gilbert Scott, grandson of famous architect Sir George Gilbert Scott, Battersea Power Station was built in two phases during the 1930s and 1950s. Decommissioned in 1983, the building is seen as an important piece of British history and popular culture, its image having been used by several musical artists and filmmakers, including The Beatles. It is now the centrepiece of a huge redevelopment program, which will see Norman Foster and Frank Gehry create multi-purpose spaces for living, working, eating and shopping.

188 Kirtling Street
SW8 5BN
Overground: Battersea Park
+44 (0)20 7501 0688
batterseapowerstation.co.uk
Map M09 | D1

Vauxhall

Situated between Lambeth and Battersea, Vauxhall is famous as the location of the headquarters of MI6, Britain's secret intelligence service. The area was formerly industrial, but investment in residential and commercial properties, in combination with the area's close proximity to central London has transformed it. Damien Hirst has opened Newport Street Gallery nearby, which is likely to bring even more people to the area.

148
Gasworks Gallery

Art & Design

Gasworks is a non-profit contemporary visual art organisation that provides studio space for London-based artists. It commissions UK and International artists to present their first major exhibitions in the UK, and runs international residency programs allowing artists to come to London to carry out research and develop new work. Gasworks has worked with over 250 artists from 70 countries around the world. Many alumni have gone on to exhibit at major institutions and art events, and have received nominations for - or won - prestigious awards including the Turner Prize, Absolut Award and Pinchuk Art Prize. Alumni include Yinka Shonibare, Marvin Gaye Chetwynd, Tania Bruguera, Alexandre da Cunha, Subodh Gupta and many more.

155 Vauxhall Street
SE11 5RH
Tube: Vauxhall
+44 (0)20 7587 5202
gasworks.org.uk
Map M06 | B8

149
Newport Street Gallery

Art & Design

Newport Street Gallery was set up by Damien Hirst to enable him to share his extensive art collection with the public. The gallery space is architecturally impressive with six exhibition spaces over two floors. Hirst's collection includes works by Francis Bacon, Banksy, Tracey Emin, Richard Hamilton, Jeff Koons, Sarah Lucas, Pablo Picasso, Richard Prince, Haim Steinbach and Gavin Turk. Also in the building is Pharmacy 2, the second version of the popular restaurant in Notting Hill that closed down in 2003. Admission is free.

Newport Street
SE11 6AJ
Tube: Vauxhall
+44 (0)20 3141 9320
newportstreetgallery.com
Map M06 | B6

"Many alumni have gone on to exhibit at major institutions and art events, and have received nominations for - or won - prestigious awards including the Turner Prize, Absolut Award and Pinchuk Art Prize."

148

149

"*The theatre company have counted many esteemed actors as members including Sir John Gielgud, Michael Redgrave, Alec Guiness, Laurence Olivier, Judi Dench, Peter O'Toole, Anthony Hopkins and Maggie Smith.* "

150

151

Lambeth

Lambeth is an inner city area across the river from the Palace of Westminster. The major landmark is Lambeth Palace, the home of the Archbishop of Canterbury for over 800 years. A former marshland, Lambeth developed substantially with the connection of the north and south banks of the river by Westminster Bridge in 1750. The area is filled with small markets, restaurants, cafes and pubs. Artistic and cultural attractions include The Old Vic Theatre and Damien Hirst's Newport Street Gallery.

150
Lambeth Palace

Architecture

Lambeth Palace has been a London residence of Archbishops of Canterbury since the 13th century and is the official residence of the Archbishop of Canterbury today. As head of the Church of England, the Archbishop chairs the legislative assembly that governs the workings of the church. The palace contains many historical architectural elements, including the red brick gatehouse built around 1490; and paintings by artists including Holbein, Van Dyck, Hogarth and Reynolds. The palace organises special guided tours for members of the public throughout the year.

SE1 7JU
Tube: Lambeth North
+44 (0)20 7898 1200
Map M06 | A5

151
The Old Vic

Entertainment

The Old Vic Theatre opened in 1818. The theatre company have counted many esteemed actors as members including Sir John Gielgud, Michael Redgrave, Alec Guinness, Laurence Olivier, Judi Dench, Peter O'Toole, Anthony Hopkins and Maggie Smith. Kevin Spacey was the theatre's artistic director for ten years and stepped down in 2015. The theatre runs a full schedule of plays, musicals and comedy performances throughout the year.

The Cut
SE1 8NB
Tube: Waterloo
oldvictheatre.com
Map M06 | C3

SOUTH

South Bank

The South Bank is one of London's cultural hotspots. As well as the major artistic and cultural institutions along its length, The South Bank is a magnet for pop-up markets, events and street art. The bank provides a mostly convenient cycling route from the Palace of Westminster down to Tate Modern, passing several bridges along the way. This is one of the best places to view the city's architectural sweep and there is even a beach here.

SOUTH

152
London County Hall
Architecture

Opened by King George V in 1922, the former home of the London County Council has a grand Edwardian Baroque façade. This mammoth building located on the south bank of the river opposite the Houses of Parliament #282 is now privately owned and houses numerous businesses including two hotels, an aquarium and the London Dungeon. The building sits next to the London Eye #153, and tickets for the attraction are purchased from inside the building.

Riverside Building
Westminster Bridge Road
SE1 7PB
Tube: Waterloo
londoncountyhall.com
Map M06 | A3

153
London Eye
Leisure & Nature

Also known as the Millennium Wheel, The London Eye offers spectacular views over London from 135 metres in the sky. It is Europe's tallest ferris wheel. The Eye opened for the Millennium on 31st December 1999. It is the most popular attraction in the United Kingdom and on a clear day, views can extend to 25 miles. The Eye stands next to London County Hall #152 and opposite is the Houses of Parliament #282.

The Queen's Walk
SE1 7PB
Tube: Waterloo
londoneye.com
Map M06 | A3

154
Southbank Centre
Culture

The Southbank Centre is the largest arts centre in Europe. The centre includes the Royal Festival Hall, which was constructed to celebrate Britain's creative capabilities following the Second World War at the Festival of Britain that took place in 1951. Millions of visitors attend musical, theatrical, comedic and dance performances here every year. Some of this large site is undergoing a renovation project that is due for completion in 2017, but activities and performances continue during that period.

Belvedere Road
SE1 8XX
Tube: Waterloo
+44 (0)20 7960 4200
southbankcentre.co.uk
Map M06 | B2

152

154

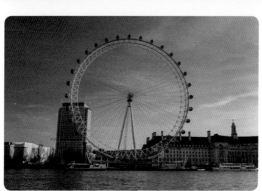

153

"The main auditorium is named 'The Olivier Theatre', after Sir Laurence Olivier, who was the first artistic director of the National in 1963. "

155

156

155
National Theatre

Entertainment

156
Oxo Tower

Architecture

The National Theatre building is an imposing concrete design on the South Bank containing three theatres that can seat a combined audience of 2,450. The main auditorium is named 'The Olivier Theatre', after Sir Laurence Olivier, who was the first artistic director of the National in 1963. Actors who have appeared on the National Theatre's stages include Laurence Olivier, Ian McKellen, Maggie Smith, Judi Dench, Anthony Hopkins, Michael Gambon, Ralph Fiennes, Kenneth Branagh, Daniel Day Lewis, Jeremy Irons, Helen Mirren, Damian Lewis, James Corden, Benedict Cumberbatch and Chiwetel Ejiofor. The NT live program streams live performances to cinemas in more than 50 countries, enabling access to more than 4 million people since its inception in 2009.

Upper Ground
SE1 9PX
Tube: Waterloo
+44 (0)20 7452 3000
nationaltheatre.org.uk
Map M06 | B2

The Oxo Tower is a large, mixed-use building housing restaurants, cafés, galleries, flats and shops in a former power station. The building was converted from a power station into a factory in the 1920s by owners of the Oxo stock cube brand. The former owners, forbidden from erecting advertising hoardings on the building's roof, circumvented the regulations by incorporating their company name into the building's tower design. Today the building is a destination for London residents and visitors alike, offering fashion, accessories, homewares, lighting, jewellery, textiles and art.

Bargehouse Street
SE1 9PH
Tube: Southwark
+44 (0)20 7021 1686
oxotower.co.uk
Map M06 | C1

SOUTH

Covent Garden

Covent Garden was transformed in the 16th century by the architect Inigo Jones, who built neoclassical houses designed to attract the wealthy, but by the 18th century the area had become a famous red light district. Today the area is buzzing with activity. The grand architecture remains, stretching around a central piazza with the old fruit and vegetable building, constructed in 1830, at its centre. Street performers, independent shops, museums and the Royal Opera House combine to create one of the city's most popular destinations. A small area within Covent Garden known as Seven Dials offers small boutiques, restaurants, cafes, pubs and galleries.

157
Victoria Embankment Gardens
Leisure & Nature

Victoria Embankment Gardens are a series of public gardens along the embankment of the Thames, which feature monuments, formal gardens and statues. Notable monuments include Cleopatra's Needle #158 and York Water Gate (pictured). York House was built in the 13th century and stood on the banks of the Thames nearby. The mansion was later acquired by Henry VIII. The water gate was constructed in 1626 as a grand, Italianate entrance to the house from the river. It now stands in the gardens. The main gardens contain a café and wine bar and music concerts are held in the summer months.

Villiers Street
WC2N 6NS
Tube: Embankment
Map M10 | F8

158
Cleopatra's Needle
History

Cleopatra's Needle is one of four ancient Egyptian obelisks, the other three being in New York, Paris and Luxor. The obelisk stands on Victoria Embankment at a height of around 21m and weighs about 224 tons. The obelisk dates from around 1450BC and was presented to the United Kingdom in 1819 by the ruler of Egypt, in commemoration of Lord Nelson's victory at the Battle of the Nile. The Needle's surface is covered in hieroglyphs that document the military victories of Ramesses II.

Victoria Embankment
WC2N 6
Tube: Embankment
Map M10 | F8

159
Gordon's Wine Bar
Food & Drink

Gordon's is a 19th century candlelit wine bar in a vaulted cellar. Established in 1890, it claims to be the city's oldest wine bar. Gordon's serves sherries and ports from the barrel and food includes homemade pies and cheeses. The bar sits on the former site of York House and the York Water Gate is located nearby. Samuel Pepys lived on the site in the 1680s, and Rudyard Kipling lived in the building in the 1890s. The building was renamed Kipling House in the 1950s. Inside, the walls are covered in historical newspaper cuttings and memorabilia. The wine list is extensive with many wines by the glass.

47 Villiers Street
WC2N 6NE
Tube: Embankment
+44 (0)20 7930 1408
gordonswinebar.com
Map M10 | F8

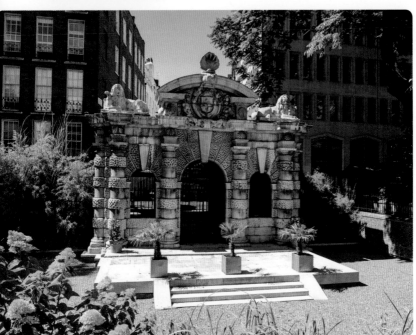

157

159

161

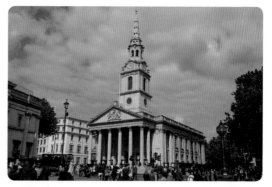

160

162

160
Strand Gallery
Art & Design

161
St-Martin-in-the-Fields
Entertainment

162
Terroirs
Food & Drink

The Strand Gallery was launched with an aim to provide a platform for both emerging and mid-career artists working across all visual media. The gallery offers space for exhibitions and pop-up events. Past exhibitions include miNiATURE Design; Arnis Purple: Re-Imagining London; The London Independent Photography Exhibition; Vic Reeves: Hot Valve Leak; Horace Panter: The Writing is on the Wall; Terry O'Neill Photography Awards; John Stewart Farrier: Voices from Westminster; and numerous graduate art shows.

32 John Adam Street
WC2N 6BP
Tube: Charing Cross
+44 (0)20 7703 6120
thestrandgallery.wordpress.com
Map M10 | F8

The church of St-Martin-in-the-Fields dates from Medieval times and the current building was constructed in the early 18th century. The church stands in a prominent position on one side of Trafalgar Square #252 and its impressive, Neoclassical architecture was modelled on the works of Sir Christopher Wren and has been copied the world over. The church's crypt holds regular lunchtime and evening classical music performances in their award winning café, as well as a popular series of jazz nights. The church is a focus of its surrounding community and counts the Queen as one of its parishioners.

Trafalgar Square
WC2N 4JJ
Tube: Charing Cross
+44 (0)20 7766 1100
stmartin-in-the-fields.org
Map M10 | E8

Terroirs is primarily a wine bar that also serves French, Spanish and Italian small plates. They source wines from small artisan growers who work sustainably, organically or biodynamically in the vineyard and with minimal interventions in the winery. Terroirs features French wines from Loire, Alsace, Beaujolais, Jura, Savoie, Burgundy, Rhone, Bordeaux and Languedoc-Roussillon. Italian wines come from Valle d'Aosta, Alto-Adige, Piemonte, Emilia Romagna, Abruzzo and Sicily. The wine list also features wines from Austria, Spain and a handful of other countries. Small plates include Lincolnshire smoked eel and celeriac remoulade; chopped raw beef, rosemary and lemon; and duck gizzards, green beans and pickled walnuts.

5 William IV Street
WC2N 4DW
Tube: Charing Cross
+44 (0)20 7836 0291
terroirswinebar.com
Map M10 | E8

CENTRAL

163
The Harp

Food & Drink

164
London Coliseum

Culture

165
The American Bar at The Savoy

Food & Drink

The Harp is an example of a traditional British alehouse, which is reflected in its design, including stained glass windows. The bar is decorated with hundreds of pump clips, the beer brand name that is attached to the beer pump, which acts as a reminder for all of the beers stocked by the pub over the years. Old portraits line the walls and the pub offers ten different hand-pulled pints. A recipient of CAMRA (Campaign for Real Ale) national pub of the year award, the pub is heavily focused on the beer selection and food is limited to sausage baps, pork pies and nibbles. The Harp is a big hit with locals and visitors alike.

47 Chandos Place
WC2N 4HS
Tube: Charing Cross
+44 (0)20 7836 0291
harpcoventgarden.com
Map M10 | E8

The largest theatre in London was built in 1904 and is home to the English National Opera and the English National Ballet. The theatre has 2,359 seats and was designed to be the most luxurious and technologically equipped theatre of its time. Grade II listed, the theatre is important architecturally as well as culturally. The full program of events includes operatic classics such as *Swan Lake* and *Madam Butterfly*, as well as modern musicals such as Andrew Lloyd Webber's *Sunset Boulevard*.

St. Martin's Lane
WC2N 4ES
Tube: Leicester Square
+44 (0)20 7845 9300
eno.org
Map M10 | E8

Located in one of the world's most famous hotels, The Savoy, The American Bar has a long history. In 1903 the first truly 'famous' bartender arrived at The American Bar, a lady named Ada 'Coley' Coleman. Her signature cocktail was the Hanky Panky, still a popular choice today. Ada's successor was the inspirational Harry Craddock, who not only created a number of classic cocktails, but who notoriously compiled these recipes into the legendary *Savoy Cocktail Book*, still regarded today as the bartender's bible. He is credited with creating the Corpse Reviver #2, a hangover cure containing gin, lemon juice, curacao, Kina Lillet, and a dash of absinthe. Corpse Reviver instructions stated that the drink should be, "taken before 11am, or whenever steam and energy are needed." They went on to say that "four of these taken in swift succession will unrevive the corpse again." Craddock is also credited with creating the White Lady.

Strand
WC2R 0EU
Tube: Embankment
+44 (0)20 7836 4343
fairmont.com
Map M10 | G8

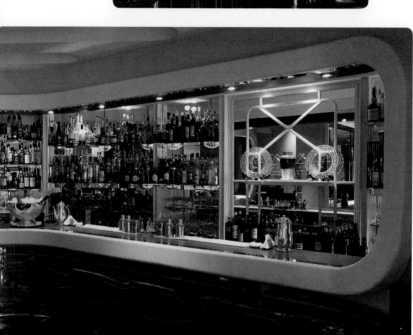

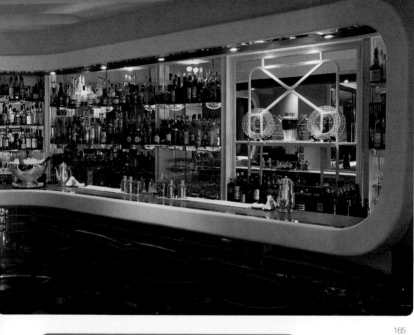

165

164

166

167

168

166
Simpsons-in-the-Strand

Food & Drink

167
Rules

Food & Drink

168
Polpo

Food & Drink

Simpsons have been offering classic British dishes to delighted patrons for over 185 years. Such patrons have included: Charles Dickens, George Bernard Shaw, Sir Arthur Conan Doyle (and his fictional creation, Sherlock Holmes), Benjamin Disraeli and William Gladstone. Breakfast items include 'The Ten Deadly Sins' - Cumberland sausage, streaky and back bacon, Stornoway black pudding, fried mushrooms, baked tomato, egg (fried, poached or scrambled), liver, fried bread, bubble and squeak and baked beans. Lunch and dinner dishes include: Brown Windsor soup, Madeira and saffron rice; Salmon tartar, Caviar, crème fraiche and confit tomatoes; Pot roasted partridge, braised leeks, bacon, apple and roast hazelnuts; and their signature dish: Roast rib of Scottish beef (aged 28 days), roast potatoes, Savoy cabbage, Yorkshire pudding and horseradish, carved at the table from an antique silver-domed trolley. Simpson's also offer carvery classes.

Rules was established by Thomas Rule in 1798 making it the oldest restaurant in London. It serves traditional British food, specialising in classic game cookery, oysters, pies and puddings. Throughout its long history the tables of Rules have been crowded with writers, artists, lawyers, journalists and actors. As well as being frequented by great literary talents – including Charles Dickens, William Makepeace Thackeray, John Galsworthy and H G Wells; Rules has also appeared in novels by Rosamond Lehmann, Evelyn Waugh, Graham Greene, John Le Carré and Dick Francis. Dishes include duck rillettes with shallot chutney and walnut bread; caramelised onion tart with endive, stilton and walnut salad; steamed steak and kidney suet pudding; spatchcocked squab pigeon with bitter leaves, croutons, smoked ham and golden raisins; and tranche of turbot with purple sprouting broccoli, lemon, capers and anchovy sauce.

Polpo is a bàcaro. This is a Venetian word to describe a humble restaurant serving simple food and good, young Italian wines. Launched in 2009, Polpo has now branched out to several locations in London and beyond. The menu offers meatballs, pizzette, fish, breads, meats, vegetables, salads and desserts. Recommended in the Michelin Guide's Bib Gourmand for the last six years, dishes include cuttlefish, ink risotto and gremolata; bresaola, goat curd and rocket pesto bruschetta; roast pork belly, apricot and sage; fennel, almond and curly endive salad; and chocolate salami.

6 Maiden Lane
WC2E 7NA
Tube: Leicester Square
+44 (0)20 7836 8448
polpo.co.uk
Map M10 | F7

100 Strand
WC2R 0EW
Tube: Charing Cross
+44 (0)20 7836 9112
simpsonsinthestrand.co.uk
Map M10 | G7

34-35 Maiden Lane
WC2E 7LB
Tube: Covent Garden
+44 (0)20 7836 5314
rules.co.uk
Map M10 | F7

CENTRAL

CENTRAL

169
London Transport Museum

History

170
Covent Garden Market

Shopping

171
Theatre Royal Drury Lane

Entertainment

The London Transport Museum uses posters, photographs, films and vehicles to chart the development of London's transport infrastructure. The museum collection is made up of over 450,000 items including buses, trams, trains and taxis. The collection ranges from a steam locomotive to a 'Boris Bike' (see useful tab - transport). The museum is housed in the former Covent Garden Flower Market building in the centre of Covent Garden, an impressive Grade II listed structure of steel and glass completed in 1871.

Covent Garden Piazza
WC2E 7BB
Tube: Covent Garden
+44 (0)20 7379 6344
ltmuseum.co.uk
Map M10 | F7

Covent Garden was laid out by architect Inigo Jones in the 16th century, and a small fruit and vegetable market sprang up here. As the area grew, it became filled with pubs, theatres, coffee houses and brothels, and it was decided that the area needed organisation and renovation. The market building we see today was built in 1830 to provide this organisation. In the 20th century, the market moved south of the river and the building became a shopping centre. Today it is the centre of a bustling entertainment area with theatres, street performers, the Royal Opera House #172 and all sorts of cafés, restaurants and shops.

Covent Garden
WC2E 8RF
Tube: Covent Garden
+44 (0)20 7420 5856
Map M10 | F7

The first theatre opened on this site in 1663, making this the oldest theatre in London. The current theatre dates from 1812. Formerly known for organizing spoken plays, today the theatre is primarily known as a venue for musicals. The theatre is claimed to be one of the most haunted theatres in the world with multiple apparitions making their presence known to actors and audience members over the years, including the ghost of the clown, Joseph Grimaldi, who was the resident clown here in the late 18th and early 19th Centuries.

Catherine Street
WC2B 5JF
Tube: Covent Garden
+44 (0)20 7557 7300
theatreroyaldrurylane.co.uk
Map M10 | G7

"The theatre is claimed to be one of the most haunted theatres in the world with multiple apparitions making their presence known to actors and audience members..."

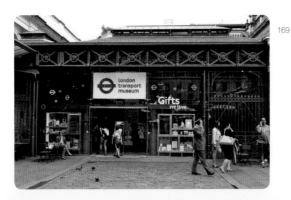

169

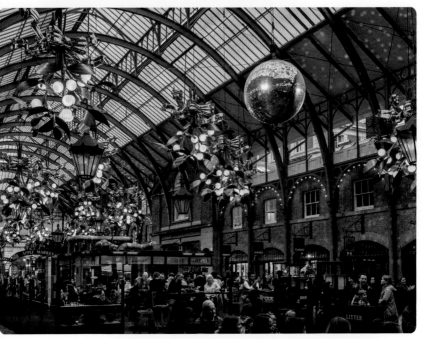

170

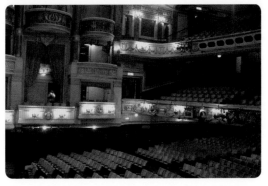

171

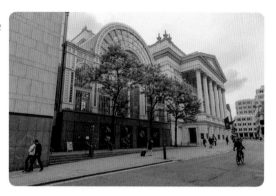

172

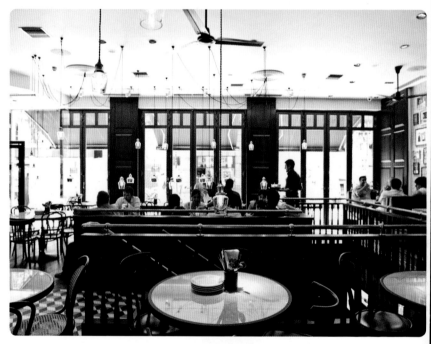

173

174

172
Royal Opera House

Entertainment

173
Dishoom

Food & Drink

174
Phoenix Garden

Leisure & Nature

Originally called the Theatre Royal, the Royal Opera House was previously a playhouse and is now home to The Royal Opera and The Royal Ballet. The main auditorium is Grade I listed and dates from 1858. It is the third theatre on the site following fires in 1808 and 1856. Under the terms of a royal patent, Covent Garden was only one of two theatres permitted to perform drama in the capital. The other patent theatre was the nearby Theatre Royal Drury Lane #171. The first important musical works to be heard at the theatre were by Handel, who, from 1735 until his death in 1759, had close links with Covent Garden. The Royal Opera House was extensively renovated in the 1990s and its patron is HRH The Prince of Wales.

Bow Street
WC2E 9DD
Tube: Covent Garden
+44 (0)20 7240 1200
roh.org.uk
Map M10 | F6

Dishoom aims to evoke the Irani cafés of Bombay in terms of design and food and serves breakfast, lunch, afternoon chai and dinner. Breakfast dishes include: *Akuri* - Three spicy scrambled eggs piled up richly alongside plump pau buns and served with grilled tomato; and *The Big Bombay* - Akuri, char-striped smoked streaky bacon from The Ginger Pig #201, peppery Shropshire pork sausages, masala baked beans, grilled field mushroom, grilled tomato and buttered pau buns. The all-day menu includes: *Keema Pau* - spiced minced lamb and peas with a toasted, buttered pau bun; *Murgh Malai* - Chicken thigh meat steeped overnight in garlic, ginger, coriander stems and a little cream; and *Prawn Koliwada* - Bombay's Koli (fishermen) Wada (district) recipe: a bowl of delicate, crispy morsels with tamarind and date chutney.

12 Upper St Martin's Lane
WC2H 9FB
Tube: Leicester Square
+44 (0)20 7420 9320
dishoom.com
Map M10 | E6

The Phoenix Garden is an environmental community garden intended to provide a green retreat in the centre of the city and a habitat for urban wildlife including birds, bees and frogs. The garden is maintained using sustainable techniques and an innovative approach to wildlife gardening. The objective is to create a beautiful space that needs minimal maintenance to grow and thrive. The garden is a popular place to sit and relax and is overlooked by the Church of St Giles-in-the-Fields, built in the early 18th century. The Phoenix Garden is a charity, staffed by volunteers and funded by donations from visitors.

21 Stacey Street
WC2H 8DG
Tube: Tottenham Court Road
thephoenixgarden.org
Map M10 | D6

CENTRAL

Bloomsbury

Bloomsbury is London's academic centre, home to the Senate House, several universities and the British Museum. The area was developed by the Dukes of Bedford, who commissioned fine architecture and large formal squares such as Bedford Square and Russell Square. Bloomsbury offers independent bookshops and cafes that cater to the academic crowd and the area is associated with the Bloomsbury Group, a group of English writers and intellectuals who met in the area in the early 20th century. Bloomsbury offers a feeling of space compared to other central London areas.

CENTRAL

175
St George's, Bloomsbury

Architecture

St George's is a church built in the classical style by Nicholas Hawksmoor, a pupil and former assistant to Sir Christopher Wren. The church was consecrated in 1730. At the time of its completion, the church was surrounded by one of London's most notorious slums: The Rookery. A painting by William Hogarth in 1751, *Gin Lane*, depicts the area and features the church's spire. The steeple features carvings of lions and unicorns and is topped by a statue of King George I in Roman dress. Other architectural features include columns, porticos and ornate, stained glass windows.

Bloomsbury Way
WC1A 2SA
Tube: Holborn
+44 (0)20 7242 1979
stgeorgesbloomsbury.org.uk
Map M10 | F4

176
The Cartoon Museum

Art & Design

The Cartoon Museum features British cartoon and comic art from the 18th century to the present day. The beginnings of modern British political and social cartooning can be found in works by Hogarth, whose social satires are regarded by many as the foundation of the British cartoon tradition. The permanent collection also includes works by a number of fine Victorian cartoonists including John Leech, George Cruikshank, George Du Maurier and John Tenniel. The Cartoon Museum shop stocks more than 900 books on the history of cartoons and comic-strips, graphic novels and children's books; and a wide range of cards, posters, prints and cartoon-related novelty gifts.

35 Little Russell Street
WC1A 2HH
Tube: Holborn
+44 (0)20 7580 8155
cartoonmuseum.org
Map M10 | E4

177
London Review Bookshop

Culture

The London Review Bookshop was established by the London Review of Books, a literary magazine with global reach. The shop has a selection of more than 20,000 titles, covering world literature, contemporary fiction, poetry, history, politics and many more subjects. The bookshop regularly holds events, which include author readings and discussions, film screenings, coffee tastings and food and cocktail evenings. A café serves teas, coffees, cakes and pastries. The bookshop is designed to be a haven for book lovers and a place to sit, read, discuss and relax.

14 Bury Place
WC1A 2JL
Tube: Holborn
+44 (0)20 7269 9030
londonreviewbookshop.co.uk
Map M10 | F4

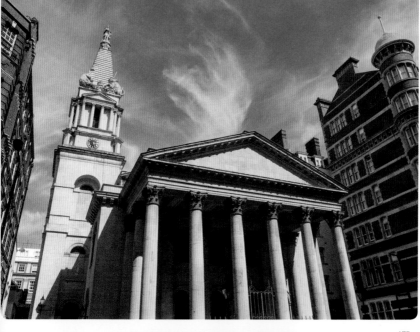

175

177

"Top exhibits at the museum include the Rosetta Stone, the Elgin Marbles and the Sir Percival David Collection of Chinese Ceramics."

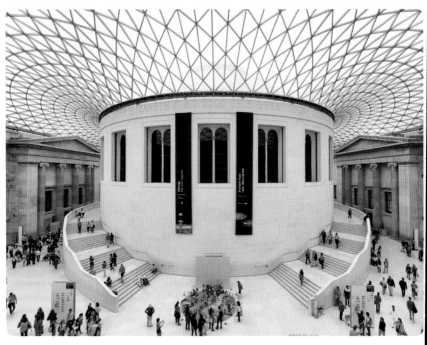

178

179

178
British Museum

History

179
Persephone Books

Shopping

Established in 1753, The British Museum's permanent collection numbers more than 8 million objects of historical, artistic and cultural significance, making it one of the most impressive collections in existence. The museum was established based on the private collection of Sir Hans Sloane, a well-known scientist, who sold his collection to King George II. The collection grew so large that two new spaces had to be created, the Natural History Museum #316 and the British Library. In 2000, the museum's inner courtyard was covered with a glass roof, creating the Great Court, the largest covered public square in Europe. Designed by Norman Foster, it is one of London's most spectacular attractions. Top exhibits at the museum include the Rosetta Stone, the Elgin Marbles and the Sir Percival David Collection of Chinese Ceramics.

Persephone Books is an independent publisher that reprints neglected fiction and non-fiction by mid-twentieth century, mostly women writers. Persephone publish novels, short stories, diaries, memoirs and cookery books. Persephone also organise lunches, teatime talks and discussions with authors. Books are published with a trademark grey cover and selected authors include Dorothy Wipple, Hilda Bernstein and Virginia Woolf. Persephone publish over 100 titles and the shop also sells notebooks.

59 Lamb's Conduit Street
WC1N 3NB
Tube: Russell Square
+44 (0)20 7242 9292
persephonebooks.co.uk
Map M10 | G3

CENTRAL

Great Russell Street
WC1B 3DG
Tube: Russell Square
+44 (0)20 7323 8299
britishmuseum.org
Map M10 | E4

CENTRAL

180
Lamb's Conduit Street
Culture

181
Charles Dickens Museum
History

182
St George's Gardens
Leisure & Nature

Lamb's Conduit Street features an impressive array of independent shops, unique for central London. The major landlord on the street is Rugby School in Warwickshire, and the lack of large chains is obviously by design. The street is home to establishments offering wine, Italian food, accessories, jewellery, cosmetics and contemporary menswear. There are cafés, art galleries, bookshops, a cooperative supermarket and a pub dating from 1779. The street has outdoor tables and chairs and one could happily spend half a day exploring. Persephone Books #179 is on the street.

London, WC1N
Tube: Russell Square
Map M10 | G3

The building that houses this museum was the London residence of the famous author from 1837-1839. Dickens wrote *Oliver Twist* and completed *The Pickwick Papers* during the time that he lived here. The rooms of the Georgian terraced house are decorated in the original style and contain original pieces of furniture, as well as manuscripts, rare editions and paintings. An extension to the original house contains a garden café that serves tea, cakes and light refreshments.

48 Doughty Street
WC1N 2LX
Tube: Russell Square
+44 (0)20 7405 2127
dickensmuseum.com
Map M10 | G2

Containing the tomb of Oliver Cromwell's granddaughter, St George's is a former graveyard that opened in 1713. It claims to be the location of the first recorded case of body snatching. Reopened as a public garden in 1890, it features winding paths, flowerbeds, lawns, London plane trees and ferns. It is now used by hundreds of people locally for rest and relaxation.

62 Marchmont Street
WC1N 1AB
Tube: Russell Square
friendsofstgeorgesgardens.org.uk
Map M10 | F1

"The street is home to establishments offering wine, Italian food, accessories, jewellery, cosmetics and contemporary menswear. There are cafés, art galleries, bookshops, a cooperative supermarket and a pub dating from 1779."

CENTRAL

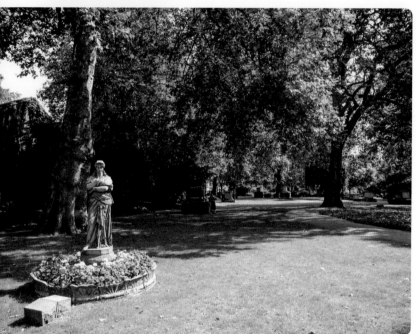

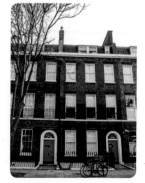

183

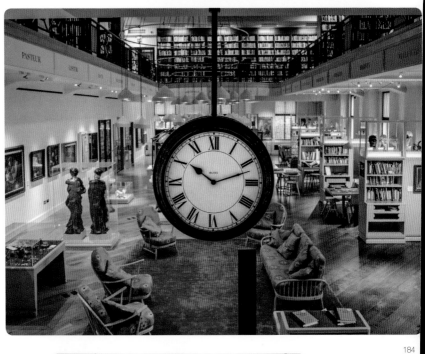

184

185

183
The Foundling Museum

History

184
Wellcome Collection

History

185
Grant Museum of Zoology

History

The Foundling Museum explores the history of the Foundling Hospital, the UK's first children's charity and first public art gallery. The Hospital was established in 1739 by the philanthropist Thomas Coram to care for babies at risk of abandonment. Instrumental in helping Coram realise his vision were the artist William Hogarth and the composer George Frideric Handel. The Foundling Museum celebrates the ways in which artists of all disciplines have helped improve children's lives for over 275 years through a busy programme of exhibitions and events.

40 Brunswick Square
WC1N 1AZ
Tube: Russell Square
+44 (0)20 7841 3600
foundlingmuseum.org.uk
Map M10 | F1

The Wellcome Collection explores the connections between medicine, life and art in the past, present and future. Sir Henry Wellcome set up the pharmaceutical company, Burroughs Wellcome & Co, with Silas Burroughs in 1880. The company was one of the first to introduce medicine in tablet form. The Wellcome Trust is his legacy and is a champion of science, funding research and influencing health policy across the globe. The Wellcome Collection documents Sir Henry's collection of over one million historical objects and offers visitors contemporary and historic exhibitions and collections, lively public events, the world-renowned Wellcome Library, a café, a shop, and a restaurant as well as publications, tours and a book prize. Admission is free.

183 Euston Road
NW1 2BE
Tube: Euston Square
+44 (0)20 7611 2222
wellcomecollection.org
Map M10 | C1

The Grant Museum is a natural history museum at University College London, containing around 68,000 zoological specimens from across the whole animal kingdom. The collection includes fossils from the Jurassic period, dodo bones, the skeleton of a Tasmanian tiger, a species driven to extinction in 1936; and the skeleton of an African rock python, which lived at London Zoo. The Grant was founded in 1828 as a teaching collection and is still used for this purpose today.

21 University Street
WC1E 6DE
Tube: Euston Square
+44 (0)20 3108 2052
ucl.ac.uk/museums
Map M10 | C2

CENTRAL

186
Petrie Museum of Egyptian Archaelogy

History

187
Senate House

Architecture

188
The Building Centre

Architecture

Containing over 80,000 objects, the Petrie Museum ranks among the world's greatest collections of Egyptian and Sudanese archaeology. The museum contains objects dating from prehistory through the time of the pharaohs, the Ptolemaic, Roman and Coptic periods to the Islamic period. The collection contains outstanding works of art, colourful tiles, carvings and frescoes. The museum houses the world's largest collection of Roman period mummy portraits. It also contains amulets, faience, tools and weapons, weights and measures, stone vessels and jewellery that provide a unique insight into the lives of people in the Nile Valley during various periods of history. Along with The Grant Museum of Zoology #185, it is part of University College London and provides a valuable teaching resource to students.

Malet Place
WC1E 6BT
Tube: Euston Square
+44 (0)20 7679 2884
ucl.ac.uk/museums/petrie
Map M10 | C2

Designed by Charles Holden, the Senate House was London's first skyscraper. It was taken over by the government during the Second World War for use by the Ministry of Information, which served as the inspiration for the Ministry of Truth in George Orwell's dystopian novel *Nineteen Eighty Four*. The building was completed in 1937 as part of a grand vision to re-house the University of London, whose growth was limited by the confined space of its premises in Kensington. The interior is filled with impressive art deco design and the spaces are regularly used in Hollywood movies. Legend has it that this behemoth escaped bombing during the war because Hitler had selected it as his headquarters following Britain's surrender to Germany.

Senate House Malet Street
WC1E 7HU
Tube: Goodge Street
+44 (0)20 7862 8500
senatehouselibrary.ac.uk
Map M10 | D3

The Building Centre is an architecture centre that promotes innovation in the built environment. Many companies involved in architecture and construction are located in the Building Centre, including the China Design Centre and New London Architecture, which features a giant model that lays out the future of central London. The centre holds many exhibitions related to contemporary building and design throughout the year. Past exhibitions include the work of Thibault Herem, a French illustrator; Oriental home decor at China Design Centre; and the work of Jean Prouvé, the French 20th Century pioneer of innovative furniture and architecture. Admission is free.

Store Street
WC1E 7BT
Tube: Goodge Street
+44 (0)20 7692 4000
buildingcentre.co.uk
Map M10 | D4

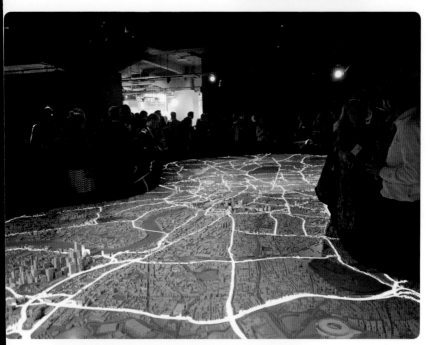

188

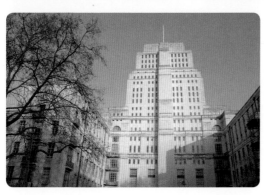

187

"The likes of BB King, Rolling Stones, Kings of Leon, Oasis, Suede, Blur and many more have performed at the club."

189

190

Fitzrovia

Fitzrovia lies to the north of Soho, across Oxford Street, but it has a very different vibe. Home to many companies in the arts and communications industries, it is also a thriving residential area filled with shops, galleries, markets, coffee shops and food outlets to suit all budgets. The area developed in the 18th and 19th centuries under the guidance of multiple, small landowners. This led to smaller streets and passageways that today give the place a character very different from neighbouring areas such as Bloomsbury. Fitzrovia's central location and proximity to Marylebone, Regent's Park and Oxford Street make it a prime area to live and work.

CENTRAL

189
The Elysee

Food & Drink

Opening in 1936, The Elysee is a mainstay of the London dining scene and features a restaurant, cocktail bar and roof terrace serving Greek and Mediterranean cuisine in stunning art deco surroundings. Dishes include Aubergine Imam - baked and filled with Mediterranean ragout and crumbled feta; Garides Katai - King prawns wrapped in katai with a balsamic shallot reduction; Keftedes - Lamb meatballs, tomato sauce, couscous and Greek yoghurt; and Kleftiko - Slow-cooked lamb shoulder spiced with oregano and bay leaves served with potatoes and braised onion. The restaurant has had many high-profile patrons over the years including members of the British and Greek Royal Families.

13 Percy Street
W1T 1DP
Tube: Tottenham Court Road
+44 (0)20 7636 4804
elyseerestaurant.com
Map M10 | C4

190
100 Club

Entertainment

A live music club showcasing some of the world's best musical talents since 1942, 100 Club is the oldest, independent live music venue still in existence worldwide. The likes of BB King, Rolling Stones, Kings of Leon, Oasis, Suede, Blur and many more have performed at the club. The club has a tradition of hosting secret shows by established artists from time to time and is committed to promoting the most exciting new musical talents from London and beyond.

100 Oxford Street
W1D 1LL
Tube: Tottenham Court Road
+44 (0)20 7636 0933
the100club.co.uk
Map M10 | C5

191
Riding House Café
Food & Drink

192
Royal Institute of British Architects
Architecture

193
Broadcasting House
Architecture

The Riding House Café is an all-day brasserie in a light, modern, retro-styled space. Breakfasts on offer include Eggs Hussard, ox heart tomato, ham, spinach, bordelaise and hollandaise; and chorizo hash browns with mushrooms and poached eggs. The rest of the menu is broad with items such as poutine, caponata, lobster lasagna, sausages and mash, cheeseburgers, poussin and salads. They have an extensive drinks list and dining is informal from 7.30am to 10.30pm on weekdays and slightly later on weekends. Service is quick and cooking is high quality. This is a place to come for almost any food or drink requirement during the day.

43-51 Great Titchfield Street
W1W 7PQ
Tube: Oxford Circus
+44 (0)20 7927 0840
ridinghousecafe.co.uk
Map M10 | A4

The Royal Institute of British Architects is a charitable organisation founded in 1834 for '…the general advancement of Civil Architecture…'. In 1848, Queen Victoria instituted the Royal Medal, awarded to distinguished architects for work of high merit and applied to a body of work (rather than a single building). Previous winners include Le Corbusier (1953), Frank Gehry (2000), Frei Otto (2005), Toyo Ito (2006), Herzog and de Meuron (2007), I. M. Pei (2010) and Sir David Chipperfield (2011). The organisation also awards the RIBA Stirling Award, the UK's most prestigious architecture prize, presented to the architects of the building that has made the greatest contribution to the evolution of architecture in the past year. RIBA's headquarters are housed in a stunning art deco building on Portland Place and regular building tours are available. The RIBA library is open to the public and holds one of the world's broadest collections of books on architecture. The RIBA bookshop is also located within and has a huge range of books on architecture, design and construction.

66 Portland Place
W1B 1AD
Tube: Regent's Park
+44 (0)20 7580 5533
architecture.com
Map M11 | E2

Built for the British Broadcasting Corporation (BBC) in 1932, Broadcasting House was the first purpose-built broadcasting centre in the United Kingdom. The modernist design is distinctively Art Deco and the building is considered to be one of the most important buildings of its type in London. Several momentous broadcasts have been made from Broadcasting House including the first time the nation heard their monarch (George V), the announcement of the outbreak of the Second World War and communications from Charles de Gaulle to the French Resistance. The building underwent huge investment and renovation to become the BBC's headquarters for television and radio in 2012, housing 6,000 employees and the largest live newsroom in Europe. Although the building is closed to the public, the external architecture is well worth a visit and All Soul's Church, by royal architect John Nash, stands next door.

Portland Place
W1A 1AA
Tube: Oxford Circus
bbc.co.uk/broadcastinghouse
Map M11 | E3

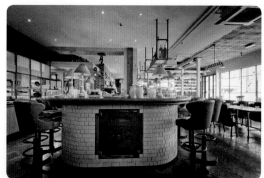

191

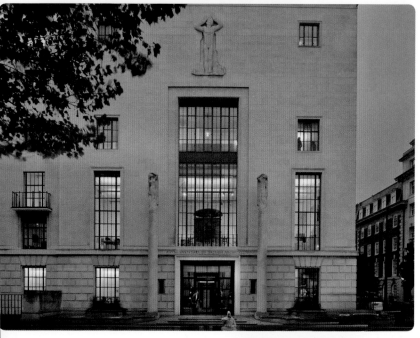

192

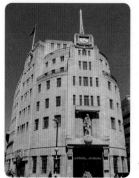

193

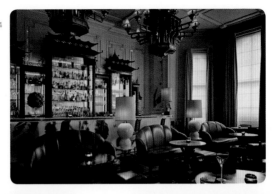

194

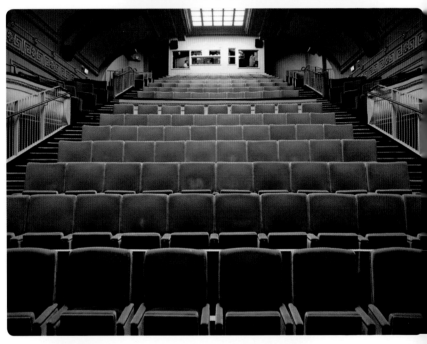

195

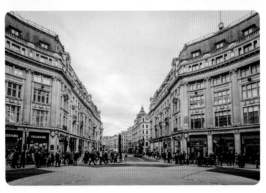

196

Marylebone

Marylebone is a large, comparatively quiet, residential neighbourhood with a village feel. Filled with elegant architecture, the high street contains butchers, florists, cheese shops, supermarkets, bookshops, coffee shops, galleries and restaurants. The area was developed by ancestors of the Howard de Walden family in the 18th century and the family still have significant landholdings and interests in the area. Harley Street and Regent's Park are within Marylebone and the area contains numerous small squares and green spaces.

194
Artesian Bar at The Langham

Food & Drink

Artesian has won multiple awards for its cocktails, which include both classics and experimental concoctions that use unusual ingredients such as ylang ylang, cypress, orange blossom, yuzu, shochu, verjus, jiaouli, yarrow, palmarosa, kombucha, ginseng and patchouli. Served within the lush surroundings of the 150 year old Langham Hotel on Portland Place, Artesian offers exceptional drinks and service and makes for an impressive start or end an evening out.

C Portland Place
1B 1JA
be: Oxford Circus
4 (0)20 7636 1000
tesian-bar.co.uk
ap M11 | E3

195
Regent Street Cinema

Entertainment

Built in 1848 and housed within the Polytechnic Institution on London's Regent Street, the cinema was the first in the country to show moving pictures. After being used as a student lecture hall by the university since 1980, it was restored into a working cinema featuring a state-of-the-art auditorium as well as an inclusive space for learning, cultural exchange and exhibitions. The cinema is one of the few in the country to show 16mm and 35mm film, as well as the latest in 4K digital films. It offers exclusive premieres, repertory screenings, retrospectives, documentaries, animation and experimental cinema.

309 Regent Street
W1B 2UW
Tube: Oxford Circus
+44 (0)20 7911 5050
regentstreetcinema.com
Map M11 | E4

196
Oxford Street

Shopping

Oxford Street is one of the world's most famous shopping streets and Europe's busiest with half a million daily visitors. The street has around 300 shops including several department stores. Its status as a retail destination mean that many global retail companies have located their UK flagship stores here including Nike, Uniqlo and H&M. The annual switching on of London's Christmas lights is an event that has taken place on the street since 1959. Oxford Street connects with the northern end of Bond Street #227 and Selfridges #209 and the 100 Club #190 are also located on the street.

W1B
Tube: Oxford Circus
Map M11 | D4

CENTRAL

CENTRAL

197
Wigmore Hall
Culture

198
Wallace Collection
Art & Design

199
Thompson's Gallery
Shopping

The Wigmore Hall is a performance space specifically designed for classical chamber music. Opening in 1901, the hall become known across Europe for having near perfect acoustics and attracted the most talented musicians. The hall has a particular relationship with the composer Benjamin Britten, who premiered several of his works here. The hall puts on around 450 performances per year spanning many classical music genres.

36 Wigmore Street
W1U 2BP
Tube: Bond Street
+44 (0)20 7935 2141
wigmore-hall.org.uk
Map M11 | C3

The Wallace Collection contains paintings, furniture, ceramics, sculpture, armour and other decorative arts collected by the Marquess of Hertford and left to the nation by the wife of his illegitimate son, Sir Robert Wallace. Located in Hertford House, the collection is world-renowned and amongst its items counts two Titian's, five Rembrandt's, eight Canaletto's, nine Rubenses, Sevres porcelain and furniture by Andre-Charles Boulle. A condition of the bequest was that no piece of the collection may ever be removed, even for loan. Admission to the collection is free.

Hertford House
Manchester Square
W1U 3BN
Tube: Bond Street
+44 (0)20 7563 9500
wallacecollection.org
Map M11 | B3

Thompson's Gallery was established in 1982 in Aldeburgh, Suffolk. The London gallery is situated on New Cavendish Street near Marylebone High Street #200. Thompson's hold up to eleven shows a year ranging from one-man to mixed exhibitions. They specialise in Modern British 20th and 21st Century artists, Scottish colourists and contemporary art and source original works by the artists represented.

15 New Cavendish Street
W1G 9UB
Tube: Bond Street
+44 (0)20 7935 3595
thompsonsgallery.co.uk
Map M11 | C2

"...the collection is world-renowned and amongst its items counts two Titians, five Rembrandts, eight Canalettos, nine Rubenses, Sevres porcelain and furniture by Andre-Charles Boulle."

199

198

200

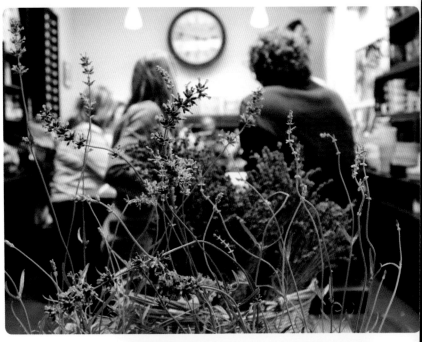

202

201

200
Marylebone High Street

Shopping

201
The Ginger Pig

Food & Drink

202
La Fromagerie

Shopping

Marylebone High Street sits at the heart of the Howard de Walden Estate, a substantial section of Marylebone owned and managed by the Howard de Walden family. The area is known for its beautiful Georgian townhouses and is a major eating and shopping destination. There are over 70 restaurants and cafés, a cookery school, many retail food shops, health and beauty outlets, over 70 fashion shops, homeware shops, galleries, cinemas and museums. The estate places an emphasis on small and independent retailers. The area stretches as far as John Nash's grand facades on Portland Place.

W1U
Tube: Baker Street
Map M11 | C2

The Ginger Pig is a butchers that rears its own livestock. Starting 20 years ago, they now have 5000 animals across 3000 acres of Yorkshire farmland. As well as beef, lamb, poultry and pork, they prepare sausage rolls, terrines, pork pies, chutneys, cured meats and pates. Their hot sausage rolls fresh from the shop are a bestseller. They also run butchery classes. The Ginger Pig is expanding rapidly across London and their comprehensive website tells you all you need to know about different cuts of meat and how to cook them. This is a destination for the foodie who wants to learn more about traditional British food.

8-10 Moxon Street
W1U 4EW
Tube: Regent's Park
+44 (0)20 7935 7788
thegingerpig.co.uk
Map M11 | C2

La Fromagerie is a cheese shop with two locations in London. The extensive cheese selection includes over 260 varieties, from all over the UK and Europe as well as the United States. Cheeses are sourced and then matured in the shop until they reach peak condition. The shop features celebration cheesecakes, which are a selection of whole cheeses stacked on top of one another and designed to complement each other. Prices range from £75 to £850 for a 20kg 'cake' serving 200 guests. The shop has a café serving breakfast items such as scrambled eggs, bacon sandwiches, frittatas and kippers. Lunchtimes offer fondues, ploughman's, charcuterie plates and snails. La Fromagerie also arranges workshops covering a variety of food and cheese-related topics.

2-6 Moxon Street
W1U 4EW
Tube: Baker Street
+44 (0)20 7935 0341
lafromagerie.co.uk
Map M11 | C2

CENTRAL

203
Daunt Books

Culture

204
The Natural Kitchen

Food & Drink

205
Sherlock Holmes Museum

Culture

Daunt Books is an original Edwardian bookshop on Marylebone High Street #200. Its success has seen a chain of Daunt shops set up across the city, but the original is special. It features long oak galleries, parquet flooring and a stained glass window. Books are organised by country and the shop has an extensive travel section. Thanks to its unique atmosphere and excellent selection of titles, Daunt Books retains a loyal following from the local community and beyond.

83 Marylebone High Street
W1U 4QW
Tube: Baker Street
+44 (0)20 7224 2295
dauntbooks.co.uk
Map M11 | C2

The Natural Kitchen offer healthy food and drinks using ingredients from sustainable and ethical sources. They offer a wide range of sandwiches, salads and hot food with dishes including British chicken breast and crispy pancetta, with Kalamata olives, cherry tomatoes, baby gem lettuce, wild rocket leaves, rustic croutons and homemade caeser dressing; Aberdeen Angus steak beef burger with caramelised red onions and rosemary mayonnaise on organic brioche bun; and poached eggs, fresh avocado guacamole, vine ripened tomatoes and baby spinach leaves on dark rye bread. A range of coffees. teas, juices and smoothies are also available. The café and deli is open from 7am to 8pm on weekdays and 8am to 7pm on weekends.

77-78 Marylebone High Street
W1U 5JX
Tube: Regent's Park
+44 (0)20 3696 6910
thenaturalkitchen.com
Map M11 | C1

Sherlock Holmes is a fictional detective created by Sir Arthur Conan Doyle. The Sherlock Holmes books are set in late 19th and early 20th century London and Holmes lives at the fictional 221b Baker Street with his sidekick, Dr Watson. The Holmes stories cover four novels and 56 short stories and such is the detail and characterisation of the protagonists, many people believe that Holmes was real. The museum sits between number 237 and 241 on Baker Street, but has special permission to use the number 221b. The museum is a private organisation containing a mock-up of Holmes and Watson's rooms, filled with period paintings, furniture, books and Holmes paraphernalia.

221B Baker Street
NW1 6XE
Tube: Baker Street
+44 (0)20 7224 3688
sherlock-holmes.co.uk
Map M12 | D2

203

205

"...one of the most influential and longest-running International contemporary art galleries in the world."

206
Alfie's Antique Market

Shopping

207
Lisson Gallery

Art & Design

Alfie's is London's largest indoor market for antiques, vintage fashion and 20th century design. Located in the former Jordan's department store, the market has an Egyptian-style art deco façade, a rooftop café and around 100 antique dealers trading inside. Alfie's attracts serious collectors, interior designers and celebrities to browse its varied collection of antiques and collectables, which include African textiles, Victorian furniture, lighting, jewellery and much more. The market is open Tuesday to Saturday from 10am to 8pm.

13-25 Church Street
NW8 8DT
Tube: Marylebone
+44 (0)20 7723 6066
alfiesantiques.com
Map M12 | B2

Lisson Gallery is one of the most influential and longest-running international contemporary art galleries in the world. Since being founded in 1967 by Nicholas Logsdail, it has championed the careers of artists who have transformed the way art is made and presented. These include many important minimal and conceptual artists, such as Sol LeWitt and Richard Long, as well as a whole generation of significant British sculptors from Anish Kapoor and Richard Deacon to Shirazeh Houshiary and Tony Cragg. It continues to support the future of its artists, the legacy of historical figures, the evolving practice of established artists and the wide-ranging potential of emerging and new talents. Lisson Gallery have two exhibition spaces in London, one in Milan and one in New York.

52 Bell Street
NW1 5BU
Tube: Edgware Road
+44 (0)20 7724 2739
lissongallery.com
Map M12 | B3

CENTRAL

208
Bernardi's

Food & Drink

209
Selfridges

Shopping

CENTRAL

Bernardi's is an Italian restaurant and bar serving modern, homemade classics. Open seven days a week for breakfast, lunch and dinner, dishes include: burratina, heritage tomato and olive pesto; beef carpaccio, Calabrian peppers, parmesan and rocket; octopus, green olive, potato and N'duja; guinea fowl, peas, pancetta and morels; and ossobuco, parmesan polenta, grappa and gremolata. Desserts include dark chocolate and hazelnut tart, praline cream; and buttermilk panna cotta, Yorkshire rhubarb, white chocolate and pistachio. The restaurant is located close to Marble Arch #298 and Hyde Park.

62 Seymour Street
W1H 5BN
Tube: Marble Arch
+44 (0)20 3826 7940
bernardis.co.uk
Map M11 | A3

Selfridges is a luxury department store on Oxford Street founded in 1909. It is the second largest shop in the United Kingdom (after Harrods #295). Set up by the American, Harry Gordon Selfridge, the shop was a revolution in retail in the United Kingdom. Believing that modern retail practices should not just be limited to the United States, Selfridge opened his store and employed innovative marketing practices to promote the shop. He created buzz and excitement by placing various objects of historical value and fascination in the shop, such as the monoplane that completed the first cross-channel flight. Selfridge believed in the art of theatre and created shop window displays designed to excite and entice. This and many other retail firsts made Selfridges a destination for both shopping and social and cultural interaction. Today, the shop stocks the world's most exciting brands across all categories including fashion, accessories, food, homeware, books, technology and health and beauty. The shop's signature yellow bags are desirable themselves and stand out among the crowds of shoppers on Oxford Street.

400 Oxford Street
W1A 1AB
Tube: Bond Street
selfridges.com
Map M11 | B4

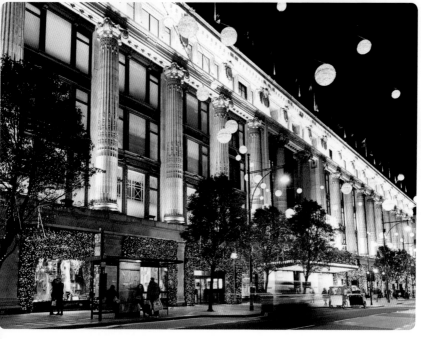

"He created buzz and excitement by placing various objects of historical value and fascination in the shop, such as the monoplane that completed the first cross-channel flight."

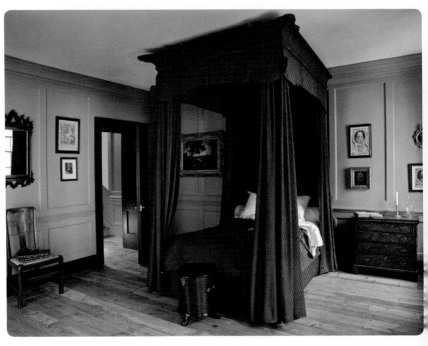

211

"A permanent exhibition introduces Hendrix's place in the musical and social world of 1960s London; his influences and his legacy."

Mayfair

Mayfair is exclusive and the home of the super rich in London. Steeped in history, its residents have included princes, prime ministers and ambassadors. Located close to Buckingham Palace and Hyde Park, the area is filled with decorative architecture, royal institutions, luxury hotels and gentlemen's clubs. One of London's most expensive areas for property, there has been a significant increase in office space over many years and it is now just as likely that a period property will contain a hedge fund as a wealthy individual. The area is a destination for luxury shopping, fine dining and rare libations.

210
Brown's

Shopping

Targeted at the trendy, cutting edge fashion market, Browns is an independent retail store for women's fashions and shoes. Founded in 1970, Browns prides itself on handpicking pieces from the world's top designers. The shop spotted such mega designers as Alexander Mcqueen, John Galliano and Commes des Garcons early on, making it something of a fashion destination. It has expanded considerably since its inception and now has floor space across several townhouses in South Molton Street and a separate menswear shop next door.

24-27 South Molton Street
W1K 5RD
Tube: Bond Street
+44 (0)20 7514 0016
brownsfashion.com
Map M11 | C4

211
Handel and Hendrix

Culture

Handel House occupies two floors of 25 Brook Street, the building in which the composer George Frideric Handel lived from 1723 until his death in 1759. The four restored historic rooms include his bedroom, and the dining room in which he rehearsed his musicians and singers and often gave informal recitals for friends and neighbours. Additional rooms in the adjoining house are used for temporary exhibitions that focus on aspects of Handel's life, professional career and associates. Hendrix Flat occupies the upper floor of 23 Brook Street, in which Jimi Hendrix lived from July 1968 to March 1969. The main room of the flat where he lived, entertained friends, rehearsed and wrote new music, and gave numerous press and media interviews has been restored. A permanent exhibition introduces Hendrix's place in the musical and social world of 1960s London, his influences and his legacy.

25 Brook Street
W1K 4HB
Tube: Bond Street
+44 (0)20 7495 1685
handelhendrix.org
Map M11 | C5

CENTRAL

CENTRAL

212
Claridge's
Art & Design

213
Grosvenor Square Gardens
Leisure & Nature

214
Le Gavroche
Food & Drink

Claridge's has long been regarded as one of the finest hotels in London, patronised by royalty and aristocracy and frequented by international heads of state and movie stars. In the hedonistic 1920s, many British designers left their mark on the hotel, creating some of the city's finest art deco designs. The hotel retains this style today. Add to this the modern food of international Michelin starred chefs and you have Claridge's spectacular mix of fascinating history and design, paired with world-beating food and drinks. Afternoon tea or dinner is highly recommended.

Brook Street
W1K 4HR
Tube: Bond Street
+44 (0)20 7629 8860
claridges.co.uk
Map M11 | C5

Grosvenor Square is named after the Duke of Westminster, whose surname is Grosvenor and who owned much of the property in surrounding Mayfair. The gardens contain a memorial to Franklin Roosevelt. The President Roosevelt statue was unveiled by Mrs Franklin Delano Roosevelt in the presence of King George VI in 1948. There is also a September 11 Memorial Garden. The square has had a strong connection with the United States since John Adams, 2nd President of the United States, established the first mission to the court of St James's here in 1785. The current US Embassy is located at No. 1 Grosvenor Square, but is scheduled to relocate south of the river.

W1K 4BN
Tube: Bond Street
+44 (0)300 062 2000
royalparks.org.uk
Map M11 | B5

Le Gavroche was the first restaurant in Britain to be awarded three Michelin stars and since 1993 has held two Michelin stars. In operation since 1967, the restaurant was opened by French chefs Albert and Michel Roux. They also opened The Waterside Inn in Berkshire. Today, Albert's son, Michel Roux Jr runs Le Gavroche and Michel's son, Alain runs The Waterside Inn. Dishes at Le Gavroche include: cheese soufflé baked on double cream; stone bass and pastilla, scented with Arabian spices, fennel, red rice and meat jus; black pudding, crumbed egg, crackling asparagus salad and spicy tomato chutney; grilled Dover sole on the bone, langoustines, smoked aubergine, olive oil and white balsamic dressing; and amedei chocolate, peanut brittle, caramel and banana.

43 Upper Brook Street
W1K 7QR
Tube: Bond Street
+44 (0)20 7408 0881
le-gavroche.co.uk
Map M11 | A5

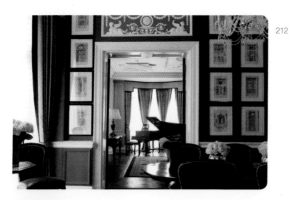

212

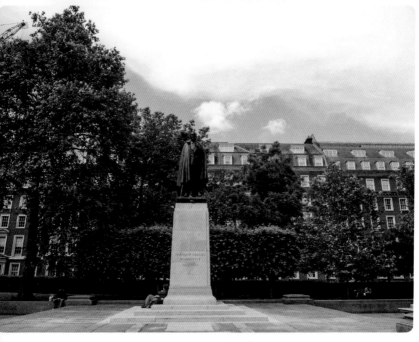

213

214

216

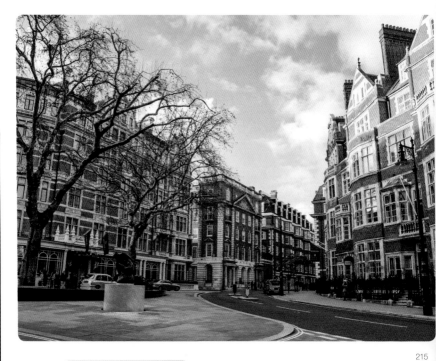

215

217

215
Mount Street

Culture

216
The Grill at The Dorchester

Food & Drink

217
Nobu

Food & Drink

Mount Street was one of the original shopping streets in Mayfair and is filled with high-end fashion boutiques, restaurants and antique shops. The street stretches from Hyde Park in the west to Berkeley Square #218 in the east. The famous Connaught Hotel is nearby. Shops include S.T. Dupont, Balenciaga, Christian Louboutin, Marc Jacobs and Oscar de la Renta. The well-known Scott's fish and seafood restaurant is also here. Beautiful Georgian townhouses run the length of the street and Mount Street Gardens, a secluded public garden created in 1889, sits behind the street.

W1K 2AP
Tube: Bond Street
Map M11 | C5

The Dorchester Hotel is a world-famous luxury hotel located on Park Lane and overlooking Hyde Park. Built in the 1930s, it retains the design of that age today. After opening, it quickly became popular with famous writers and artists of the day. The Grill is located on the ground floor and serves breakfast, lunch and dinner. Dishes include blue lobster chowder, mushroom and chive; Coddled egg, green asparagus and bacon; Seabass, green asparagus and gnocchi, 'vinjaune' reduction; Duck breast, spring vegetables, Maltese sauce; and Organic Aberdeen Angus beef tournedos, potatoes, onions, Perigourdine sauce.

53 Park Lane
W1K 1QA
Tube: Green Park
+44 (0)20 7317 6531
dorchestercollection.com
Map M11 | A6

The food at Nobu is based on classical Japanese cuisine with South American influences. A long-standing star of the London culinary scene, Nobu has become a worldwide empire under the stewardship of chef, Nobu Matsuhisa. Cold dishes on offer include: Matsuhisa shrimp with caviar; sea bass sashimi with dried miso and yuzu sauce; and langoustine with red chilli shiso salsa. Hot dishes include: lobster tempura with tamari honey sauce; tarabakani (king crab) tempura with amazu ponzu; and pan fried scallop with yuzu truffle sauce. The restaurant is located in the Metropolitan Hotel building and offers diners impressive views across Hyde Park.

19 Old Park Lane
W1K 1LB
Tube: Hyde Park Corner
+44 (0)20 7447 4747
noburestaurants.com
Map M11 | B7

CENTRAL

threesixfive **London**

CENTRAL

218
Berkeley Square

Leisure & Nature

219
Mr Fogg's Residence

Food & Drink

220
The Royal Institution of Great Britain

History

Berkeley Square is a well-known green space in Mayfair. The square was previously residential and home to prime ministers and aristocracy. Its history is reflected in the grand architecture of the remaining houses, now mostly used as offices. The area is also home to luxury hotels, gentleman's clubs and embassies. The square was immortalized by the famous jazz song, *A Nightingale Sang in Berkeley Square*, which has been performed by Vera Lynn, Frank Sinatra, Glenn Miller, Nat King Cole and many more. The square offers a good choice of places to eat and drink at various price points.

W1J 5AX
Tube: Green Park
Map M11 | C6

Mr Fogg's Residence is a cocktail bar in Mayfair set in the world of French novelist Jules Verne's protagonist in his 1873 novel, *Around the World in Eighty Days*. The bar's tagline is, 'The residence of the eccentric British adventurer'. The bar is carefully designed to reflect Phileas Fogg's eccentric nature from the Victorian decor to the opening times (all designated at one minute past the hour). The bar serves afternoon tea on weekends, or 'Tipsy Tea'; the tea consisting of Earl Grey infused Hendrick's gin, steeped in a teapot with Cointreau, crème de peche, orange marmalade, homemade sugar syrup and fresh lemon juice. The bar run 'The Explorer Series', a collection of talks by well-known travellers and explorers. Past guests include Bear Grylls and Simon Reeve.

15 Bruton Lane
W1J 6JD
Tube: Green Park
+44 (0)20 7036 0608
mr-foggs.com
Map M11 | D6

Founded in 1799, The Royal Institution is dedicated to scientific education and research. The institution has played an important role in the development and discovery of science and scientific applications. The organisation counts 15 Nobel laureates and significant developments at or connected with it include the discovery of ten chemical elements and the development of the electric generator based on the work of Michael Faraday. The institution runs many exhibitions and educational programs, the most famous of which are the Christmas lectures, which have run every year since 1825 (except 1939-1942) and are practical in nature and aimed at a young audience.

Albemarle Street
W1S 4BS
Tube: Green Park
+44 (0)20 7409 2992
rigb.org
Map M11 | D6

218

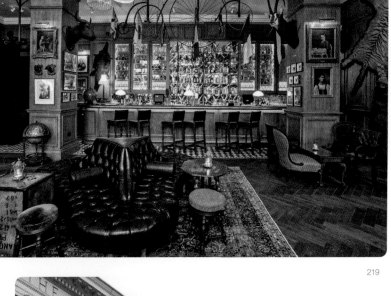

219

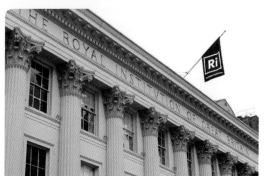

220

221

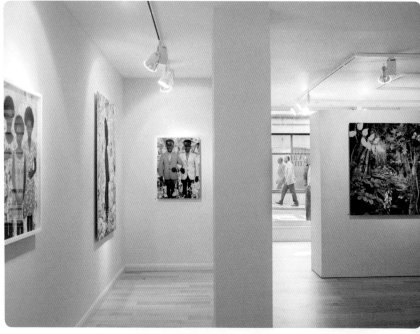

223

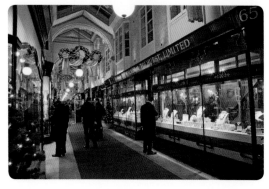

222

221
Gymkhana

Food & Drink

222
Burlington Arcade

Shopping

223
Beetles+Huxley

Art & Design

Gymkhana serves classic and contemporary Michelin-starred Indian cuisine, with a strong focus on chatpata and boldly spiced sharing dishes. The interior design of Gymkhana references the clubs of India with ceiling fans that hang from a dark-lacquered slatted oak ceiling, cut glass wall lamps from Jaipur and hunting trophies from the Maharaja of Jodhpur. Reminiscent of the gymkhana clubs, the dining room is flanked by turned cane detailed oak booths, marble tables and ox-blood leather banquettes. Brass edged tables and classic rattan chairs punctuate the dining space, which is embellished with Punch sketches and Indian sports prints. A la carte dishes include: wild muntjac biryani, pomegranate and mint raita; gilafi quail seekh kebab with raw papaya chutney; black pepper fish tikka with lasooni tomato chutney; and duck egg bhurji with lobster and malabar paratha.

42 Albemarle Street
W1S 4JH
Tube: Green Park
+44 (0)20 3011 5900
gymkhanalondon.com
Map M11 | D7

The Burlington Arcade opened in 1819 and is an early example of the modern shopping centre. It was commissioned by the brother of the Duke of Devonshire, Lord George Cavendish, whose London home was the adjacent Burlington House (now the Royal Academy of Arts #224). The Arcade features high-end shops selling antique silver, jewellery, clothes, shoes and accessories. The arcade is made more famous for the 'Beadles' who provide security and wear top hats and frockcoats. The arcade connects Piccadilly with Burlington Gardens next to Bond Street #227.

51 Piccadilly
W1J 0QJ
Tube: Green Park
+44 (0)20 7493 1764
burlingtonarcade.com
Map M11 | D7

Beetles+Huxley is an art gallery specialising in International photography and offering prints and framing services. Their small gallery on Swallow Street has hosted exhibitions by artists such as Steve McCurry, Cecil Beaton, Terence Donovan and Wang Qingsong. The prints on sale here run into the thousands of pounds. Admission to the gallery is free.

3-5 Swallow Street
W1B 4DE
Tube: Piccadilly Circus
+44 (0)20 7434 4319
beetlesandhuxley.com
Map M11 | E7

CENTRAL

CENTRAL

224
Royal Academy of Arts

Art & Design

225
Gieves and Hawkes

Shopping

226
Savile Row

Shopping

The Royal Academy is an independent institution governed by eminent artists and architects. Known as Royal Academicians, they are entitled to put the letters R.A. after their name. The institution was set up in 1768 and its first president was the painter Joshua Reynolds. The first piece of art in the Royal Academy's collection was a self-portrait by Reynolds and donating a work of art became a pre-requisite for becoming president. The academy has had several homes since its inception, including Somerset House #113, but has been located at Burlington House on Piccadilly since 1868. Graduates of the Royal Academy Schools include J.M.W. Turner and Sir John Soane and the academy continues to offer a three-year postgraduate course in fine art to a small number of talented artists. The Academy organises art exhibitions throughout the year, the most famous being the Summer Exhibition, which is open to all artists and has run continuously since 1769.

Located at No. 1, Savile Row #226, Gieves and Hawkes is one of the oldest men's tailors in the world, and holder of several royal warrants. For centuries they provided uniforms to the British Army and Royal Navy. Former customers include Winston Churchill, the Duke of Wellington, Charlie Chaplin and Bill Clinton. A previous incarnation of the tailor, Hawkes & Co. provided clothing to the famous explorer, David Livingstone. Off-the-peg suits start at around the £800 price mark and bespoke suits go up to several thousand pounds.

1 Savile Row
W1S 3JR
Tube: Piccadilly Circus
+44 (0)20 7432 6403
gievesandhawkes.com
Map M11 | E6

Built between 1731 and 1735, Savile Row is known for its bespoke men's tailoring. The tailors moved in to the area in the late 18th century. The oldest tailor on the street is Henry Poole & Co., whose founder is credited with creating the dinner jacket for Edward VII. Tailors include Ozwald Boateng, Richard James, Kilgour and Gieves and Hawkes #225. The street's inhabitants have extended beyond bespoke tailoring to include contemporary fashion designers such as Alexander Mcqueen. Bespoke suits can take around 80 man-hours to create and prices vary but expect to pay between £3,000 and £5,000 for a bespoke two-piece suit.

W1S 3JR
Tube: Piccadilly Circus
Map M11 | D6

Burlington House
W1J 0BD
Tube: Green Park
+44 (0)20 7300 8000
royalacademy.org.uk
Map M11 | E7

225

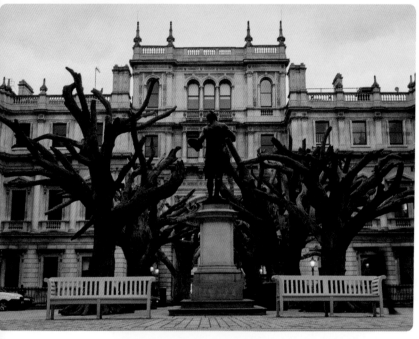

224

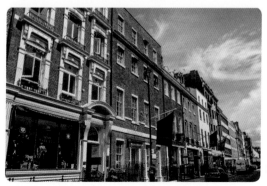

226

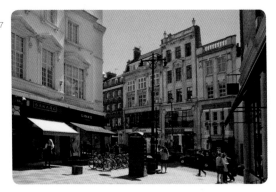

227

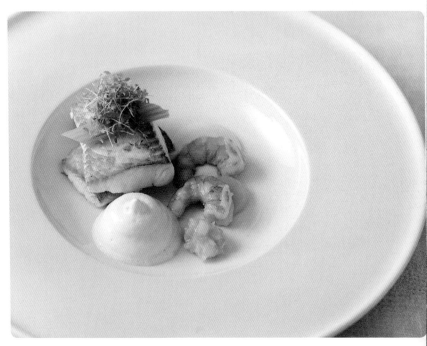

229

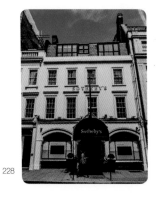

228

227
Bond Street

Shopping

228
Sotheby's

Shopping

229
Pollen Street Social

Food & Drink

One of the world's most famous shopping streets, Bond Street is lined with the stores of global super fashion brands and high-end art and antiques stores. Developed by Sir Thomas Bond in the 18th century, the street first became a place for the upper classes to socialise, and the shops followed. Bond Street stretches from Piccadilly in the south to Oxford Street in the north and has two distinct sections, Old Bond Street (south) and New Bond Street (north). At the southern end is Allies, a sculpture of Churchill and Roosevelt which is a popular photo opportunity. The street has featured in novels by Jane Austen and Virginia Woolf.

W1S 1SP
Tube: Bond Street
Map M11 | D6

Sotheby's is an auctioneer of fine and decorative arts, books and jewellery founded in 1744. Sotheby's has been entrusted with the sale of many of the world's treasures, amongst them: Napoleon's St Helena library, the Duchess of Windsor's jewels, the estate of Jacqueline Kennedy Onassis, Rembrandt's *Aristotle Contemplating the Bust of Homer*, Rubens' *Massacre of the Innocents*, Picasso's *Garçon à la Pipe*, Bacon's *Triptych, 1976*, The Grand Ducal Collections of Baden, the Qianlong Yellow-Ground Famille-Rose Double-Gourd Vase, the 5,000-year-old Guennol Lioness, Giacometti's *L'Homme Qui Marche I*, the Magna Carta, the first printing of the Declaration of Independence and the Martin Luther King Jr collection. Sotheby's conduct 250 auctions each year across four main salerooms in London, New York, Paris and Hong Kong. Lots can range from a few hundred pounds to $140m paid for a Jackson Pollock painting in 2006.

34-35 New Bond Street
W1A 2AA
Tube: Bond Street
+44 (0)20 7293 5000
sothebys.com
Map M11 | D5

Pollen Street Social is the flagship restaurant of British Chef Jason Atherton, whose global restaurant group stretches from New York to Sydney via Shanghai and Hong Kong. It was awarded one Michelin star in 2011 and is one of several Atherton restaurants in London. Dishes include Slow cooked Burford Brown egg, turnip puree, parmesan, sage and kombu crumb, chicken gravy; Raw Orkney sea scallop, pickled kohlrabi, nashi pear, black olive, sea herbs and dill; Salad of Goosnargh duck, woodland mushrooms, hazelnuts and truffle dressing; Cornish lamb loin, braised neck, roasted artichoke, merguez sausage, curds and whey; Cumbrian suckling pig, roasted apple, cabbage, granola clusters; and whole roasted duck for two, braised celery and New Forest mushrooms, served with a salad of duck leg in Moroccan spices.

8-10 Pollen Street
W1S 1NQ
Tube: Oxford Circus
+44 (0)20 7290 7600
pollenstreetsocial.com
Map M11 | D5

CENTRAL

Soho

Soho is the epicentre of London's entertainment scene. A lively and liberal area, the streets are filled with bars, restaurants, cafes, nightclubs, theatres, cinemas and Chinatown is also located here. Soho is famous as London's seedy red light district and elements of its illustrious past remain. Soho is also the centre of London's gay community. Creative, colourful, buzzing and open 24hrs, Soho is an unstoppable mass of energy in the city's centre.

230
Hamley's

Shopping

Established in 1760, Hamley's is the oldest and the largest toyshop in the world, stocking more than 50,000 toys. It was named after William Hamley, who founded a toyshop in London in 1760 called *Noah's Ark*. The shop moved to Regent Street in 1881. Hamley's sells all sorts of toys and games and is famous for its selection of soft toys, including Steiff teddy bears. Other products include books, models, dolls, Lego, action toys, puzzles, jigsaws and science kits. The store is a major tourist attraction welcoming around five million visitors each year.

188-196 Regent Street
W1B 5BT
Tube: Oxford Circus
+44 (0)371 704 1977
hamleys.com
Map M10 | B7

231
Carnaby Street

Culture

Carnaby street is a pedestrianised shopping area in Soho. Made famous in the 1960's as a destination for clothes shopping, the street became a focal point for London's social scene, attracting bands such as The Rolling Stones and The Who to work and play in the area. The street epitomised the vibe of 'The Swinging Sixties' and mods and hippies alike frequented the area to shop and hang out. The street's cultural impact is reflected in numerous popular musical references and it remains a shopping hub for independent fashion retailers.

W1F
Tube: Oxford Circus
Map M10 | B6

232
Liberty London

Shopping

Founded by Arthur Liberty in 1875, Liberty started life as a homeware and fashion bazaar, satisfying London's appetite for objects from Japan and The East. Liberty continues this tradition today, stocking the finest designer fashion and homeware from around the world. Liberty's stunning, mock-Tudor building was built in 1924 using the timbers of two ships: HMS Impregnable and HMS Hindustan. Inside the shop, carved oak staircases, fireplaces and an abundance of small rooms, give the shop a unique character and allow a natural separation of different products and themes. Liberty has extensive, modern collections of beauty, menswear, womenswear, homeware, accessories and stationary, as well as a well-stocked café on the top floor.

Regent Street
W1B 5AH
Tube: Oxford Circus
+44 (0)20 7734 1234
liberty.co.uk
Map M10 | A6

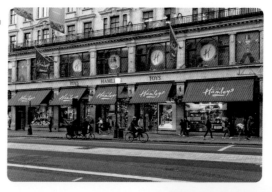

230

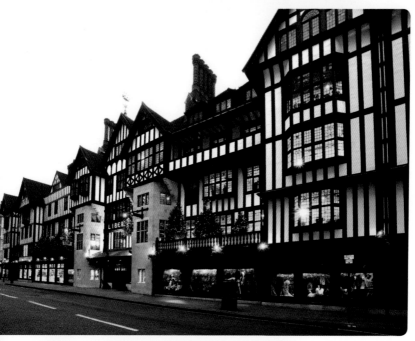

232

231

234

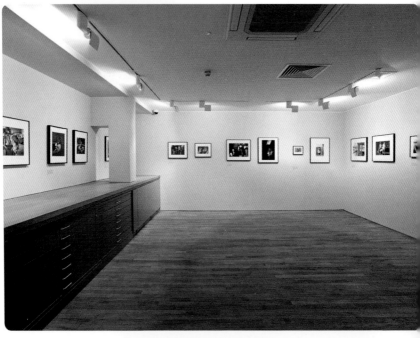

233

235

233
The Photographer's Gallery

Art & Design

234
Pizza Express Jazz Club

Entertainment

235
Milroy's of Soho

Shopping

The Photographer's Gallery is the largest public gallery in London dedicated to photography. The gallery was opened in 1971 with the objective of providing a proper home for photographers and their work, as well as establishing the medium as a serious art form. Over the last forty years, it has been responsible for bringing such key names in international photography as Robert Capa, Jacques-Henri Lartigue, Dorothea Lange, Sebastião Salgado, Andreas Gursky, Lee Miller, Juergen Teller, Boris Mikhailov, Joel Sternfeld and Taryn Simon to UK audiences, as well as championing the work of UK-based practitioners. The gallery holds exhibitions, workshops and courses as well as having a print sales gallery, online bookshop and café.

16-18 Ramillies Street
W1F 7LW
Tube: Oxford Circus
+44 (0)20 7087 9300
thephotographersgallery.org.uk
Map M10 | B6

The Pizza Express Jazz Club is located in the basement of a Pizza Express restaurant in Soho. The restaurant chain's founder, a fervent jazz fan, set up Pizza Express Live, which now organizes over 1000 live music events each year, at various venues, including this one. Past performers have included Gregory Porter, Amy Winehouse, Bill Wyman, Jamie Cullum, Brian May, Rick Wakeman, Van Morrison, Cybill Shepherd, Diana Krall, Benny Waters, Charlie Watts and Anita O'Day.

10 Dean Street
W1D 3RW
Tube: Tottenham Court Road
+44 (0)20 7437 9595
pizzaexpress.com
Map M10 | C6

Milroy's is London's oldest whisky shop and stocks over 250 whiskies from Scotland and around the world. John and Wallace Milroy founded the shop in 1964 and became famous whisky experts around the world, touring Japan and supplying the great and the good of London. They have scotch from Highlands, Lowlands, Speyside, Islands, Islay and Cambeltown; as well as a whole range of other whiskies from United States, Japan, Sweden, Australia and more. Milroy's offer whisky tasting and expert advice about which bottle to select. They also supply whisky to the Queen.

3 Greek Street
W1D 4NX
Tube: Tottenham Court Road
+44 (0)20 7734 2277
milroys.co.uk
Map M10 | D6

CENTRAL

CENTRAL

236
Barrafina
Food & Drink

237
Ronnie Scott's
Entertainment

238
Bar Italia
Food & Drink

This 2015 winner of National Restaurant of the Year is Spanish and tapas-style dishes include seafood tortillas, Iberian pork fillet, crab croquetas, herb crusted rabbit shoulder and Spanish desserts such as crema catalana. The wine list features an extensive choice of sherries. The restaurant has open kitchens to allow customers to see, hear and smell their food being prepared. Executive chef, Nieves Baragan Mohacho comes from the Basque Country and holds one Michelin Star. Barrafina has a no reservations policy, so eager customers queue outside along the street at peak times.

54 Frith Street
W1D 4SL
Tube: Tottenham Court Road
barrafina.co.uk
Map M10 | D6

Ronnie Scott's is a jazz club founded in 1959. The favoured venue for many jazz performers in London, many famous names have played here over the years including Chet Baker, Count Basie, Miles Davis, Ella Fitzgerald, Anita O'Day, Nina Simone, Curtis Mayfield, Dianne Reeves, Stacey Kent, Katie Melua, Jamie Cullum, Bobby Broom, Wynton Marsalis, Madeleine Peyroux, Prince, Chick Corea and Cassandra Wilson. The club is full to bursting for almost every performance and booking well in advance is usually required. The club also has an upstairs cocktail bar (Upstairs at Ronnie Scott's) that stays open late and plays various live and pre-recorded music.

47 Frith Street
W1D 4HT
Tube: Leicester Square
+44 (0)20 7439 0747
ronniescotts.co.uk
Map M10 | D6

Opening in 1949, Bar Italia has been run by three generations of the same family. A landmark of central Soho, people come here for the excellent coffee and friendly disposition of the staff. Its loyal customers are diverse in their backgrounds, fashions and tastes, which makes for an interesting and lively mix. The café stays open until 5am and serves freshly made pizzas late into the night.

22 Frith Street
W1D 4RF
Tube: Leicester Square
+44 (0)20 7437 4520
baritaliasoho.co.uk
Map M10 | D6

237

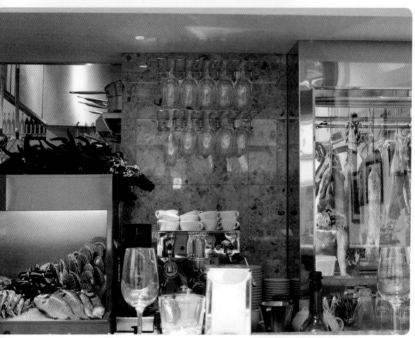

236

238

239

240

241

239
Andrew Edmunds

Food & Drink

240
Bao

Food & Drink

241
Yauatcha

Food & Drink

Located in an 18th century townhouse in Soho, Andrew Edmunds is an informal restaurant featuring wooden bench seating and candles on the tables. The space is intimate and atmospheric, especially with the lighting in the evening. The menu features seasonal dishes such as artichoke, ricotta and spinach tartlet; confit pork temples, shaved fennel and burnt apple; whole lemon sole, puntarelle and anchovy; and Swaledale pork neck fillet, braised carrots, creamed parsley and buckwheat. The restaurant is a favourite with people who live and work in the area and offers a good value wine list.

Located in an evolving part of Soho between Carnaby Street #231 and the West End, Bao creates steamed, filled buns and assorted Taiwanese side dishes. The restaurant space is small and modern with tables and counter seats. 'Baos' are freshly steamed and filled with various marinated and slow-cooked meats such as fried chicken with a Sichuan mayonnaise; and slow-braised pork belly with pickles and coriander. Bao also offer various pickles, peanut milk, pig blood cake (black pudding) with egg yolk on top and an extensive tea list. The format is small plates and the service is fast. Expect to queue for a while at peak meal times.

Yauatcha is the creation of Alan Yau, a Hong-Kong born restaurateur and founder of the Wagamama food chain. He also created Busaba Eathai and Hakkasan and has several other restaurants spanning the globe. Yauatcha is a Chinese restaurant with a particular focus on dim sum. The restaurant has one Michelin star, awarded in 2005. Dishes on offer include: scallop shui mai; har gau; char siu bun; Lobster dumpling with tobiko caviar with ginger and shallot; spinach ball with prawn and cuttlefish in black bean sauce; and spicy pork Szechuan wonton with peanut. Next door is another Yau creation, *Duck and Rice*, a contemporary design 'pub' serving beers on tap, Asian snacks and Chinese dishes in the restaurant upstairs.

16 Lexington Street
W1F 0LP
Tube: Piccadilly Circus
+44 (0)20 7437 5708
andrewedmunds.com
Map M10 | B6

53 Lexington Street
W1F 9AS
Tube: Oxford Circus
baolondon.com
Map M10 | B6

15-17 Broadwick Street
W1F 0DL
Tube: Oxford Circus
+44 (0)20 7494 8888
yauatcha.com
Map M10 | C6

CENTRAL

242
Milk and Honey

Food & Drink

243
Nordic Bakery

Food & Drink

244
Bocca Di Luppo

Food & Drink

Founded in 2002, Milk and Honey is a member's cocktail bar in Soho. Access to non-members is by reservation only and only until 11pm. The entrance to the bar is a challenge to find in itself, tucked away on a small street. Milk and Honey are serious about cocktails and the drinks list includes champagne cocktails, cobblers, fizzes, fixes, shorts, sours, pick-me-ups, restoratives and digestives, as well as wines and beers. Example cocktails include New Orleans Cobbler: rye, orange, pineapple, lemon, bitters, pastis; Continental Sour: cognac, claret, lemon, sugar, egg white; and Coffee Cocktail: cognac, port, egg, nutmeg.

61 Poland Street
W1F 7NU
Tube: Oxford Circus
+44 (0)20 7065 6800
mlkhny.com
Map M10 | B6

Nordic Bakery is a Scandinavian café offering a selection of open rye bread sandwiches, hearty cinnamon buns and cakes and delicious coffee. The café design is focused on simplicity, with wood panelling, tables, chairs and little else to distract. Sandwiches include liver pate with pickled beetroot; heavy-smoked salmon with dill and black pepper on dark rye bread; meatballs and lingonberry jam on dark rye; and peeled Greenland prawns, sliced boiled eggs and mayonnaise on dark rye bread. As well as the delicious, heavy Finnish-style cinnamon buns, the bakery also offer date cake, traditional double cream and chocolate marbled cake and Norwegian custard buns.

14A Golden Square
W1F 9JG
Tube: Piccadilly Circus
+44 (0)20 3230 1077
nordicbakery.com
Map M10 | B7

Bocca di Lupo offers simple, regional Italian cuisine making their own gelati, breads, sausages, salame, pickles, mostarda and pasta. Dishes are intended for sharing and come in small or large sizes. Dishes also indicate which region of Italy they are from so that you can order a variety of cuisines or focus on one particular region. Example dishes include roast suckling pig with chestnuts from Emilia, caponata from Sicilia and tortellini stuffed with pork and prosciutto from Bologna.

12 Archer Street
W1D 7BB
Tube: Piccadilly Circus
+44 (0)20 7734 2223
boccadilupo.com
Map M10 | C7

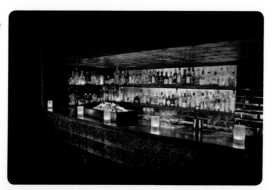

243

244

"In 2013, over 14.5m people attended performances generating ticket sales of over £500m."

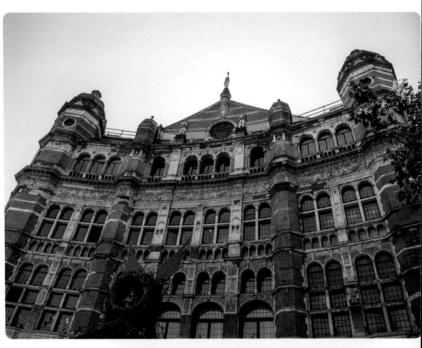

245

246

Leicester Square

Located to the south of Soho, Leicester Square was formerly a high-end residential area and home to the Prince of Wales, William Hogarth and Joshua Reynolds. Today, it is an area of entertainment and includes the Odeon Cinema; where the UK's major movie premieres take place; Shaftesbury Avenue; the main focus of London's theatreland; the Empire Cinema, the Hippodrome, hotels, shopping arcades and casinos. This central London area fizzes with artistic and cultural activities and borders St James's to the south and Covent Garden to the east.

245
Theatreland

Entertainment

Theatreland is the term used for around 40 venues in the West End that put on musicals, plays and comedic performances. London has a long theatrical history with venues such as Sadler's Wells Theatre #099 and Theatre Royal Drury Lane #171 having been founded in the 17th century. The Palace Theatre (pictured) was built in 1891 and is one of the West End's great theatres, seating around 1400 people. In 2013, over 14.5m people attended performances generating ticket sales of over £500m. Theatreland proper is centered in Leicester Square and Shaftesbury Avenue.

W1
Tube: Leicester Square
Map M10 | C7

246
Experimental Cocktail Club

Food & Drink

The Experimental Cocktail Club have bars in Paris, New York and London. This one is located in Chinatown #247 behind an unmarked door. ECC are building a strong reputation for world-class cocktails. They also serve cheeseboards and charcuterie plates, but people come for the drinks. Its advisable to reserve a table, but they also hold tables for walk-ins. There is a cover charge after 11pm.

13A Gerrard Street
W1D 5PS
Tube: Piccadilly Circus
chinatownecc.com
Map M10 | D7

CENTRAL

247
Chinatown

Culture

248
Piccadilly Circus

Entertainment

249
Dover Street Market

Shopping

London's Chinatown occupies a small area adjacent to Soho off Shaftesbury Avenue, and is primarily known for restaurants serving Chinese and other Asian cuisines. Chinatown is also the focal point for Chinese cultural activities in London and Chinese New Year celebrations. In the past, the Chinese community was centred in Limehouse in the east, due to its proximity to trade and shipping, before many communities moved in to Soho in the 1970s. The London Chinatown Community Centre is based here and as well as lots of commercial activity, there is also a residential complex at one end. Chinese food in Britain is heavily influenced by Cantonese cuisine and dim sum, but Chinatown offers a range of cuisines such as Sichuanese, Vietnamese, Taiwanese, Dongbei (north-east China) and Mongolian hotpot to name a few.

Gerrard Street
W1D 5PS
Tube: Leicester Square
chinatownlondon.org
Map M10 | D7

Constructed in 1819, Piccadilly Circus lies at the heart of London's Theatreland #245 and connects Regent Street, Shaftesbury Avenue, Piccadilly and Haymarket. The circus is world-famous for its illuminated advertising hoardings and is compared with New York's Times Square as a result. The first advertisements went up in 1908. Being at the centre of London's entertainment area means that the area attracts many visitors. Leicester Square sits at the eastern end of Piccadilly Circus and Soho also connects on the north-eastern edge.

W1D 7ET
Tube: Piccadilly Circus
Map M10 | C8

Dover Street Market is a multi-brand fashion retail store created by the founder of Japanese fashion label Comme des Garcons. Located in Dover Street in Mayfair since 2004, the shop relocated to a brand-new, five-storey building on Haymarket in 2016. The building was commissioned by Thomas Burberry, of the famous British fashion label, in 1912. The shop features almost sixty luxury fashion brands in one space and is one of only three 'markets' worldwide.

18-22 Haymarket
SW1Y 4DG
Tube: Piccadilly Circus
+44 (0)20 7518 0680
london.doverstreetmarket.com
Map M10 | C8

248

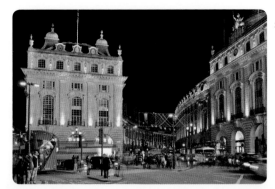

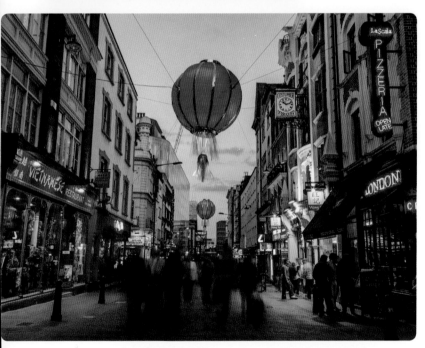

247

249

250

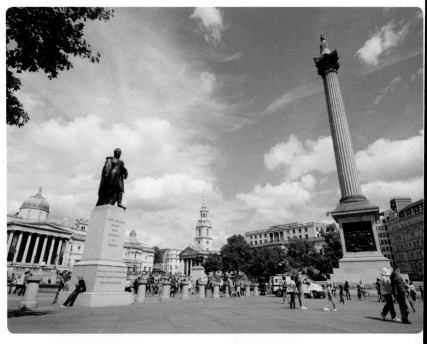

252

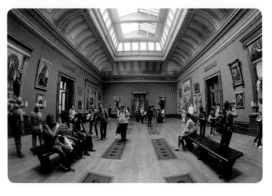

251

St James's

St James's is an upmarket area between Mayfair and The Mall containing gentlemen's clubs, luxury shops, artistic institutions, luxury hotels and residential property. Some of the city's oldest purveyors of goods are established here including wine merchants, tea merchants, shirtmakers, hatmakers and barbers. The area contains St James's Palace, a former home of the sovereign and the grand architecture nearby reflects the wealth and status of those who commissioned it in past centuries. Many of the grand private houses are now gone but a handful remain, such as Spencer House.

250
National Portrait Gallery

Art & Design

CENTRAL

Sitting adjacent to the National Gallery #251, the National Portrait Gallery was set up to house portraits of historically important British people and the selection of artworks has always been based on the status of the sitter, rather than the artist. The collection includes paintings, sculptures and the first work given to it upon opening in 1856, a painting of William Shakespeare from the early 17th century known as *The Chandos Portrait*. The gallery also organizes temporary exhibitions that have included contemporary photographic portraits by Mario Testino.

St. Martin's Place
WC2H 0HE
Tube: Leicester Square
+44 (0)20 7306 0055
npg.org.uk
Map M10 | D8

251
National Gallery

Art & Design

The National Gallery houses more than 2,300 paintings by artists such as Canaletto, Vermeer, Velazquez, Rubens, Cezanne, Turner, Leonardo da Vinci and many more. The collection also includes Van Gogh's *Sunflowers*. Unlike in other countries, where Royal art collections were nationalised, the National Gallery collection was started by the government in 1824 through the purchase of a small number of paintings. The British Royal Collection still exists independently, belonging to the sovereign and some of it is housed in the Queen's Gallery, Buckingham Palace #274.

Trafalgar Square
WC2N 5DN
Tube: Charing Cross
+44 (0)20 7747 2885
nationalgallery.org.uk
Map M10 | D8

252
Trafalgar Square

Leisure & Nature

Trafalgar Square is a major landmark designed as part of John Nash's grand plan for central London opening in 1844. The square contains Nelson's Column, a 51.6m high monument topped by a statue of Admiral Horatio Nelson, a British naval commander who died at the Battle of Trafalgar. The monument is protected by four bronze lions at the base and there are four reliefs depicting different battle scenes. There are four plinths around the square. Three hold statues of historical figures and the famous fourth plinth features a series of modern art pieces. St-Martin-in-the-Fields #161 and The National Gallery #251 are on the square and Admiralty Arch #253 is nearby.

WC2N 5DN
Tube: Charing Cross
+44 (0)20 7983 4750
london.gov.uk
Map M10 | D8

253
Admiralty Arch
History

254
The Mall
History

255
Institute of Contemporary Arts
Art & Design

Completed in 1912, Admiralty Arch was commissioned by King Edward VII in memory of his mother Queen Victoria. The arch connects Trafalgar Square #252 with The Mall #254 and ultimately Buckingham Palace #274. An example of grand Edwardian architecture, the building was used as government offices, but has now received planning approval to be turned into a hotel complex. Due to its location, the arch sees frequent use during ceremonial processions between the palace, Whitehall #279 and Westminster Abbey #281.

The Mall
SW1A 2WH
Tube: Charing Cross
Map M13 | F1

The Mall runs from Admiralty Arch #253 to the Queen Victoria Memorial in front of Buckingham Palace #274. The Mall is a broad avenue, lined with trees and has St James's Park #275 on one side and Carlton House Terrace #256, Clarence House (London home of the Prince of Wales) and other historic houses on the other side. It was designed to be part of a ceremonial route for use during special occasions such as the state opening of parliament and state visits. On such occasions, the Queen travels on The Mall in the state landau, a horse-drawn carriage. When the Duke and Duchess of Cambridge got married, as many as one million people packed The Mall, eager for a glimpse of the royal couple and the royal family, who came out onto the balcony of Buckingham Palace #274.

SW1A
Tube: Green Park
Map M13 | F2

Founded in 1947, the ICA was intended to be a place where artists could debate outside of the confines of the Royal Academy of Arts #224. The institute focuses primarily on experimental visual art, performance and film, and contains galleries, a theatre, two cinemas and a café. The ICA is located on The Mall #254. Contributors to exhibitions at the ICA have included Yoko Ono, Damien Hirst and Steve McQueen. The institute runs a full calendar of exhibitions and events.

The Mall
SW1Y 5AH
Tube: Charing Cross
+44 (0)20 7930 3647
ica.org.uk
Map M13 | F2

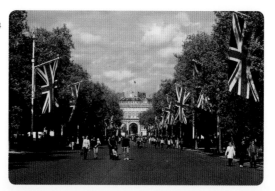

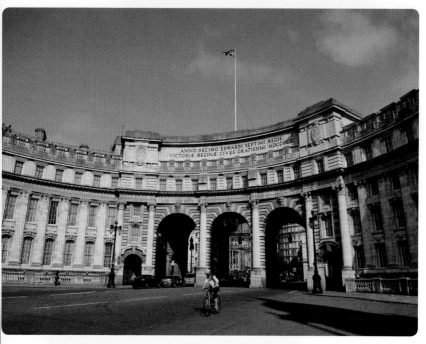

253

255

257

256

258

256
Carlton House Terrace

Architecture

257
Clubland

Culture

258
Jermyn Street

Shopping

Carlton House stood on the site formerly and was home to the Prince of Wales when the sovereign lived in St James's Palace. The House was taken down to redevelop the site in 1829 and many pieces of art and furniture were removed to various royal palaces including Buckingham Palace #274. Designed by renowned architect John Nash, Carlton House Terrace was the replacement and formed part of a design of five terraces around St James's Park #275, only two of which were built. Home to several prime ministers, ambassadors and embassies over the years, today the houses mostly belong to businesses, institutes and societies. The terraces are dissected by the Duke of York steps and the area has many sculptures and monuments of interest.

Carlton House Terrace
SW1Y 5AH
Tube: Charing Cross
Map M13 | F2

Centred around the area of St James's, clubland is a collective term for the gentlemen's clubs organised for English high society. Traditionally, these clubs welcomed a mix of royals, aristocracy, military officers, politicians and the wealthy. Typically, a club offers food and drinks, recreation such as squash and fencing, and often rooms to stay over night. Clubs cater exclusively to members and their guests, and joining normally requires referral by existing members. London's clubs are usually housed in large, grand buildings and historically, the clubs that you were a member of were an indication of your power and status in society.

St. James's
SW1A 1EA
Tube: St. James's Park
Map M13 | E2

Jermyn Street is most famous for its shirtmakers, but many other fashion and luxury goods shops also occupy the street. Shoes, cheeses, barbers, cigar shops and upscale nightclubs can be found here. It is also the location of Fortnum and Mason #261 and Floris #259. Located within St James's, the street supplies wealthy residents with essentials and high-flying city workers with shirts, ties and shoes. A pair of hand-made shoes makes for a special souvenir of the city for the gentlemen who can afford the £2,000 price tag.

SW1Y 6JH
Tube: St. James's Park
Map M13 | D1

CENTRAL

CENTRAL

259
Piccadilly Market

Shopping

260
Floris

Shopping

261
Fortnum and Mason

Shopping

Piccadilly Market takes place from Monday to Saturday in the grounds of St James's Church Piccadilly, an important building by Sir Christopher Wren completed in 1684. The market comprises stalls selling various curios including arts, crafts, books, antiques and food. The market attracts locals and city visitors and along with the church, hosts musical performances. It gets particularly busy at weekends.

197 Piccadilly
W1J 9LL
Tube: Piccadilly Circus
+44 (0)20 7734 4511
piccadilly-market.co.uk
Map M13 | D1

Founded in 1730, Floris is an English perfumer, which has been located at 89 Jermyn Street since the 18th century. The company started off making combs before moving to scents, and Florence Nightingale was a customer. Their No.89 fragrance was famously the aftershave of choice of James Bond. Other notable customers have included Mary Shelley, Beau Brummell, Diana, Princess of Wales, Winston Churchill and Marilyn Monroe. The shop also provides fragrances and other products to the Queen and the Prince of Wales. The shop is a museum in itself, containing historical royal warrants and a mahogany counter that was purchased from the Great Exhibition in 1851.

89 Jermyn Street
SW1Y 6JH
Tube: Piccadilly Circus
+44 (0)330 134 0180
florislondon.com
Map M13 | D1

Established in 1707, Fortnum and Mason is located at 181 Piccadilly. Created as an upmarket purveyor of fine foods and especially teas, it also offers luxury fashions, teaware, homewares and jewellery. The store offers afternoon tea at the Diamond Jubilee Tea Salon that was opened by the Queen and has a dedicated ice cream parlour. Fortnum and Mason also specialize in food hampers, offering F&M branded wicker picnic hampers filled with tea, biscuits, jams and chutneys. Popular with visitors seeking souvenirs, the store also has an ornate clock on its exterior, on which, every hour, Mr Fortnum and Mr Mason come out, face each other and bow.

181 Piccadilly
W1A 1ER
Tube: Piccadilly Circus
+44 (0)20 7734 8040
fortnumandmason.com
Map M13 | D1

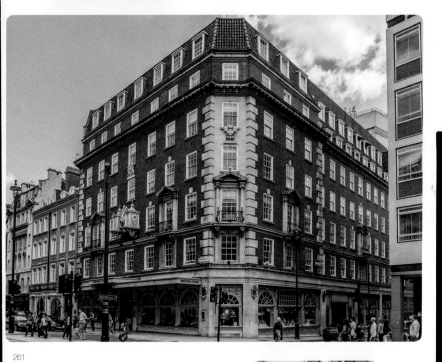

261

260

262

264

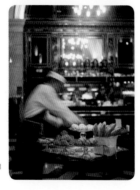

263

262
Wilton's
Food & Drink

263
The Wolseley
Food & Drink

264
Tea at The Ritz
Food & Drink

Wilton's is an English restaurant that started life as a shell-fish-mongers in 1742. Their specialities are seafood and game. Dishes include: twice baked Cropwell Bishop stilton soufflé; cured Chalk Stream trout, caviar, avocado and nasturtium; Dover sole, grilled or meunière; mixed grill - beef fillet, lamb cutlet, lamb kidney, black pudding, bacon and sausage; and Yorkshire rhubarb soufflé with ginger ice cream. They also offer a carving trolley with a different meat daily, including: Roast leg of Romney Marsh lamb; Rack of free range Blythburgh pork, crackling and apple sauce; and Fillet of beef Wellington.

55 Jermyn Street
SW1Y 6LX
Tube: Green Park
+44 (0)20 7629 9955
wiltons.co.uk
Map M13 | D1

The Wolseley is a grand restaurant on Piccadilly serving breakfast, lunch, afternoon tea and dinner. Breakfast options include 'The English' - a choice of fried, poached or scrambled eggs with bacon, sausage, baked beans, tomato, black pudding and mushroom; prunes with lemon and elderflower; and French toast or pancakes with bacon. Sample lunch and dinner items include: minted pea soup; sauteed duck livers with brioche and marsala cream; lemon sole St.Germain; and calf's liver and bacon with sauce Robert. The Wolseley serves food until midnight.

160 Piccadilly
W1J 9EB
Tube: Green Park
+44 (0)20 7499 6996
thewolseley.com
Map M13 | C1

The Ritz opened in 1906 and became a symbol of high society and luxury, counting Charlie Chaplin, Winston Churchill, Charles De Gaulle, President Eisenhower, Noel Coward and the Aga Khan as patrons. The architecture and decoration is Louis XVI in style and the hotel contains grand rooms and chandeliers, giving it the feeling of a palace. The hotel overlooks Green Park #271 and the afternoon tea is an institution. Served in the Palm Court, the silver teapots, cake stands and chinaware add to the sense of tradition and occasion. The afternoon tea offers 18 types of tea, sandwiches, scones, cakes and pastries. Gentlemen must wear a jacket and tie.

150 Piccadilly
W1J 9BR
Tube: Green Park
+44 (0)20 7493 8181
theritzlondon.com/palm-court
Map M13 | C1

CENTRAL

CENTRAL

265
Pickering Place
History

266
Lock and Co.
Shopping

267
Truefitt and Hill
Leisure & Nature

Pickering Place is a small courtyard tucked away at the end of an alley in St James's. It is the location of the former embassy of the Republic of Texas before they joined the United States in 1845. The square sits behind the wine merchants, Berry Bros and Rudd and contains beautiful, original Georgian architecture. It was also the sight of gambling dens, prostitution and duels in the 18th century and it is claimed that it was the location of London's last duel.

St. James's
SW1A 1EA
Tube: Green Park
Map M13 | D2

Established in 1765 at the current address, 6 St James's Street, Lock and Co. is the oldest hat shop in the world. Former prominent patrons include Lord Grenville, prime minister between 1806-1807; The Duke of Bedford, Beau Brummell, Admiral Lord Nelson, Oscar Wilde, Winston Churchill, Douglas Fairbanks Junior, Charlie Chaplin and Jacqueline Kennedy. Lock currently supplies hats to the Duke of Edinburgh and the Prince of Wales. Over the course of three hundred years in business, hats have evolved significantly. Lock now create many styles including fedoras, homburgs, pork pies, panamas, top hats, coke hats, trilbies and flat caps.

6 St. James's Street
SW1A 1EF
Tube: Green Park
+44 (0)20 7930 8874
lockhatters.co.uk
Map M13 | D2

Truefitt and Hill is a gentleman's barbers established in 1805, making it the oldest barbers in the world. Their client list includes William Gladstone, the Duke of Wellington, Sir Winston Churchill, Charles Dickens, William M Thackeray, Lord Byron, Oscar Wilde, Beau Brummell, Alfred Hitchcock, Laurence Olivier, Danny Kaye, John Wayne, Frank Sinatra, Stewart Granger, Fred Astaire and Cary Grant. They also cut the hair of the Duke of Edinburgh. Various services are on offer including haircuts, wet shaves, head massages and facials. They also carry their own ranges of scents and grooming products.

71 St. James's Street
SW1A 1PH
Tube: Green Park
+44 (0)20 7493 8496
truefittandhill.co.uk
Map M13 | D2

265

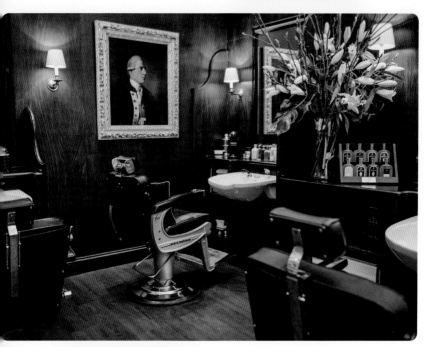

267

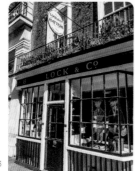

266

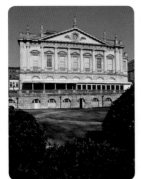

269

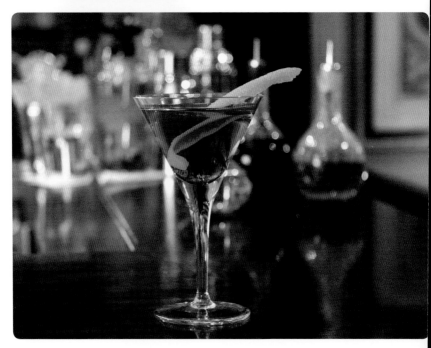

268

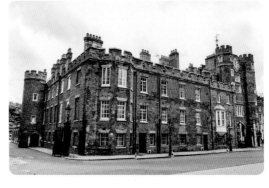

270

268
Duke's Bar

Food & Drink

269
Spencer House

Architecture

270
St James's Palace

History

Frequented by Ian Fleming, Dukes Bar is said to be the inspiration for his famous line, 'shaken, not stirred'. The martinis here are world-famous and Dukes recently created a new drink in cooperation with Floris #259, called the Fleming 89. The bar also serves a white truffle martini, which takes 3 weeks to prepare. Dukes is the perfect place for an aperitif with a story. The dress code is smart.

Dukes Hotel
35 St. James's Place
SW1A 1NY
Tube: Green Park
+44 (0)20 7491 4840
dukeshotel.com
Map M13 | D2

Located in St James's and overlooking Green Park, Spencer House was built as the London home of Earl Spencer in the 18th Century. Such grand, private houses were common amongst the aristocracy and designed to sustain and elevate the owner's social status. The current Earl Spencer, brother of Diana, Princess of Wales, let Spencer House to Lord Rothschild, who restored the interiors to their original appearance making Spencer House one of the greatest of the remaining 18th Century houses in London. Visitors can join tours of the house on Sundays and the Neoclassical facade will be of particular interest to architecture fans.

27 St. James's Place
SW1A 1NR
Tube: Green Park
+44 (0)20 7514 1958
spencerhouse.co.uk
Map M13 | C2

St James's Palace is the official residence of the sovereign, although in practice, the Queen resides at Buckingham Palace #274. Built by Henry VIII in the 16th century, ambassadors and high commissioners to the United Kingdom are still accredited to the court of St James's. The palace is the former home of the Prince of Wales and the current home of the Princess Royal and several other members of the Royal Family. The palace is notable for its Tudor design, especially its red brick gatehouse and clock. Although not open to the public, the palace is nevertheless a popular visitor attraction for its history and architecture.

Marlborough Road
SW1A 1BS
Tube: Green Park
+44 (0)20 7930 4832
royal.gov.uk
Map M13 | D2

CENTRAL

271
Green Park
Leisure & Nature

272
Apsley House
History

273
Wellington Arch
Architecture

Green Park is a comparatively small royal park adjacent to Buckingham Palace #274 and Piccadilly. The park is one of the locations used for royal gun salutes, where a number of rounds are fired to mark special occasions, such as the Queen's birthday. The park contains various memorials and ornate gates that remember those who served with the British in the two world wars. The park is a popular location for picnics and sunbathing and in spring, around 250,000 daffodils turn the landscape brilliant yellow. The park is overlooked by the Ritz Hotel and Spencer House #269.

SW1A 2BJ
Tube: Green Park
+44 (0)300 061 2350
royalparks.org.uk
Map M13 | C3

Once known as Number One London, Apsley House is the former London home of the 1st Duke of Wellington, who defeated Napoleon at Waterloo. The Duke filled the house's grand spaces with paintings, sculptures, silver and porcelain, many of which were gifts from grateful European rulers. More than 3,000 items are on display at the house, which remains a residence of the Dukes of Wellington but is open to the public on weekends.

W1B 1PE
Tube: Hyde Park Corner
Map M13 | A3

Wellington Arch is a grand, triumphal arch first built in 1825-27 to commemorate Wellington's victory at the Battle of Waterloo in 1815. The arch is Neoclassical and was designed by Decimus Burton (a protégé of John Nash), a well-known architect who designed the Royal Botanic Gardens, Kew #357 and London Zoo #023. The arch is topped by a bronze Quadriga (four-horse chariot) containing Nike, the Winged Goddess of Victory. It is open to the public and from the top you can see the Houses of Parliament #282 and the gardens of Buckingham Palace #274. The arch also contains exhibition galleries and a shop.

W1J 7JZ
Tube: Hyde Park Corner
Map M13 | A3

"The arch is topped by a bronze Quadriga (four-horse chariot) containing Nike, the Winged Goddess of Victory."

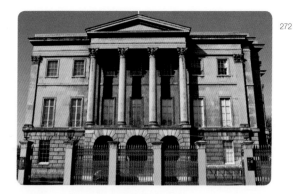

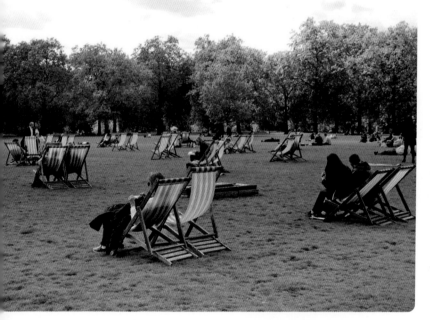

271

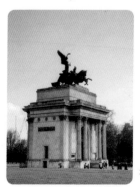

273

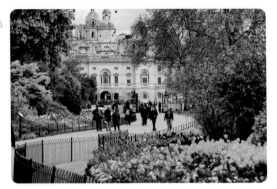

275

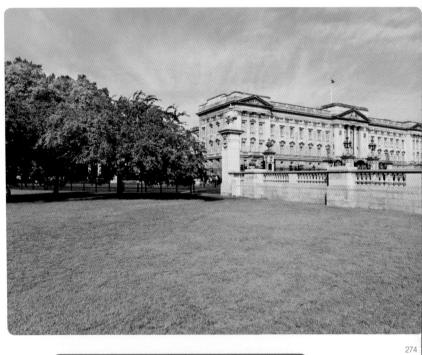

274

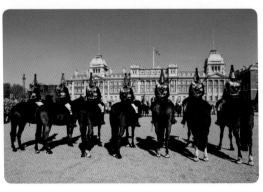

276

Westminster

Westminster is the home of the British Government and location of the former Palace of Whitehall, the home of the monarch in the 16th century. The Palace of Westminster includes the House of Commons, the House of Lords and Westminster Hall, erected in 1097. The main road through the area, Whitehall, is the location of the residence of the prime minister, 10 Downing Street, and various government ministries. As well as the heart of British politics, Westminster is also a major tourist attraction for its architecture and history.

274
Buckingham Palace

History

The Palace has 775 rooms and the largest private garden in London. It was built as a private house for the Duke of Buckingham in 1703 and was known as Buckingham House. In 1837, it became the home of the British monarch when Queen Victoria moved in. Marble Arch #298 used to stand at the front of the palace and was used for ceremonial purposes, but was moved to make way for the new east wing, the facade facing The Mall #254 that we see today. The Palace was updated by John Nash (see Carlton House Terrace #256) and contains the State Rooms, the Royal Mews and the Queen's Gallery. This is the main site of the Royal Collection, the art collection of the Royal Family and one of the most important art collections in the world. The State Rooms are only open during the summer months.

SW1W 0QH
Tube: Victoria
+44 (0)303 123 7302
Map M13 | C4

275
St James's Park

Leisure & Nature

St James's Park is the oldest of the eight Royal parks in London. It is surrounded by the Houses of Parliament #282, Buckingham Palace #274 and St James's Palace #270 and Green Park #271 is nearby across The Mall #254. Henry VIII acquired the land for a deer park in 1532. Charles II redesigned the park, laying out lawns, flowerbeds, shrubberies and trees, and opened the park to the public. Birds and other wildlife were introduced to the park and today the park has pelicans, tits, great spotted woodpeckers, tawny owls and wrens, as well as ducks and squirrels. There are several royal monuments in the area including statues of King George VI and the Queen Mother.

SW1A 2BJ
Tube: St. James's Park
+44 (0)300 061 2350
royalparks.org.uk
Map M13 | E3

276
Household Cavalry Museum

Culture

Based in Horse Guard's, a grand building at the end of The Mall #254 dating from 1750, the Household Cavalry is also known as Her Majesty The Queen's Mounted Bodyguard. Visitors can see the working stables and the horses that are used to protect the Queen. The museum also includes objects from the Battle of Waterloo, in which the Household Cavalry saw action. Outside the building is Horse Guard's Parade, on which is held Trooping the Colour, a ceremony that marks the Queen's birthday each year.

Horse Guards
Whitehall
SW1A 2AX
Tube: Charing Cross
+44 (0)20 7930 3070
householdcavalrymuseum.co.uk
Map M13 | F2

CENTRAL

277
Banqueting House
Architecture

278
Corinthia Hotel
Art & Design

279
Whitehall
History

The Banqueting House is the only remaining building of the original Palace of Whitehall, commissioned by King Henry VIII and intended to be the grandest palace ever created. The architect was Inigo Jones, who based his designs on the ancient architecture of Rome and brought neoclassical architecture to England. In 1636, the ceiling was fitted with giant canvasses painted by Rubens, which helped the building to rise to the pinnacle of style and taste of the day. In 1649, following the English Civil War, King Charles I was executed on a scaffold outside the building. Of the original palace buildings, only the Banqueting House survived a fire in 1698. Today it is open to visitors for most of the year.

Whitehall
SW1A 2ER
Tube: Charing Cross
hrp.org.uk
Map M13 | G2

The Corinthia is a luxury hotel located close to the River Thames in the heart of Westminster. The grand building dates from 1885 and is adjacent to Victoria Embankment Gardens #157 and Trafalgar Square #252. The hotel has garnered critical praise and multiple awards for its design, carried out by the same company as The Booking Office Bar at St Pancras Renaissance Hotel #027. The modern interiors contrast with the Victorian façade of the building offering space and light. You can enjoy the interiors in one of the hotel's restaurants and bars.

Whitehall Place
SW1A 2BD
Tube: Embankment
+44 (0)20 7930 8181
corinthia.com
Map M13 | G2

Whitehall is the name of an area of central London that is the home of the government of the United Kingdom. The area contains number 10 Downing Street; the home of the prime minister; and several government departments and ministries. The name derives from the Palace of Whitehall (see Banqueting House #277), Henry VIII's grand home that stood on this site. The Houses of Parliament #282 are nearby and there are many national statues and monuments, including the cenotaph, Britain's foremost war memorial. The area is filled with historic architecture, the Foreign and Commonwealth Office building #280 being one of the highlights.

King Charles Street
SW1A 2AH
Tube: Westminster
+44 (0)20 7008 1500
Map M13 | G3

278

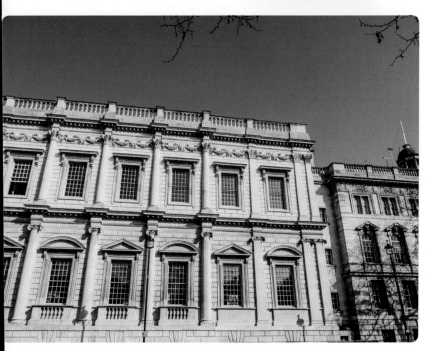

277

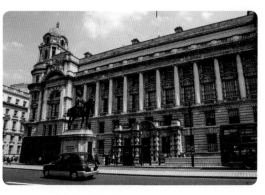

279

280

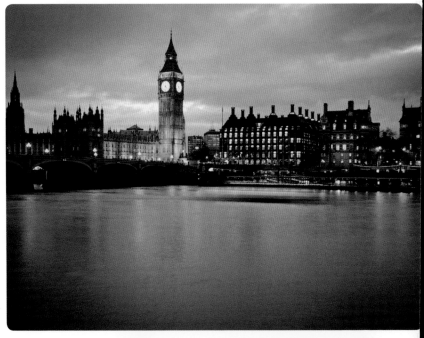

282

281

280
Foreign and Commonwealth Office
Architecture

281
Churchill War Rooms
History

282
Houses of Parliament
Architecture

The main building of the Foreign and Commonwealth Office was designed in the Italianate style by Sir George Gilbert Scott, who also designed the St Pancras Renaissance Hotel #027, the Albert Memorial #320 and the chapel of St John's College in Cambridge. Completed in 1868, the architecture and interior design were intended to impress visiting foreign dignitaries. Notable spaces include Durbar Court with its classical columns and elaborate marble floors designed by Matthew Digby Wyatt, winner of the Royal Institute of British Architects (RIBA) Gold Medal; the Locarno suite of three rooms and the grand reception room featuring a gilded, barrel-vaulted ceiling. The interiors are only open to the public during the 'Open House Weekend', which takes place in September.

King Charles Street
SW1A 2AH
Tube: Westminster
+44 (0)20 7008 1500
Map M13 | G3

Part of the Imperial War Museum, the War Rooms sit underneath the Treasury and the Foreign and Commonwealth Office #280 in Whitehall. They were used by Winston Churchill as the command centre for operations during the Second World War. The permanent exhibition contains the offices and the map room, which has been left as it was in 1945. The site is also home to the Churchill Museum, which contains objects, letters and extracts of famous speeches of the wartime leader.

Clive Steps
King Charles Street
SW1A 2AQ
Tube: Westminster
+44 (0)20 7930 6961
iwm.org.uk
Map M13 | F3

The Houses of Parliament, also known as the Palace of Westminster, comprise the House of Commons and the House of Lords. They are the seat of the British Government. It is at the House of Commons where laws of the United Kingdom are conceived, discussed, approved and ratified. On the site was once a royal palace where the English parliament held meetings. In 1512, the royal palace burnt down and the site was subsequently used to build the Palace of Westminster. The current building was constructed in the 19th century by Sir Charles Barry and incorporates Westminster Hall, which has existed since 1097 and is where President Obama made an address to both houses in 2011, a very rare occurrence. Perhaps the most famous element of the palace is the Elizabeth Tower, often mistakenly called Big Ben, the name of the largest of five bells inside the tower.

SW1A 0AA
Tube: Westminster
+44 (0)20 7219 3000
parliament.uk
Map M13 | G4

CENTRAL

CENTRAL

283
Westminster Abbey

History

284
Cinnamon Club

Food & Drink

285
Victoria Tower Gardens

Leisure & Nature

Westminster Abbey is a church in the gothic architectural style dating from the 11th century. The church is the main venue in the United Kingdom for royal weddings, coronations and burials. The marriage of Prince William and Catherine Middleton took place there, as well as the funeral of Diana, Princess of Wales and the coronations of Queen Elizabeth II; and William the Conqueror in 1066. King Edward's chair is inside the Abbey and it is the chair that has been used for coronations since 1308.

20 Deans Yard
SW1P 3PA
Tube: Westminster
+44 (0)20 7222 5152
westminster-abbey.org
Map M13 | G4

Located in the former Westminster Library, the Cinnamon Club serves high-end, modern and creative Indian cuisine. The chefs transform British-sourced ingredients, such as Gressingham duck, Herdwick Lamb and Scottish lobster, into curries, kebabs and tandoori dishes. The high quality of the food in combination with the grand, historic surroundings makes for an exciting culinary experience.

30-32 Great Smith Street
SW1P 3BU
Tube: St. James's Park
+44 (0)20 7222 2555
cinnamonclub.com
Map M13 | F5

Victoria Tower Gardens is a large green space sitting adjacent to the Houses of Parliament #282 and contains the sculpture, *The Burghers of Calais* by Auguste Rodin. The Burghers were a group of six citizens who, during the siege of Calais in 1347, offered their lives to King Edward III in exchange for sparing the lives of the rest of the town. In the end, all of the townspeople were spared. It is one of four casts of the original made by Rodin and he came to London to advise on where to place the sculpture. The gardens also contain a statue of Emmeline Pankhurst, the leader of the suffragettes who campaigned for women's right to vote. She is buried in Brompton Cemetery #313. The colourful, ornate Buxton Memorial commemorates the abolition of slavery. There is also a children's playground in the gardens.

SW1P 3JA
Tube: Westminster
+44 (0)300 061 2350
royalparks.org.uk
Map M13 | G5

283

285

286

288

287

"It is regarded as a masterpiece of English Baroque architecture and the grandest of 50 new London churches built as the result of an act of parliament in 1710."

CENTRAL

286
St John's
Smith Square

Culture

Sitting in a quiet square near Westminster Abbey #283, the Church of St John the Evangelist dates from 1728 and after being gutted during the Blitz, it was turned into a concert hall. It is regarded as a masterpiece of English Baroque architecture and the grandest of 50 new London churches built as the result of an act of parliament in 1710. St John's run a full calendar of events covering classical music, choral performances and opera. The crypt contains a restaurant and an exhibition of historical photographs of St John's.

W1P 3HA
Tube: St. James's Park
+44 (0)20 7222 1061
ss.org.uk
Map M13 | G6

287
Regency Café

Food & Drink

The Regency Café is a 'greasy spoon' serving English breakfasts, homemade steak pies and 'builder's tea'; a large cup of strong tea with lots of milk and sugar. The café opened in 1946 and is a well-known and much-loved café in the area. The café is notable for its distinctive external black tiling and stylised lettering. It has featured in many television and film scenes and the walls inside are decorated with pictures of London footballers. The cafe opens early for breakfast at 7am and closes in the afternoon before opening again between 4pm and 7.15pm.

17-19 Regency Street
SW1P 4BY
Tube: Pimlico
+44 (0)20 7821 6596
Map M13 | F6

288
Tate Britain

Art & Design

Tate Britain is one of the largest museums in the country and is focused on exhibiting art from the United Kingdom. The collection includes works by Rubens, Hogarth, Blake, Constable, Turner, Stubbs, Sickert, David Hockney, Francis Bacon and Henry Moore. It is considered to be the greatest collection of its kind in the world. Tate Britain is connected with Tate Modern #115 downriver by high-speed boat and visiting both museums with a boat trip in between is a popular activity for visitors and residents.

Millbank
SW1P 4RG
Tube: Pimlico
+44 (0)20 7887 8888
tate.org.uk
Map M13 | G8

Pimlico

Pimlico was developed as a residential area in the 19th century by famous planner Thomas Cubitt, who built Regency period stucco terraces and houses. The area's close proximity to Westminster attracted wealthy individuals. Today, its location attracts members of parliament. The area is a draw for its architecture, green squares and wide roads. There are many small restaurants and cafes and Tate Britain is located nearby.

289
Long and Ryle

Art & Design

Long and Ryle is a contemporary art gallery showcasing established British and International artists, as well as young and emerging talent. Located just behind Tate Britain #288 in Westminster, featured artworks include paintings, sculptures, charcoal drawings and wood engravings. Some of the gallery's featured artists also accept portrait commissions.

4 John Islip Street
SW1P 4PX
Tube: Pimlico
+44 (0)20 7834 1434
longandryle.com
Map M13 | F8

290
Grumbles

Food & Drink

Grumbles is a bistro in Pimlico that opened in 1964. When they opened, their rent was £12 a week and a fillet steak cost 45 pence. Their main objective was and is to offer good food at reasonable prices. They offer a la carte; pre-theatre, three-course set menus for £13.75; and Sunday roast three-course set menus for £14.95. The menu includes French and British inspired classics such as: steak tartare; avocado and prawns with Marie-Rose sauce; cod in beer batter with chips, minted peas and tartare sauce; and Moroccan lamb tagine with sweet potato, flaked almond and raita. Former clientele include The Beatles, The Mamas & The Papas and members of the Royal Family.

35 Churton Street
SW1V 2LT
Tube: Pimlico
+44 (0)20 7834 0149
grumblesrestaurant.co.uk
Map M13 | D8

291
Pimlico Fresh

Food & Drink

Pimlico Fresh is a small and stylish café serving homemade salads, soups, stews, smoothies, juices and coffee. The café is open for breakfast and popular items include homemade granola, bruschetta, chilli eggs and avocado salsa. Takeaway is a great option here, as indoor seating is limited and it is always in high demand. There is some outdoor pavement-side seating available. The café is located close to Victoria Station, which makes the street busy with commuters.

86-87 Wilton Road
SW1V 1DN
Tube: Victoria
+44 (0)20 7932 0030
Map M13 | C7

SOUTH-WEST

290

289

291

293

292

294

Belgravia

Belgravia is primarily a residential area and property here is amongst the most expensive in the world. Home to many embassies and institutions, the area contains well-manicured green spaces and an abundance of church architecture. Shops reflect the pursuits of the neighbourhood residents and are filled with art, antiques, rugs and sculpture. There are many high-quality restaurants and an organic delicatessen providing fresh meats and produce from farms outside London.

292
The Orange
Food & Drink

The Orange is a light and stylish pub and hotel offering all-day seasonal, modern European dining. Breakfast items include: Baked eggs, tomato and lentil ragout, strained yoghurt, garlic sourdough; and Buttermilk pancakes, apple and pomegranate compote, roasted almond, Chantilly cream. Lunch and Dinner offerings include: Ox tongue, black garlic, cornichons, Lincolnshire poacher croquettes; Wye Valley asparagus, sheep's curd, truffle and lemon; Slow cooked rabbit pie, baked mash and chervil buttered asparagus; and Norfolk Horn lamb rump, potato purée, new season onion and wild garlic. The Orange also offer wood-fired pizzas and Sunday Roasts.

37 Pimlico Road
W1W 8NE
Tube: Sloane Square
+44 (0)20 7881 9844
theorange.co.uk
Map M14 | D3

293
Hunan
Food & Drink

There is no menu at Hunan. Diners are simply required to mention anything they don't eat and how much spice they can take. Guests are then served with a procession of around 18 courses of tapas-size dishes. Although named Hunan, the food is mostly influenced by Taiwanese cuisine. The Hunan dishes that do feature include double-cooked pork, homemade wind dried meat, braised pork and spicy aubergine. The signature dish is a broth of minced pork, Chinese mushroom and ginger. Other dishes include crispy frogs' legs served with fermented bamboo shoots and chilli. The element of surprise is a key part of the dining experience. Lunch is £40.80; dinner is £60.80 per person.

51 Pimlico Road
SW1W 8NE
Tube: Sloane Square
+44 (0)20 7730 5712
hunanlondon.com
Map M14 | D3

294
Cadogan Hall
Art & Design

This former church is home to the Royal Philharmonic Orchestra, one of the most prestigious orchestras in the United Kingdom. Primarily a venue for classical music performances, Cadogan Hall also hosts contemporary jazz and folk musicians throughout the year. In total it puts on around 300 events annually. The building itself is particularly notable for its stained glass windows. The hall is situated in Chelsea, two minutes from Sloane Square tube station, making it easily accessible from the city centre for a night out.

5 Sloane Terrace
SW1X 9DQ
Tube: Sloane Square
+44 (0)20 7730 4500
cadoganhall.com
Map M14 | C2

SOUTH-WEST

Knightsbridge

Knightsbridge is a super-wealthy residential area and shopping destination. Apartments at No.1 Hyde Park are among the world's most expensive with the penthouse selling in 2014 for £140m. Harrods and Harvey Nichols are located here alongside the flagship stores of luxury fashion houses. Knightsbridge is bordered by Hyde Park, Belgravia and Kensington and counts many fine dining restaurants, casinos and luxury hotels within its boundaries.

SOUTH-WEST

295
Harrods

Shopping

Founded in 1834 by Charles Henry Harrod, this well-known department store has 330 departments, 12,000 staff and is the largest department store in Europe. Harrods sells almost everything, from horse saddles to four-poster beds. The store's Christmas lights and Boxing Day sales are particularly famous, and they have a well-stocked food and drinks department. Harrods caters to all, from locals who do their weekly food shop there, to visitors looking for a London souvenir.

87-135 Brompton Road
SW1X 7XL
Tube: Knightsbridge
+44 (0)20 7730 1234
harrods.com
Map M15 | E3

296
Harvey Nichols

Shopping

Opening in 1831, Harvey Nichols is a high-end department store focused on fashion, beauty and food. Known widely as 'Harvey Nics', the store was popularized by the BBC television comedy, Absolutely Fabulous. The store is filled with luxury fashion labels and the food hall includes teas, chocolates, wine and spirits. The fifth floor contains a restaurant, bar, café and outdoor terrace. Situated in fashionable Knightsbridge, the shop attracts monied locals and visitors.

109-125 Knightsbridge
SW1X 7RJ
Tube: Knightsbridge
+44 (0)20 7235 5000
harveynichols.com
Map M15 | E3

297
Dinner by Heston Blumenthal

Food & Drink

Heston Blumental is a three Michelin starred British chef. At 'Dinner', he seeks to chart the course of the main meal of the day in Britain. Influences include 14th century cookbooks, the food of King Henry VIII at Hampton Court Palace, and Lewis Carroll's *Alice in Wonderland*. The restaurant is located in the Mandarin Oriental, Hyde Park and features views over the park. The restaurant gained two Michelin stars in 2015. The 'Chef's Table' tasting menu features nine courses including: Earl Grey tea cured salmon (c.1730) - lemon salad, gentleman's relish, wood sorrel and Exmoor caviar; Meat Fruit (c.1500) - mandarin, chicken liver parfait and grilled bread; and Salamagundy (c.1720) - chicken oysters, salsify, marrowbone, horseradish cream and pickled walnuts.

66 Knightsbridge
SW1X 7LA
Tube: Knightsbridge
+44 (0)20 7201 3833
dinnerbyheston.co.uk
Map M15 | E3

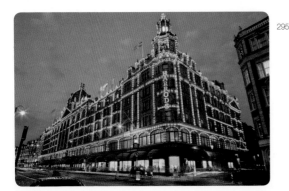

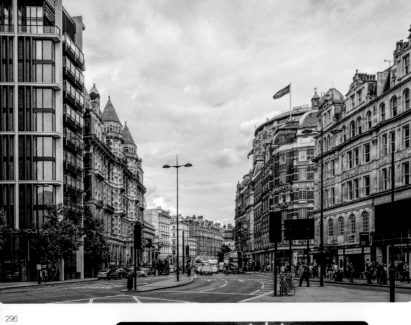

296

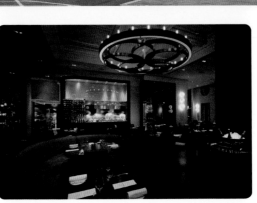

297

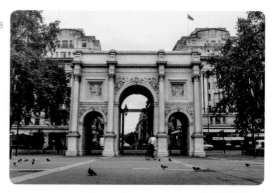

298

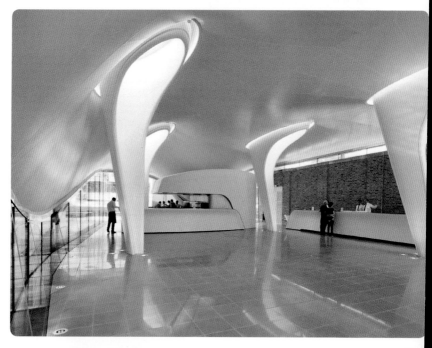

300

299

Hyde Park

Hyde Park is a royal park in central London. As with many green spaces in London, it was a deer park in the time of Henry VIII. The park opened to the public in 1637 and became a popular place to visit for leisure and recreation. Today, the park contains many features and activities. The Serpentine Galleries are centrally located and the Diana Princess of Wales Memorial Fountain is a popular place to splash around. There are cafes and restaurants, as well as a designated swimming area and a boating lake. Adjacent to Hyde Park are Kensington Gardens. Together these green spaces stretch from Mayfair in the east to Kensington in the west.

298
Marble Arch

Architecture

Marble Arch was designed by John Nash as part of Buckingham Palace. The palace design, much like that of Versailles in France and other large palaces had a three-sided courtyard, flanked by the main building and two wings. The arch stood at the front of the Palace, creating an entrance. When Queen Victoria moved in to the Palace, it was decided that it needed extending to accommodate her and the East wing was added to close the courtyard. This is the front facade of the palace we know today. Marble Arch was relocated to create a ceremonial entrance to Hyde Park. Then in the 1960s, Park Lane was widened, leaving Marble Arch stranded in the middle of a traffic island. Historically, only the Royal Family and the King's Troop, Royal Horse Artillery were permitted to pass through the arch.

W1H 7DX
Tube: Marble Arch
Map M15 | E1

299
Speaker's Corner

Culture

Speakers' Corner is an area in Hyde Park set aside for public speaking, discussion and debate. The area was created by an act of parliament in 1872. It is one of the world's most famous symbols of free speech and the main site of protest in Britain. The site has been the location of anti-war protests and was also used for protest during the suffragette movement. Famous visitors have included Karl Marx, Vladimir Lenin and George Orwell. Traditionally, speakers are allowed to say whatever they like, as long as they are standing on something, usually termed, 'a soapbox'. The main activity takes place on Sunday mornings.

Marble Arch
W2 2EU
Tube: Marble Arch
speakerscorner.net
Map M15 | E1

300
Serpentine Galleries

Art & Design

Consisting of two separate art galleries, the Serpentine Galleries are located in Kensington Gardens and Hyde Park and are separated by a bridge. The Serpentine Gallery is a former teahouse and artists whose works have been exhibited here include Damien Hirst, Jeff Koons, Andy Warhol, Marina Abramovic and Henry Moore. Across the bridge, the Serpentine Sackler Gallery is a former gunpowder store with a modern extension designed by Zaha Hadid. Each summer, the Serpentine Gallery invite a notable artist and/or architect to create a Summer Pavilion. Previous creators have included Ai Wei Wei, Frank Gehry, Zaha Hadid and Rem Koolhaus. Both galleries run a full program of exhibitions throughout the year and admission is free.

Kensington Gardens
W2 3XA
Tube: Knightsbridge
+44 (0)20 7402 6075
serpentinegalleries.org
Map M15 | C2

SOUTH-WEST

Chelsea

As late as the 18th century, Chelsea was a wealthy rural area located outside of London and filled with large private houses. The King's Road was maintained as a private road for the use of King Charles II to get from St James's Palace to Fulham in the west. The 19th and 20th centuries saw much development in the area, but Chelsea essentially remains a wealthy residential area, just a lot more urban. The area was popularized in the 1960's by The Beatles and other pop culture icons, and the King's Road today is a major retail destination full of independent fashion boutiques. The Royal Hospital is a major landmark in the area dating from the 17th century.

SOUTH-WEST

301
Colbert
Food & Drink

Colbert is a Parisian-style café overlooking Sloane Square, serving breakfast, lunch and dinner. Classic dishes include escargots a la Bourguignonne; steak tartare; herb crusted rack of lamb, ratatouille and mint jus; as well as eggs benedict, oysters and many others. The quality of the food, service and the prime location are reflected in the prices. This is a great place for a break from shopping on the King's Road #304.

50-52 Sloane Square
SW1W 8AX
Tube: Sloane Square
+44 (0)20 7730 2804
colbertchelsea.com
Map M14 | C3

302
Sloane Square
Shopping

Sloane Square is an open public square situated at the intersection of Chelsea, Belgravia and Knightsbridge in central London. The square sits at the eastern end of the King's Road #306 and at the southern end of Sloane Street, which connects the square with Knightsbridge. The square has various shops, restaurants and bars, including Colbert #301. The square is named after Sir Hans Sloane, the famous physician whose vast natural history collection became the foundation of the British Museum #178 and subsequently the Natural History Museum #316. Laid out in the 18th Century, the square and surrounding areas contain some fine examples of period architecture. The square also contains the Venus Fountain, which sits at its centre.

SW1W
Tube: Sloane Square
Map M14 | C3

303
Saatchi Gallery
Art & Design

This contemporary art gallery set up by Charles Saatchi became famous in the 1990's for exhibiting artistic works by Damien Hirst, specifically *The Physical Impossibility of Death in the Mind of Someone Living*, a 13 foot tiger shark suspended in a tank of formaldehyde. As well as many works by Hirst, the gallery has exhibited works by Andy Warhol, Jeff Koons and Lucian Freud. The gallery is now based in a large space at the Duke Of York's Headquarters on the King's Road #304 in Chelsea.

Duke Of York's HQ
King's Road
SW3 4RY
Tube: Sloane Square
saatchigallery.com
Map M14 | C3

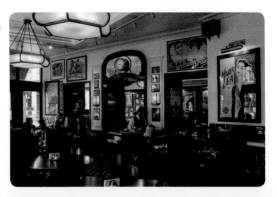

301

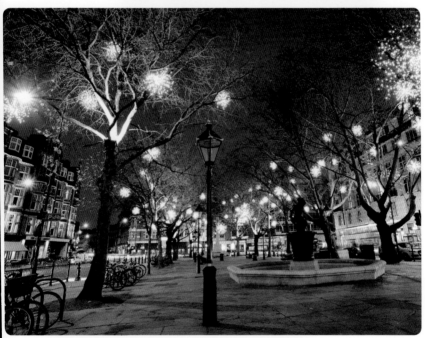

302

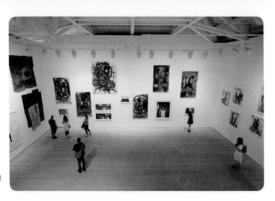

303

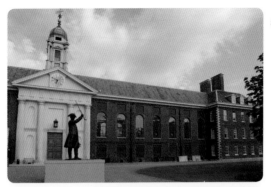

305

304

306

304
King's Road

Shopping

305
Royal Hospital Chelsea

Architecture

306
Chelsea Physic Garden

Leisure & Nature

The name is derived from the road's former use as a private road for King Charles II to travel to Kew. The road remained private until 1830. The road became a symbol of 1960s style in association with fashion designers Mary Quant and Vivienne Westwood. It was also associated with counter-culture, and Malcolm McLaren of the Sex Pistols once had a shop here. Today, it is much more sanitised, but remains a world-famous shopping destination. Although the global megabrands have moved in, there remains a selection of small and independent shops along the street's two-mile length. There are also galleries, restaurants, cafes and cinemas along the road.

SW3
Tube: Sloane Square
Map M14 | B3

The Royal Hospital is a retirement home for British soldiers founded by King Charles II in 1682. A gilded statue of the King stands in the Figure Court. Residents are known as 'Chelsea pensioners' and are famous for their ceremonial dress consisting of scarlet coats and tricorne hats. The Hospital's Great Hall and chapel were designed by Sir Christopher Wren and feature several important paintings that span several centuries, including a mural of Charles II on horseback by Antonio Verrio dating from 1690. The grounds contain several cannons, one of which, 'The Singora Cannon', was made around 1623. Tours of the museum and the site can be booked in advance and are led by the pensioners themselves.

Royal Hospital Road
SW3 4SR
Tube: Sloane Square
+44 (0)20 7881 5200
chelsea-pensioners.co.uk
Map M14 | C4

Founded in 1673, Chelsea Physic Garden is the second oldest botanical garden in Britain. It was set up for the purpose of studying the medicinal qualities of plants. With over 5,000 plants, the walled garden makes for a beautiful and peaceful place to walk or sit. The garden contains many tree species including pomegranates, gingkos, mulberries and eucalyptus. There is an olive tree and the world's most northerly outdoor grapefruit tree. There is also a bookshop and a café serving light lunches, cakes and refreshments.

66 Royal Hospital Road
SW3 4HS
Tube: Sloane Square
+44 (0)20 7352 5646
chelseaphysicgarden.co.uk
Map M14 | B4

SOUTH-WEST

SOUTH-WEST

307
The Surprise
Food & Drink

308
Ziani
Food & Drink

309
Michael Hoppen Gallery
Art & Design

The Surprise is a neighbourhood gastropub located on a quiet street around the corner from Royal Hospital Chelsea #305. They offer updated British classics such as: Charred asparagus, English parmesan custard, slow cooked lemon rind; Smoked wood pigeon breast, yoghurt, praline, radicchio; Slow cooked shin of beef, smoked oyster and green peppercorn pie, butter mash and gravy; Pan roast cannon of lamb 12 hour crispy shoulder, Swiss chard, shaved beetroot; Treacle tart with salted caramel, milk ice cream; and white chocolate and marmalade bread and butter pudding. Drinks include cocktails, wine and a selection of draught beers.

6 Christchurch Terrace
SW3 4AJ
Tube: Sloane Square
+44 (0)20 7351 6954
Map M14 | B4

Ziani is a traditional, much-loved neighbourhood restaurant run meticulously and lovingly by Roberto Colussi for over 30 years. Venetian specialities include Fegato alla Veneziana - Thin strips of calf's liver cooked with onions and red wine vinegar; Tagliatelle Tartufate - Home-made noodles sautéed with wild mushrooms, courgettes and truffle olive oil; Coda di Rospo alla Graticola - Charcoal grilled monk fish; and a choice of desserts including Creppe Ziani - Pancakes filled with mascarpone cream, topped with crushed almond biscuits and Tia Maria. The restaurant is located on a quiet street off the Kings Road #304 and is open for lunch and dinner every day.

45 Radnor Walk
SW3 4BP
Tube: Sloane Square
+44 (0)20 7351 5297
ziani.co.uk
Map M14 | B4

The Michael Hoppen Gallery is a photography gallery that opened in 1992. The gallery features new and interesting artists alongside acknowledged photographic masters. Three floors of gallery space in Chelsea allows for a broad collection of photography including one of the most extensive collections of post-war Japanese photography outside of Asia. The gallery also regularly organise talks, seminars and book signings with featured artists.

3 Jubilee Place
SW3 3TD
Tube: Sloane Square
+44 (0)20 7352 3649
michaelhoppengallery.com
Map M14 | B3

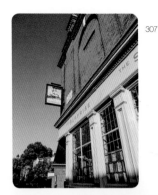

307

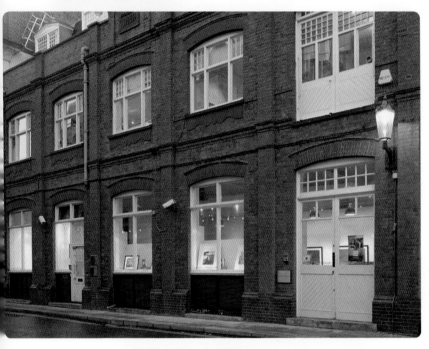

309

308

310

312

311

310
Tom's Kitchen

Food & Drink

311
Bibendum

Food & Drink

312
Bluebird

Shopping

Tom Aikens was the youngest British chef to be awarded two Michelin stars, at Pied a Terre in London. Tom's Kitchen is a more laid back concept using seasonal and locally sourced ingredients to create modern British dishes. Serving breakfast, lunch and dinner, sample dishes include: Dill Cured Salmon, vanilla, pink peppercorns, dill creme fraiche; 650g cote de boeuf with bearnaise sauce; seven hour confit lamb to share, mashed potato, balsamic onions; courgette and black olive tart, wild mushrooms, parmesan, truffle oil; and wild berry posset, hazelnut praline, caraway shortbread.

27 Cale Street
SW3 3QP
Tube: South Kensington
+44 (0)207 349 0202
tomskitchen.co.uk
Map M14 | B3

Bibendum is a French restaurant named after the Michelin mascot, Monsieur Bibendum. The restaurant is located in the former British headquarters of the Michelin tyre company. Built in 1911, this beautiful art deco building retains original features such as stained glass windows and Michelin lettering. Classic French dishes here include: Soupe de poisson, rouille and croutons; Foie gras terrine, Armagnac jelly; Escargots de Bourgogne; Calf's liver, pomme puree, Madeira sauce; Barbary duck breast, jambon de Bayonne, endive and sauce bigarade; and Prune and Armagnac baba, vanilla cream. The restaurant is open from Tuesday to Sunday and has various prix fixe menus available.

Michelin House
81 Fulham Road
SW3 6RD
Tube: South Kensington
+44 (0)207 581 5817
bibendum.co.uk
Map M14 | B3

Bluebird is a high-end store offering fashion, books, homeware and a spa under one roof. Fashion brands include Maison Kitsune, Oliver Spencer, Folk, Paul Smith and Marni. The Bluebird site also offers an upmarket restaurant, a café serving breakfast and an epicerie. This mini emporium of shopping and eating is a long-standing feature on the King's Road #304, Chelsea's world-famous shopping street. In a previous incarnation, the building and site were used for the Bluebird Garage, a car garage and petrol station.

350 King's Road
SW3 5UU
Tube: Sloane Square
+44 (0)20 7351 3873
theshopatbluebird.com
Map M14 | A4

SOUTH-WEST

Fulham

Fulham was home to the Bishops of London for over a millennia, who resided at Fulham Palace. The area is located to the west of Chelsea and is a major residential area for professionals due to the high quality of life and relatively cheaper house prices compared to its neighbour. The Hurlingham Club, located adjacent to the river, has extensive sports facilities including a polo field and has counted monarchs among its members. Fulham is also home to the football stadiums of Fulham and Chelsea football clubs.

SOUTH-WEST

313
Brompton Cemetery

Leisure & Nature

This large green space in west London is the only cemetery managed by the Royal Parks Organisation. A somewhat strange destination to walk and relax, many locals do exactly this, wandering around the extensive grounds looking at old gravestones and grand monuments, of which there are over 30,000. Over 200,000 people are buried here including many notable personalities such as Emmeline Pankhurst, the suffragette movement leader; Samuel Leigh Sotheby, the auctioneer (see Sotheby's #228); Sir Samuel Cunard, the shipbuilder; and James Macdonald, the co-founder of Standard Oil, whose monument resembles a miniature church. Public tours of the cemetery are usually organised on Sunday afternoons.

Fulham Road
SW10 9UG
Tube: Fulham Broadway
+44 (0)20 7352 1201
Map M16 | D6

314
The Harwood Arms

Food & Drink

The Harwood Arms is a Michelin-starred "pub" offering a seasonal British menu. Set up by Brett Graham of The Ledbury (two Michelin stars) the kitchen is overseen by Alex Harper and dishes include: Squid 'porridge' with wild garlic and Jersey Royal soup, smoked cod's roe and radish; Roast haunch of Berkshire venison with new season garlic, baked beetroot and smoked bone marrow tart; Suffolk Duck Breast with carrots cooked in hay, black cabbage and blood orange; and Warm malted chocolate cake with pearl barley and lovage ice cream. The Harwood Arms offers a set-priced menu for lunch and dinner, priced at £35.50 for two courses and £42.50 for three courses.

Walham Grove
SW6 1QP
Tube: Fulham Broadway
+44 (0)20 7386 1847
harwoodarms.com
Map M16 | C7

315
Fulham Palace

Architecture

Fulham Palace was a Bishop's residence from 700 to 1975 and there is archaeological evidence of a Neolithic (3000BC) settlement on the site. The Palace became a summer retreat for the Bishops of London and the existing architecture is a mix of Tudor, Georgian and Victorian styles. The 13 acres of botanical gardens include a 450-year-old oak tree and a walled garden. The museum, art gallery, gardens, some historic rooms and the Drawing Room Café are all open to the public and admission is free.

Bishop's Avenue
SW6 6EA
Tube: Putney Bridge
+44 (0)20 7736 3233
fulhampalace.org
Map M16 | A10

313

313
314
315

SOUTH-WEST

314

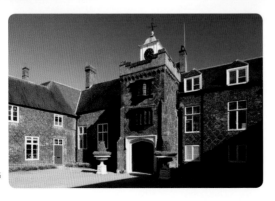

315

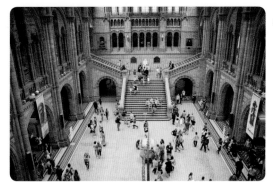

316

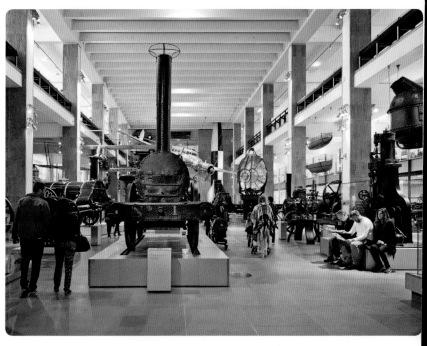

317

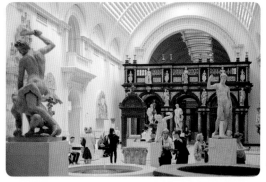

318

Kensington

Kensington is defined by its proximity to Kensington Palace. The area is the home of the super-rich and contains the most expensive residential street in the world, Kensington Palace Gardens. The high street has all sorts of shops and restaurants catering to the local population and Kensington Gardens provide options for many different activities including visiting the Italian Gardens. South Kensington contains universities and world-class museums, as well as the Royal Albert Hall.

316
Natural History Museum

History

The world's most important natural history collection takes the form of over 80 million specimens covering botany, entomology, zoology, palaeontology and mineralogy. The museum grew out of the British Museum #178 and the building we see today opened in 1881. The grand building is one of London's most iconic landmarks and was built specifically for the museum. It is covered in ornate terracotta tiles that served the practical purpose of repelling the dirt and soot of Victorian London. Some of the star exhibits include: the skull of a Tricertops; the first T.Rex fossil ever found; a 420,000-year-old Clacton spear; and the collections of Charles Darwin and Sir Hans Sloane, whose collection founded the museum in 1756.

Cromwell Road
SW7 5BD
Tube: South Kensington
+44 (0)20 7942 5511
nhm.ac.uk
Map M14 | A2

317
Science Museum

History

The Science Museum is a world-class collection of scientific, technological and medical achievements from across the globe. The collection numbers over 300,000 and includes Stephenson's Rocket; the first jet engine; a working model of Charles Babbage's difference engine; and a replica of Crick and Watson's DNA model. The museum is an educational organisation and thousands of young people visit on educational trips each year. The Science Museum welcomes over 3 million visitors annually and the Natural History Museum #316 and The Victoria and Albert Museum #318 are nearby.

Exhibition Road
SW7 2DD
Tube: South Kensington
sciencemuseum.org.uk
Map M14 | A2

318
Victoria and Albert Museum

History

The V&A is the one of the world's leading museums of art and design with a collection of over 4.5 million objects that span over 5,000 years. The museum holds many of the UK's national collections and houses resources for the study of architecture, furniture, fashion, textiles, photography, sculpture, painting, jewellery, glass, ceramics, book arts, Asian art and design, theatre and performance. It was established in 1852, the year after The Great Exhibition took place in Hyde Park. The museum is housed in a series of grand Victorian buildings and the most popular exhibition to date was, 'Alexander Mcqueen: Savage Beauty', which attracted 480,000 visitors in 2015. The V&A Museum of Childhood #043 is a sister museum in Bethnal Green. Admission to the V&A is free.

Cromwell Road
SW7 2RL
Tube: South Kensington
+44 (0)20 7942 2000
vam.ac.uk
Map M14 | A2

SOUTH-WEST

319
Royal Albert Hall
Entertainment

320
Albert Memorial
Architecture

321
The Roof Gardens in Kensington
Leisure & Nature

<div style="float:left">SOUTH-WEST</div>

The Royal Albert Hall opened in 1871 and its official name is the Royal Albert Hall of Arts and Sciences. The hall was dedicated to Prince Albert by Queen Victoria. Having organised and presided over the Great Exhibition in 1851, Albert was keen to create a permanent structure in central London to host similar ongoing events, however the hall was not completed until after his death. The hall is a grand space with a capacity of over 5,500. The Royal Albert Hall hosts around 390 events per year including musical and sporting events such as the ATP Champions Tour Masters tennis event. It is also the location for the proms, a series of daily classical music concerts held every summer.

Kensington Gore
SW7 2AP
Tube: South Kensington
+44 (0)20 7589 8212
royalalberthall.com
Map M15 | C3

The Albert Memorial was commissioned by Queen Victoria to commemorate her husband, Prince Albert. It was designed by Sir George Gilbert Scott, the architect behind St Pancras Railway Station (see #027). The Gothic revival design features ornate marble figures and gilded bronze statues. The memorial features a statue of Prince Albert holding the catalogue of the Great Exhibition of 1851, which he helped to organise. It stands in Kensington Gardens facing the Royal Albert Hall #319 and is open for close-up tours from March to December.

Kensington Gardens
W2 2UH
Tube: South Kensington
+44 (0)20 7298 2000
Map M15 | C3

Until 2012, The Roof Gardens in Kensington were the largest roof gardens in Europe. Located on top of the former Derry and Toms building on Kensington High Street, the gardens were laid out between 1936 and 1938. There are three distinct styles of gardens: Spanish, Tudor and English woodland. Together they form a magical landscape filled with hidden spaces, lawns, trees and flowers. The roof complex has a restaurant and clubhouse that offer lunch, dinner, cocktails, club nights and private events. The gardens are open to the public when there are no private events scheduled.

99 Kensington High Street
W8 5SA
Tube: High Street Kensington
+44 (0)20 7937 7994
Map M16 | D3

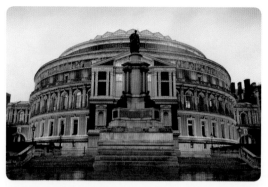

319

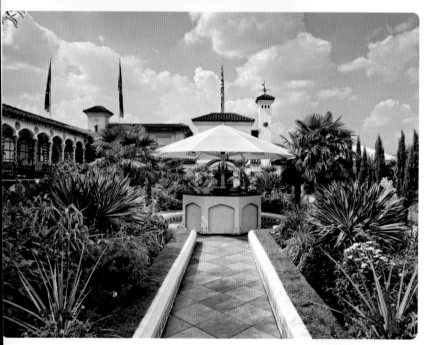

321

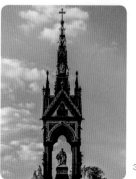

320

322

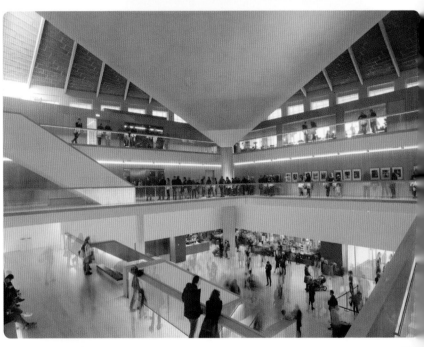

323

324

322
Yashin Sushi
Food & Drink

323
London Design Museum
Art & Design

324
Leighton House Museum
Art & Design

Yashin is an upscale sushi restaurant that works on the principle of 'without soy sauce'. This principle is designed to emphasize the taste of the fish and accompaniments without overwhelming the palate (although soy sauce is available). Ingredients are selected based on the time of year when they are at their tastiest and prepared individually according to the unique qualities within. This means that salmon is served as fresh as possible, whereas tuna tastes better when slightly aged. Yashin research and explore complex accompaniments for each fish to bring out the best flavours. Dishes include: Scottish salmon with seaweed and yuzu jelly; Tuna with truffle infused ponzu jelly; Grouper with summer truffle and tosa yuzu dressing; Sugar snap and cauliflower with ginger lime salt; and mizuna leaf and deep fried soft shell blue crab with tosa vinegar. 'The Yashin' consists of fifteen pieces of sushi and costs £60.

A Argyll Road
W8 7DB
Tube: High Street Kensington
+44 (0)20 7938 1536
yashinsushi.com
Map M16 | C3

The Design Museum is the world's leading museum devoted to contemporary design in every form from architecture and fashion to graphics, product and industrial design. The museum runs the annual *Designs of the Year* competition aimed at highlighting designs that deliver change and extend design practice. Past exhibitions have included retrospectives of world-renowned fashion designers, architects and furniture designers. In 2016, the museum tripled its space by moving to the Former Commonwealth Institute in Kensington and now welcomes over 500,000 visitors each year.

224 - 238 Kensington High Street
W8 6AG
Tube: High Street Kensington
+44 20 3862 5900
designmuseum.org
Map M16 | C3

Leighton House Museum houses paintings, sculptures and drawings by the artist Lord Frederic Leighton and is housed in his former home in Holland Park #326. Besides the many works by Leighton, the permanent collection here also includes works by John Everett Millais and George Frederick Watts. The house itself is well worth a visit for its architecture and opulent, oriental interiors including a stunning collection of Islamic tiles.

12 Holland Park Road
W14 8LZ
Tube: Kensington Olympia
+44 (0)20 7602 3316
Map M16 | B3

SOUTH-WEST

325
Belvedere

Food & Drink

326
Holland Park

Leisure & Nature

327
Kensington Church Street

Shopping

SOUTH-WEST

Located in Holland Park #326, Belvedere is a formal restaurant housed in a 17th century building that was the former summer ballroom of Holland House, a stately home largely destroyed during the Blitz in 1940. The restaurant is surrounded by beautiful, landscaped gardens and offers a French and Italian inspired menu including dishes such as celeriac veloute, ricotta and parma ham ravioli; daube of beef bourguignonne; gigolette of venison; and herb crusted halibut. Belvedere also provides a special Sunday lunch menu with various roasted meats available.

Holland Park is a mixed-use park including woodland, formal gardens and sports pitches located to the west of Kensington Palace #328. At the centre of the park sit the ruins of Holland House, a grand Elizabethan house built in 1605 and destroyed by German bombing during the Second World War. The park also contains the Kyoto Garden; a stunning Japanese garden donated by the Kyoto Chamber of Commerce and Industry on the occasion of the 100th anniversary of the Japan Society in Britain in 1991. The park also contains Belvedere #325, which is located in the house's former summer ballroom.

Kensington Church Street is a quaint shopping street located to the west of Kensington Palace and Gardens #328. Filled with centuries old architecture, the street features small, independent shops and cafes with a focus on art and antiques. The shops serve the wealthy residents of neighbouring Holland Park. The street counts several churches and offers various restaurants such as My Old Dutch Pancake House, Dirty Bones Hot Dog Shack and Ffiona's, a restaurant serving English breakfasts. The street connects with Kensington High Street, a major shopping street which is also the location of Kensington Roof Gardens #321.

Holland Park
Abbotsbury Road
W8 6LU
Tube: Holland Park
+44 (0)20 7602 1238
belvedererestaurant.co.uk
Map M16 | B3

Ilchester Place
W8 6LU
Tube: Notting Hill Gate
+44 (0)20 7602 2226
Map M16 | B3

Kensington Church Street
W8 4BA
Tube: High Street Kensington
Map M16 | C2

325

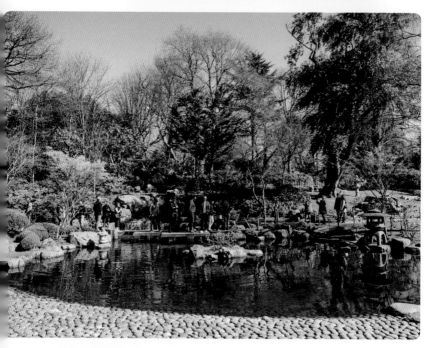

326

327

"...wine shop with a particularly extensive list of 40 wines by the glass from France, Spain, Argentina, Austria, Italy, Germany, South Africa and Australia."

328

329

328
Kensington Palace and Gardens

Architecture

329
Kensington Wine Rooms

Food & Drink

The first house built on the site of present day Kensington Palace was completed in 1605. King William III and Queen Mary II bought the house and turned it into Kensington Palace in 1689 under the direction of Sir Christopher Wren. The King and Queen's state apartments date from this period. William later died here after a riding accident at Hampton Court Palace #352. George II was the last monarch to live at the palace, dying here in 1760. The palace gardens were once part of a private area that included Hyde Park where the King hunted deer. Visitors can explore the beautiful sunken garden and the Orangery, built for Queen Anne in 1705, which is now a café and restaurant. Today, the palace is the London home of Prince William, Duke of Cambridge and Prince Harry, as well as several other members of the Royal Family.

Kensington Gardens
W8 4PX
Tube: Queensway
hrp.org.uk/kensington-palace
Map M15 | A2

Kensington Wine Rooms is a wine bar, restaurant and wine shop with a particularly extensive list of wines by the glass from France, Spain, Argentina, Austria, Italy, Germany, South Africa and Australia. The wine rooms prioritise provenance and stock beers from Greenwich and gin and vodka from Hammersmith. Food is designed to accompany the wine and includes British cheeses, Spanish meats, Cornish crab, Scottish beef and Gressingham duck. Design is relaxed and the space has exposed brick and vintage wood tables and floors. Regular wine tastings are also held here.

127-129 Kensington Church Street
W8 7LP
Tube: Notting Hill Gate
+44 (0)20 7727 8142
winerooms.london
Map M16 | C1

SOUTH-WEST

Visitors can explore the beautiful sunken garden and the Orangery, built for Queen Anne in 1705, which is now a cafe and restaurant."

330

331

"Club nights feature live music acts and DJs covering a broad range of genres such as hip-hop, R&B, reggae, dancehall, salsa, cumbia, merengue, samba, jazz and bossa nova."

Notting Hill

Notting Hill is a once rundown area to the north-east of Kensington Gardens, which is now very wealthy and affluent. The area has strong creative connections and is home to the Notting Hill Carnival and Portobello Road Market. Property prices have exploded in the area in the last twenty years and the Victorian terraced houses are notable by their bright colours. The area has a village feel with plenty of impressive old churches, pavement cafes, upscale restaurants and local shops. At weekends, the area fills up with visitors to Portobello Road.

330
Notting Hill Arts Club

Entertainment

Notting Hill Arts Club is a live music and arts venue hosting a broad range of events. Club nights feature live music acts and DJs covering a broad range of genres such as hip-hop, R&B, reggae, dancehall, salsa, cumbia, merengue, samba, jazz and bossa nova. Art events include photography, film, sculpture and painting. NHAC is a hive of activity and there is almost always something going on. The vibe is relaxed and the club has sofas and an extensive cocktail list just to reinforce the point.

21 Notting Hill Gate
W11 3JQ
Tube: Notting Hill Gate
+44 (0)20 7460 4459
nottinghillartsclub.com
Map M17 | C5

331
Electric Cinema

Entertainment

The Electric Cinema is one of the oldest working cinemas in the country. Opening in 1911, during the silent film era, the cinema's grand design features terra cotta brickwork, ionic pilasters, pillars, high ceilings and a proscenium arch. During the First World War, the manager, who was German by birth, was rumoured to be signalling to German zeppelins from the roof and was interned in a camp. Inside, this luxury cinema has sixty-five leather armchairs with footstools, three sofas and three double beds to ensure maximum comfort for the audience. Adjacent to the cinema, The Electric Diner serves unfussy breakfast, lunch and dinner.

191 Portobello Road
W11 2ED
Tube: Ladbroke Grove
+44 (0)20 7908 9696
electriccinema.co.uk
Map M17 | B4

WEST

332
Granger & Co.
Food & Drink

333
The Cow
Food & Drink

334
Couverture and the Garbstore
Shopping

Granger and Co. is an all-day Australian restaurant serving breakfast until 12pm, lunch from 12pm until 5pm and dinner from 5pm. Breakfast includes healthy juices and smoothies, rye breads, eggs, avocado and jasmine tea amongst other tempting offers. For lunch there are sandwiches, burgers, salads and pastas. Dishes for dinner include steamed sea bass, green tea noodles, samphire and soy mirin broth; and braised lamb, white polenta, fennel, parsley and lemon. Overall, food is carefully constructed with delicate flavours and healthy ingredients on offer. They also serve coffees all day.

175 Westbourne Grove
W11 2SB
Tube: Bayswater
+44 (0)20 7229 9111
grangerandco.com
Map M17 | B4

The Cow is a pub offering a broad range of British and International dishes. Down-to-earth, home-grown classics include half pint of prawns and mayonnaise; pate, piccalilli and toast; sausages, mash and onion gravy; beef and Guinness pie with spring greens; a Sunday roast menu; and oysters. Upstairs is a small dining room and more complex dishes include: burrata, asparagus, broad beans, mint and citrus dressing; romanesco and gruyere tart, bitter leaves, garlic vinaigrette; roast shoulder of spring lamb, white beans, green sauce; and Aberdeen Angus forerib, potato and rosemary gratin and green peppercorn butter. The Cow's dish of the day is available from Monday to Friday before 7pm for £10. They celebrated their 20th anniversary in 2015 and are a local favourite.

89 Westbourne Road
W2 5QH
Tube: Royal Oak
+44 (0)20 7221 5400
thecowlondon.co.uk
Map M17 | C3

Couverture and the Garbstore is a large, independent fashion store focusing on niche independent clothing labels, books and homeware. Set up with a philosophy of avoiding the big brands and seeking out the unique, the store sells clothes by Velva Sheen, GMT, Mountain Research, Mina Perhonen, Zespa, Humanoid and many more. Situated in a period townhouse in Notting Hill, the store design is light and spacious, creating a shopping experience of a similar high quality to the products available.

188 Kensington Park Road
W11 2ES
Tube: Ladbroke Grove
+44 (0)20 7229 2178
couvertureandthegarbstore.com
Map M17 | B4

WEST

334

333

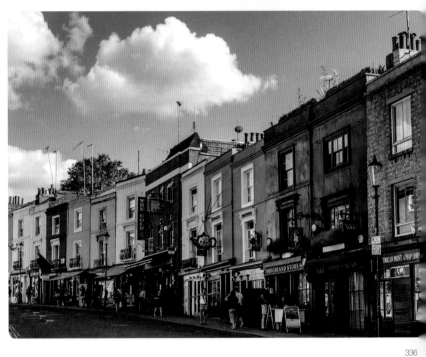

"*The collection contains around 12,000 items mostly made up of packaged products and adverts. Products include cosmetics, tea, coffee, confectionary, household goods, cigarettes, board games, bikes and printed materials.*"

335
Museum of Brands, Packaging and Advertising

Art & Design

336
Portobello Road

Culture

This small museum tells the story of consumerism in the 19th and 20th centuries. The collection contains around 12,000 items mostly made up of packaged products and adverts. Products include cosmetics, tea, coffee, confectionery, household goods, cigarettes, board games, bikes and printed materials. The exhibition starts in Victorian times with assorted memorabilia from the marriage of Queen Victoria and Prince Albert. There are newspapers and magazines that document the important events of the day. There is a comprehensive display of the development of the Marmite jar over several decades and other famous British brands are also well represented. The museum puts these objects into their historical contexts to give the visitor a unique insight into the daily lives of the British people over the course of over one hundred and fifty years.

111-117 Lancaster Road
UK W11 1QT
Tube: Ladbroke Grove
+44 (0)20 7243 9611
museumofbrands.com
Map M17 | A4

Portobello Road is a shopping street running through Notting Hill in West London. It is known for its small shops and Saturday market that attracts thousands of visitors every week. The street is filled with small shops, cafes, restaurants and pubs. The street itself is picturesque, winding its way through Notting Hill, lined with attractive Victorian terraced houses painted in bright colours. The area is primarily known for antiques but shops and market stalls also sell bric-a-brac, vintage fashions, fresh fruit and vegetables, street food and other goods. At the Northern end, Portobello Road crosses Golborne Road (see Golborne Road Market #337).

W10 5TA
Tube: Ladbroke Grove
Map M17 | B4

WEST

Ladbroke Grove

Ladbroke Grove sits to the north of Notting Hill and is seen as slightly more down to earth than its famous neighbour. Filled with small restaurants serving exotic foods, the cultural centre of the area is Golborne Road Market. There are also hip bars, galleries and the Electric Cinema is nearby.

337
Golborne Road Market

Culture

Golborne Road is filled with cafes, restaurants and shops. There is a street market every day except Sunday, which draws visitors from the nearby Portobello Road and beyond. The street is notable for Morroccan and Portuguese cuisines. Lisboa Patisserie #338 is at number 57. The buzzing activity takes place in the shadow of Trellick Tower #339, which stands at the end of the road. Saturdays offer a busy mix of residents and visitors causing long queues for the street's most delicious culinary offerings.

Golborne Road
W10 5PE
Tube: Westbourne Park
Map M17 | A2

338
Lisboa Patisserie

Food & Drink

Famous for its egg tart pastries or pastel de nata, Lisboa Patisserie is a Portuguese patisserie located on Golborne Road. As well as egg tarts, it serves Portuguese coffees and all sorts of other breads and pastries, both sweet and savoury. Lisboa is popular with locals and visitors alike and there are often queues down the street, especially at weekends. There is simple indoor and outdoor seating.

57 Golborne Road
W10 5NR
Tube: Westbourne Park
+44 (0)20 8968 5242
Map M17 | A2

WEST

"As well as egg tarts, it serves Portuguese coffees and all sorts of other breads and pastries, both sweet and savoury."

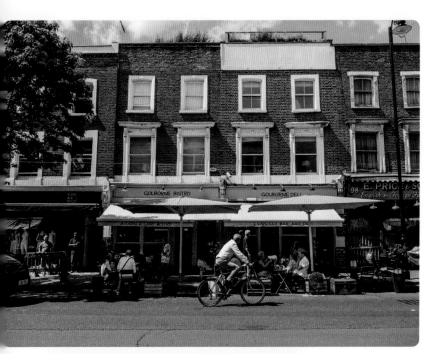

337

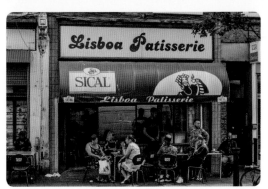

338

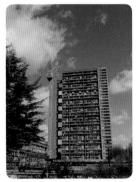

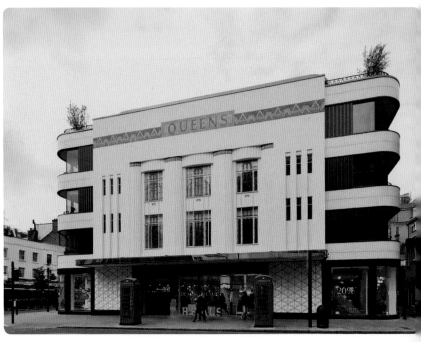

340

"*Designed by Erno Goldfinger (see 2 Willow Road #010), it is Grade II listed and considered to be a masterpiece of brutalist architecture.*"

339
Trellick Tower

Architecture

340
Queen's Cinema

Architecture

Trellick Tower is a 31-storey block of flats near Golborne Road in West London. Designed by Erno Goldfinger (see 2 Willow Road #010), it is Grade II listed and considered to be a masterpiece of brutalist architecture. It was completed in 1972 for the Greater London Council and designed to provide social housing in the area. It has become a popular cultural icon and has featured regularly in film, television and music. The building's design and the popularity of adjacent areas such as Notting Hill and Goldborne Road Market #337 mean that the price of flats within the building have risen sharply in recent years.

5 Golborne Road
W10 5PB
Tube: Westbourne Park
Map M17 | B2

The Queen's Cinema was completed in 1932 by architects J. Stanley Beard & Clare. No longer a working cinema, the building has been renovated to house 16 modern apartments and several retail shops. The mix of original art deco features and modern design make the building a unique piece of architectural design in the area. The original features include colourful mosaic tiles, stained glass windows and period signage that offer an insight into the building's history.

98 Bishop's Bridge Road
W2 5AA
Tube: Royal Oak
queensbuilding.co.uk
Map M17 | B2

WEST

Maida Vale

This residential area is located to the west of Regent's Park and is adjacent to Little Venice. The area is filled with large stucco terraced houses and there are many small restaurants and shops catering to the local population. There are old churches and pubs and the BBC Maida Vale Radio Studios are also here. Abbey Road Studios are not far away. The area is best explored on foot on a sunny day.

WEST

341
The Truscott Arms
Food & Drink

The Truscott Arms is a four storey Victorian pub serving a British menu with dishes such as: Hen's egg, asparagus, lemon crumb, spring onion dressing; Braised beetroot, goat's curd, pickled beetroot; Roast hake, cauliflower puree, spinach, roast chicken jus; Lamb saddle, tomatoes, fava beans and broccoli; and English strawberries, lemon cream, strawberry sorbet. The pub has a broad selection of local draught ales and an extensive wine list.

55 Shirland Road
W9 2JD
Tube: Warwick Avenue
+44 (0)20 7266 9198
thetruscottarms.com
Map M17 | D2

342
The Summerhouse
Food & Drink

The Summerhouse is a seafood restaurant that offers outdoor dining on a terrace overlooking the Grand Union Canal in Little Venice. Dishes include: Maldon smoked salmon, pea pancake, creme fraiche and keta dressing; Seared scallops, saffron Irish stew and samphire; Fish pie: salmon, smoked haddock, prawns, rosemary and lemon crumbs, mixed leaves; and Whole Brixham lemon sole, seaweed butter sauce, jersey royals and samphire. They also offer a selection of English desserts including puddings, crumbles and cheese.

Opposite 60 Blomfield Road
W9 2PA
Tube: Warwick Avenue
+44 (0)20 7286 6752
thesummerhouse.co
Map M17 | D2

343
Little Venice
Leisure & Nature

Little Venice is a small residential area between Paddington and Maida Vale, where the Grand Union Canal and Regent's Canal #040 meet. 'Little Venice' is an unofficial name for the area, some claim was coined by Lord Byron. The area is quiet and scenic, offering beautiful views of the canals. It is an affluent neighbourhood and is filled with small restaurants, cafes and shops. There is a regular waterbus service around Regent's Park to Camden Town.

Warwick Crescent
W2 6NE
Tube: Warwick Avenue
Map M17 | D3

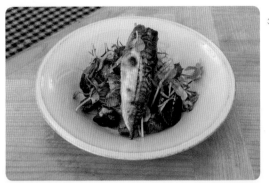

341

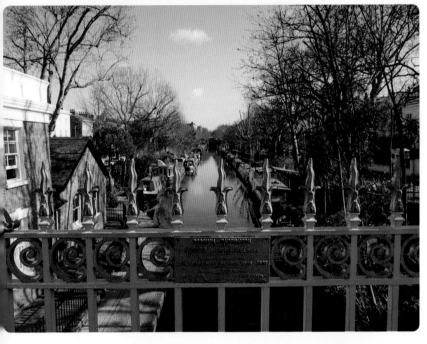

343

342

"A normal straight bridge when down, the bridge curls when lifted, eventually rolling back onto itself to create a circular sculpture when closed."

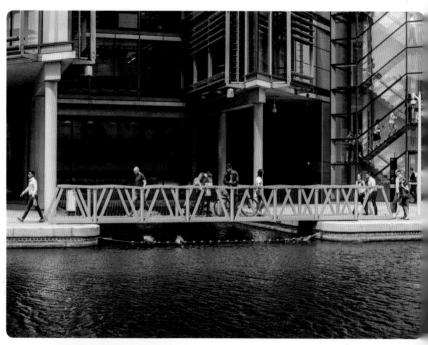

344

345

Paddington

Paddington's major landmark is the railway station that connects London with the west of England and Wales. The station was designed by one of Britain's foremost architects, Isambard Kingdom Brunel, and was constructed in 1854. The area's proximity to Hyde Park makes it a draw but it is less upmarket than nearby Bayswater. Paddington Basin is a large new development of office and residential space and features Thomas Heatherwick's Rolling Bridge.

344
Rolling Bridge

Architecture

Rolling Bridge is an award-winning pedestrian bridge designed by Heatherwick Studio and located across an inlet on the Grand Union Canal at Paddington Basin. The design brief included the requirement that the bridge could open to allow access to a boat moored in the inlet. The unique aspect of the design is its opening mechanism. A normal straight bridge when down, the bridge curls when lifted, eventually rolling back onto itself to create a circular sculpture when closed. The bridge is powered by a series of hydraulic rams and is opened every week on Friday at midday.

South Wharf Road
W2 1AS
Tube: Paddington
Map M17 | E3

345
The Duke of Kendal

Food & Drink

The Duke of Kendal is a neighbourhood pub ideally located to provide sustenance to those exploring nearby Hyde Park. They serve traditional pub food, burgers, salads, puddings and a selection of more structured dishes such as sea bass served with garlic spinach, rocket salad, lemon, butter and capers sauce. There is a pavement seating area that wraps itself around the interesting, curved building and features beautiful hanging flower arrangements. Draught beers and new world wines by the glass keep patrons refreshed.

38 Connaught Street
W2 2AF
Tube: Marble Arch
+44 (0)20 7723 8478
dukeofkendal.co.uk
Map M17 | F4

WEST

Bayswater

Located on the northern edge of Kensington Gardens, Bayswater is a mix of prime residential property and lower cost social housing. St Sophia's Cathedral is the focus of a large Greek community in the area and Queensway features a broad range of ethnic cuisines. Many well-known actors, politicians and authors have lived in the area and there is plenty of attractive Victorian architecture to explore.

346
St Sophia's Cathedral

Architecture

The full name of this Greek Orthodox Church is 'The Greek Orthodox Cathedral of The Divine Wisdom, Hagia Sophia' and it was completed in 1879. It is a focus for the Greek Community in north London holding regular services, music recitals, educational activities and dancing lessons. The architecture of the building is Byzantine Revival and the Church's facade is large and grand featuring a domed roof. Inside, the church is decorated with stunning multicoloured marble mosaics. The church also contains a museum in the crypt containing historical treasures and archive material from the Greek community in London.

Moscow Road
W2 4LQ
Tube: Bayswater
+44 (0)20 7229 7260
stsophia.org.uk
Map M17 | C4

347
Hereford Road

Food & Drink

Hereford Road is a neighbourhood restaurant offering seasonal British cooking with a menu that changes daily. Dishes include: cold roast lamb, chicory and anchovy; smoked eel, potato and horseradish; pearl barley, red wine, mushrooms and spinach; whole lemon sole, Jersey Royals and sorrel; guinea fowl, lentils and wild garlic; bread and butter pudding and buttermilk ice cream; Bakewell tart; and chilled rice pudding and jam. The chef here was formerly head chef at St John Restaurant #093. The restaurant offers two courses for £13.50 or three for £15.50 during the week.

3 Hereford Road
W2 4AB
Tube: Bayswater
+44 (0)20 7727 1144
herefordroad.org
Map M17 | C4

WEST

"*Dishes include: cold roast lamb, chicory and ancho-vy; smoked eel, potato and horseradish; pearl barley, red wine, mushrooms and spinach; whole lemon sole, Jersey Royals and sorrel; guinea fowl, lentils and wild garlic; bread and butter pudding and buttermilk ice cream; Bakewell tart; and chilled rice pudding and jam.*"

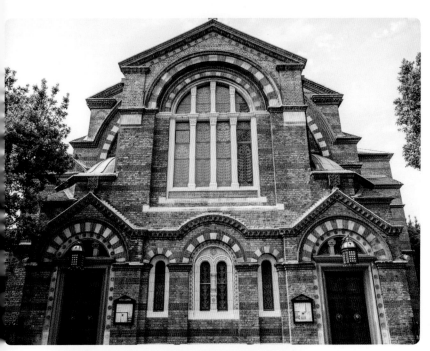

346

347

348
Alexandra Palace
Leisure & Nature

349
Wembley Stadium
Entertainment

350
Hoover Building
Architecture

Opened as 'The People's Palace' in 1873, Alexandra Palace was intended as a recreation and entertainment centre open to all. The building was destroyed by fire 16 days after opening, to be rebuilt in 1875. The palace and surrounding park provided Victorians with music recitals and performances and included one of the largest organs in Europe at the time. During The First World War, the space was used as a hospital. The first public television transmissions were made by the BBC from here in 1936. Today, all sorts of activities take place at the palace including ice-skating, tree climbing, music concerts, a boating lake, a skate park, a pitch and putt golf course, regular farmers' markets and a drive-in film club.

Alexandra Palace Way
N22 7AY
Rail: Alexandra Palace
Tube: Wood Green
+44 (0)20 8365 2121
alexandrapalace.com

Wembley Stadium is the home of the English National Football Team. The original Wembley Stadium was built in 1923 and hosted many significant sporting and musical events over the course of its history including: the London Olympics in 1948; Henry Cooper versus Cassius Clay; the Football World Cup Final in 1966; Live Aid in 1985; and Michael Jackson; and Queen. The famous footballer Pele once called Wembley, 'the cathedral of football'. The stadium was replaced in 2007 and is the largest stadium in the United Kingdom with a capacity of 90,000.

Wembley
HA9 0WS
Tube: Wembley Park
wembleystadium.com

Built in 1933 for the American vacuum cleaner company, the Hoover Building is widely considered to be an important piece of art deco design. Designed by architects Wallis Gilbert and partners, the building's bright white cement exterior contrasts with the primary colours used in the building's decorations, which evoke ancient Egypt. Used as an aircraft factory in the Second World War, the building now houses a supermarket and has been fully restored in line with its Grade II listing. It is located on the A40, outside central London and will certainly be worth the trip for architecture and art deco fanatics.

Greenford
UB6 8DW
Tube: Perivale

348

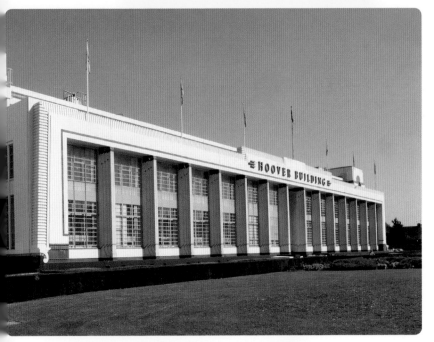

350

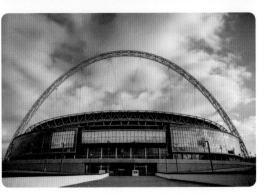

349

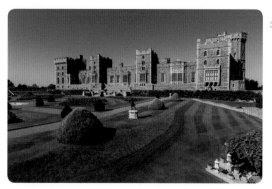

351

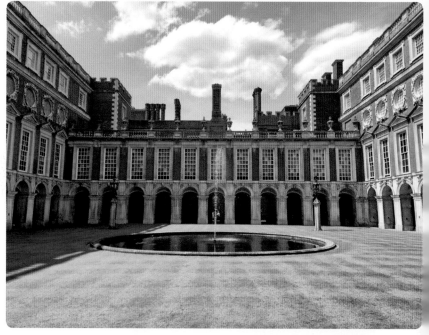

352

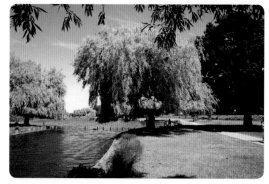

353

351
Windsor Castle

History

352
Hampton Court Palace

History

353
Bushy Park

Leisure & Nature

Windsor Castle is a royal residence to the west of London, built in the 11th century after the Norman invasion. It is the longest-occupied palace in Europe and home to England's monarchs for centuries. The castle has survived the English Civil War, the Second World War and a fire in 1992; and is the largest inhabited castle in the world. The castle complex includes the State Apartments renovated in the 19th Century to reflect Georgian tastes; St George's Chapel, constructed in the 15th century; and The Round Tower, a medieval structure that was extended in the 19th Century. Windsor is widely known to be the Queen's favourite residence and it is where, increasingly, she spends most of her time. One of the highlights of the castle is Queen Mary's Dolls House, a miniature residence built by British architect Sir Edwin Lutyens in 1924. The house contains thousands of objects, electricity, running hot and cold water, working lifts and clothes designed by Lanvin, Cartier, Hermès and Vuitton; given to the Queen by the French Government.

Hampton Court Palace is one of two surviving palaces owned by King Henry VIII, the other being St James's Palace #270. The palace had been the home of Cardinal Wolsey before he fell from favour and gifted the palace to the King. King Henry made the palace his principal residence. Notable additions made by Henry include the Great Hall and the Royal Tennis Court, a real tennis court which is one of the most used courts in the world today, counting over 450 members. Successive descendants of Henry lived at the palace and the architecture was updated by Sir Christopher Wren for King William and Queen Mary. Today, the house contains many works from The Royal Collection (see Buckingham Palace #274).

East Molesey, Surrey
KT8 9AU
Rail: Hampton Court
hrp.org.uk/hampton-court-palace

Bushy Park is one of eight Royal Parks and contains a mixture of woods, gardens, ponds and parkland. The park has been settled for at least 4,000 years and is the site of a Bronze Age burial mound as well as medieval settlements. When Henry VIII took ownership of the land in 1529, he turned it into a deer park, and it contains red and fallow deer today. Chestnut Avenue is a famous section conceived by Sir Christopher Wren as a formal approach to Hampton Court Palace #352. The avenue stretches for one mile and is lined with horse chestnut and lime trees. The park also contains The Diana Fountain, a 17th century statue originally designed for Somerset House #113. The park was a US base for operations during the Second World War. The Pheasantry Café provides refreshments.

The Stockyard
TW12 2EJ
Rail: Teddington/Hampton Wick/
Hampton Court
+44(0)300 061 2250
royalparks.org.uk

Windsor
SL4 1NJ
Rail: Windsor & Eton Central
+44 (0)20 7839 1377
royalcollection.org.uk

SUBURBS

354
Twickenham Stadium

Entertainment

355
Osterley Park and House

Leisure & Nature

356
Marble Hill House

Architecture

Twickenham is the home of England Rugby and the stadium has a capacity of 82,000. Created in 1907, the site was formerly used for growing vegetables and the stadium is nicknamed, 'The Cabbage Patch'. Twickenham has played host to two Rugby World Cup Finals and is the second largest stadium in the United Kingdom after Wembley Stadium #349. As well as rugby, the stadium regularly holds music events and past performers have included Iron Maiden, Bon Jovi, U2, R.E.M., the Rolling Stones and Coldplay. The venue runs stadium tours and has a world rugby museum on site.

Whitton Road
TW2 7BA
Rail: Twickenham
englandrugby.com

Osterley Park and House is a Georgian country estate in west London. It was originally built in the 1570s by Sir Thomas Gresham, a wealthy merchant who funded The Royal Exchange #081 and founded Gresham College #108. Originally Tudor in style, the house was remodelled by Robert Adam in the 1760s. The formal gardens contain a summer house built by Adam, lemon trees, herbaceous borders and vegetables. The estate includes acres of parkland and The Stables Café for refreshments.

Jersey Road
TW7 4RB
Rail: Isleworth
+44 (0)20 8232 5050
nationaltrust.org.uk

Built for the mistress of King George II, when he was Prince of Wales, Marble Hill House is a Palladian villa set in extensive riverside parkland in Richmond. Completed in 1729, it was designed to be a countryside retreat from the noise and clamour of London. The house contains Georgian paintings, hand-painted Chinese wallpaper and other important oriental antiquities and furniture reflecting the tastes of the owner and the age. The grounds include the Coach House Café, picnic areas, a gift shop and 66 acres of parkland for dogs to explore.

Richmond Road
TW1 2NL
Rail: St. Margaret's
+44 (0)20 8892 5115
english-heritage.org.uk

"Created in 1907, the site was formerly used for growing vegetables and the stadium is nicknamed, 'The Cabbage Patch'."

SUBURBS

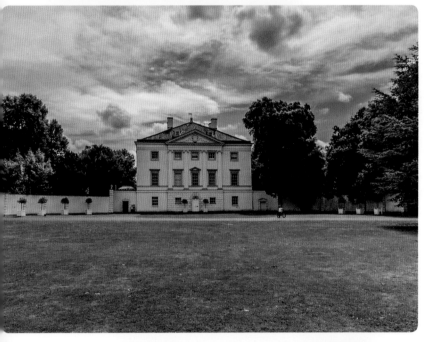

356

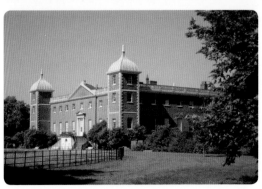

355

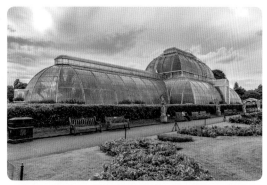

357

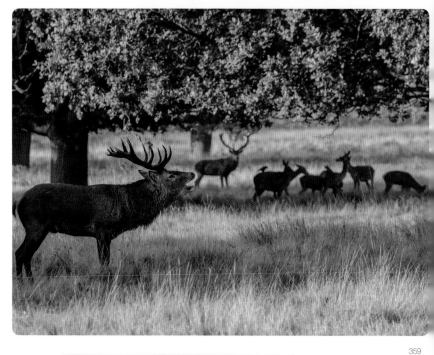

359

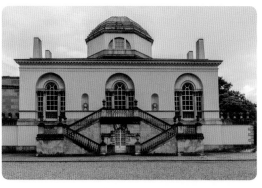

358

357
Kew Gardens

Leisure & Nature

358
Chiswick House

Architecture

359
Richmond Park

Leisure & Nature

Kew Gardens is home to the world's largest collection of living plants, numbering over 30,000 types. The 300-acre site includes bonsai trees, an azalea garden, Victorian glasshouses, the Chinese pagoda built in 1762; the Arboretum, tree-top walkways, a conservatory designed for Buckingham Palace, moved to Kew by King William IV; and a Henry Moore Sculpture. The gardens are a UNESCO World Heritage Site. Kew is also the site of a former royal palace, which is also open to the public.

Kew, Richmond
Surrey
TW9 3AB
Rail: Kew Gardens
+44 (0)20 8332 5655
kew.org

Inspired by the architecture of ancient Rome, Lord Burlington and William Kent designed Chiswick House in the style of the Renaissance architect Palladio. The building and gardens were intended to house Burlington's art and book collections rather than serve as a private residence. The house contains carved fireplaces, statues, domed ceilings and a collection of old master paintings. The gardens were the birthplace of the English landscape movement and served as inspiration for gardens the world over, including Central Park in New York. Esteemed guests to the house and gardens have included King George V, Queen Mary and Tsar Nicholas I. Chiswick House has recently undergone extensive work to restore it to its former glory.

Conservatory Yard
W4 2QN
Rail: Chiswick
+44 (0)20 8995 0508
chgt.org.uk

Richmond Park is a national nature reserve and the largest royal park in London. Charles I moved to the area in 1625, to escape the plague, and turned it into a deer park. The park contains King Henry's Mound, a prehistoric burial chamber from the Bronze Age, used as a viewpoint for hunting. St Paul's Cathedral #086 (12 miles away) is visible from the mound and the view is protected so that no new building is allowed to impede it. The park also contains Isabella Plantation, a woodland garden; and Pembroke Lodge, the former home of Lord John Russell, a former prime minister; and now a restaurant with stunning architecture and views.

Holly Lodge
TW10 5HS
Tube: Richmond
+44 (0)300 061 2200
royalparks.org.uk

SUBURBS

360
All England Lawn Tennis and Croquet Club

Entertainment

361
South London Gallery

Art & Design

362
Brunel Museum

History

The All-England Club is best known for hosting the annual Wimbledon Championships, one of the four grand slam tennis tournaments and the only one to be played on grass. The event has been held at the club since its inception in 1877. Around 450,000 spectators descend upon Wimbledon each June, and the Lawn Tennis Association runs a ballot enabling a large proportion of tickets to be sold to local tennis clubs up and down the country. The club's grounds are home to the Wimbledon Lawn Tennis Museum, the largest tennis museum in the world. The museum is open to the public all year round, apart from during the championships when it is only accessible to ticketholders. Museum visitors can see the tournament trophies and visit centre court.

Founded in 1891, The South London Art Gallery is a contemporary art space that is free to the public. The gallery is housed in an impressive Victorian building and organizes tours, talks, screenings and performances by artists, curators and thinkers. The gallery's emphasis is on presenting new work by British and international artists, often by those who have rarely or never had a solo show in a London institution. The gallery's live art, talks and film programme has featured presentations by Charles Atlas, Tony Conrad, Nathaniel Mellors, Shana Moulton, Kelly Nipper, OMSK, Gail Pickering, Lucy Raven, Marina Rosenfeld and Gisele Vienne. The gallery's purpose includes providing opportunities for learning and participation and there is a full programme of activities for young people and adults.

The Brunel Museum documents the life and work of one of Britain's most famous engineers, Isambard Kingdom Brunel and his father, Marc Isambard Brunel. The collection of prints, statues and models is housed in the Brunel Engine House, which was designed as part of the Thames Tunnel. The tunnel was designed and built by the Brunels in 1843 and was the world's first to be constructed under a navigable river. Stretching from Rotherhithe across to Wapping, the pedestrian tunnel ran to 396m in length and became a major tourist attraction, with 2 million people a year paying to walk through it. The grand entrance to the tunnel was used as a performance space and in 2016 will be used for this purpose again, 150 years after the last show. Today, the tunnel is part of the London Overground network and is used for trains. Infrequently, when maintenance is required walking tours through the tunnel are organised. The museum also contains a café, a bookshop and a small garden.

Church Road
Wimbledon
SW19 5AE
Tube: Wimbledon Park
+44 (0)20 8946 6131
wimbledon.com

65-67 Peckham Road
SE5 8UH
Overground: Peckham Rye
+44 (0)20 7703 6120
southlondongallery.org

Railway Avenue
SE16 4LF
Overground: Rotherhithe
+44 (0)20 7231 3840
brunel-museum.org.uk

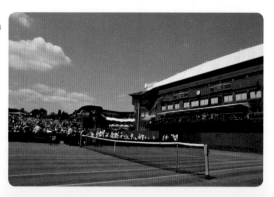

SUBURBS

361

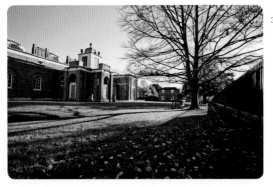

363

365

364

363
Dulwich Picture Gallery

Art & Design

364
Eltham Palace

Architecture

365
Queen Elizabeth Olympic Park

Leisure & Nature

This art gallery opened in 1817 and was designed by Sir John Soane (see #105). The oldest public art gallery in England, it is particularly focused on old master paintings and includes works by artists such as Gainsborough, Reynolds, Constable, Hogarth, Rubens, Van Dyck, Fragonard, Poussin and Canaletto. The gallery design itself was revolutionary at the time, using skylights to illuminate the paintings through natural light. The gallery includes a café and outdoor spaces with sculptures.

Gallery Road
Southwark
SE21 7AD
Rail: West Dulwich
+44 (0)20 8693 5254
dulwichpicturegallery.org.uk

The Eltham Estate was presented to King Edward II in 1305. Henry VIII spent parts of his childhood here and at that time the gardens included a 1,000-acre deer park. Rebuilt by Stephen Courtauld (younger brother of Samuel Courtauld who founded the Courtauld Institute – see #112) in the 1930s, the palace became one of the finest examples of art deco architecture and design in the country. The gardens still contain a 15th century bridge, which crosses the moat. Managed by English Heritage, the house and gardens are open to the public and also appear on the organisation's list of most haunted places in the United Kingdom.

Court Yard
Eltham
SE9 5QE
Rail: Mottingham
+44 (0)20 8294 2548
english-heritage.org.uk

The Olympic Park was the scene of the 2012 London Olympics and contains The Olympic Stadium and The London Aquatics Centre, designed by Zaha Hadid. The Aquatics Centre is open to the public for swimming. The park also contains The Arcelor Mittal Orbit, a sculpture and observation tower designed by Turner Prize winning artist, Sir Anish Kapoor; and Britain's largest piece of modern art. The games involved substantial regeneration of the local area and many events were hosted at the site.

E20 2ST
Overground: Stratford
queenelizabetholympicpark.co.uk

Categories

Explore 365 items by type. There are 8 categories and each one has an introduction and a listing of all the items in the book that fall into that category, along with more detailed information such as cuisine.

Architecture

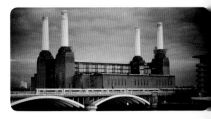

147

Arguably the greatest influences on London's long architectural history have been the church and the monarch. Long before the Palace of Westminster we see today had any democratic power, it was a royal palace and home of the king. Westminster Hall was constructed before the Norman Conquest and features a wooden hammerbeam roof. Westminster Abbey was originally constructed in 1050 and rebuilt in 1245 in the gothic style. Lambeth Palace and the Tower of London were built in the 12th century for the church and the king respectively.

When Henry VIII dissolved the monasteries and consolidated his power in the 16th century, he took over many palaces and buildings from the church. The greatest architects of the day were put to work to create and extend such properties. Inigo Jones brought Palladian architecture from the continent to London and designed the Queen's House for Elizabeth I, Henry's daughter. The style was employed in the building of the Palace of Whitehall, from which only Banqueting House remains. Later architects built Marble

Hill House and Chiswick House in the Palladian style. Hampton Court Palace, St James's Palace and Somerset House were all built or extended under the guidance of Henry and his relatives.

Regular housing in London consisted mostly of wooden framed houses tightly packed together caused by unregulated construction. This caused the Great Fire of London in 1666 to destroy large area of the city and presented an opportunity for a redesign. Over 70 churches were built including the rebuilding of St Paul's Cathedral by Sir Christopher Wren.

The 17th century saw the English Baroque style employed by Christopher Wren and Nicholas Hawksmoor in many churches across London as well as the Old Royal Naval College, the Royal Observatory and the Royal Hospital Chelsea.

The 18th century brought large, white stucco Neoclassical buildings by John Nash, Decimus Burton and Robert Adam. These included Carlton House Terrace, Park Crescent and Kenwood

House. John Nash's plan to connect Regent's Park with The Mall created the grand sweep of buildings that we see today.

The 19th century saw the gothic revivalist style in buildings such as St Pancras Railway Station and the Houses of Parliament; by George Gilbert Scott and Charles Barry respectively.

In the 20th century, London is increasingly becoming a playground for modern architects. The structural expressionist style can be seen in buildings such as the Lloyd's Building and 'the Cheesegrater'. Architects are pushing the boundaries of design in projects such as the Millennium Bridge, the first lateral suspension bridge in the world. Architecture as sculpture seems to be the theme in Renzo Piano's Shard.

Investment in London property continues apace and along with it come opportunities for architects to realize their own vision for the city.

Building	#	Year	Style	Architect	Map
Lambeth Palace	150	1440	Tudor/Gothic	Cardinal John Morton	06 \| A5
Eltham Palace	364	1483	Tudor/Art Deco		
Fulham Palace	315	1495	Tudor		16 \| A10
Kensington Palace and Gardens	328	1605	Jacobean	George Coppin	15 \| A2
Banqueting House	277	1622	Palladian	Inigo Jones	13 \| G2
Queen's House Greenwich	135	1635	Palladian	Inigo Jones	08 \| C8
Royal Observatory Greenwich	136	1676	English Baroque	Christopher Wren	08 \| C9
Old Royal Naval College	134	1694	English Baroque	Christopher Wren	08 \| B8
Royal Hospital Chelsea	305	1695	English Baroque	Christopher Wren	14 \| C4
St Paul's Cathedral	086	1697	English Baroque	Christopher Wren	05 \| D6
Marble Hill House	356	1729	Palladian	Roger Morris	
Chiswick House	358	1729	Palladian	Lord Burlington	
St George's, Bloomsbury	175	1730	English Baroque	Nicholas Hawksmoor	10 \| F4
Bank of England	082	1734	Neoclassical	Robert Taylor	05 \| F6
Spencer House	269	1766	Neoclassical	James Stuart	13 \| C2
Somerset House	113	1776	Neoclassical/Victorian	William Chambers	05 \| A7
Kenwood House	004	1779	Neoclassical	Robert Adam	01 \| B2
Little Green Street	013	1780	Georgian		01 \| E4
Park Crescent	021	1821	Neoclassical	John Nash	11 \| E1
Wellington Arch	273	1827	Neoclassical	Decimus Burton	15 \| E1
Marble Arch	298	1827	Neoclassical	John Nash	13 \| A3
Carlton House Terrace	256	1832	Neoclassical	John Nash	13 \| F2
Houses of Parliament	282	1835	Gothic Revival	Charles Barry	13 \| G4
Royal Exchange	081	1844	Neoclassical	William Tite	05 \| F6
St Pancras Renaissance Hotel	027	1868	Gothic Revival	George Gilbert Scott	13 \| G3
Foreign and Commonwealth Office	280	1868	Italianate	George Gilbert Scott	02 \| A4
Albert Memorial	320	1872	Gothic Revival	George Gilbert Scott	15 \| C3
Albert Bridge	145	1873	Bridge	Rowland Mason Ordish	09 \| A1
St Sophia's Cathedral	346	1879	Byzantine Revival	John Oldrid Scott	17 \| C4
Royal Courts of Justice	111	1882	Gothic Revival	George Edmund Street	05 \| B6
Tower Bridge	068	1894	Gothic Revival	Horace Jones	05 \| I8
London County Hall	152	1922	Edwardian Baroque	Ralph Knott	06 \| A3
Oxo Tower	156	1929	Art Deco	Albert Moore	06 \| C1
Broadcasting House	193	1932	Art Deco	Val Myer	11 \| E3
Queen's Cinema	340	1932	Art Deco	J. Stanley Beard & Clare	17 \| B2
Battersea Power Station	147	1933	Art Deco	J. Theo Halliday	09 \| D1
Hoover Building	350	1933	Art Deco	Wallis, Gilbert and Partners	
Isokon Gallery	012	1934	Art Deco	Wells Coates	01 \| C5
Royal Institute of British Architects	192	1934	Neoclassical/Modernist	George Grèy Wornum	11 \| E2
Senate House	187	1937	Neoclassical/Art Deco	Charles Holden	10 \| D3
Willow Road	010	1939	Modernist	Erno Goldfinger	01 \| B4
Trellick Tower	339	1972	Brutalist	Erno Goldfinger	17 \| B2
Lloyd's Building	076	1986	High Tech	Richard Rogers	05 \| G6
Millennium Bridge	116	2000	Bridge	Foster + Partners	06 \| E1
30 St Mary Axe	078	2001	Modern	Foster + Partners	05 \| H6
The City Hall	126	2002	Modern	Foster + Partners	07 \| D2
Rolling Bridge	344	2004	Modern	Thomas Heatherwick	17 \| E3
The Shard	124	2009	Modern	Renzo Piano	07 \| C2
The Leadenhall Building	077	2010	High Tech	Rogers, Stirk + Harbour	05 \| G6
The Building Centre	188				10 \| D4

CATEGORIES

Art & Design

160

As a subject matter, London's long and eventful history has provided artists with plenty of inspiration and there are many famous portraits of the city by artists such as Canaletto and Monet.

Over the last several hundred years, London's relative stability (except for the world wars) has enabled the city to build and develop several major artistic institutions that both support the next generation of artistic talent and collect and preserve important works from past generations. These include the Royal Academy of Arts, the National Gallery, Tate Britain, Tate Modern, the Courtauld Gallery, the Wallace Collection and the Royal Collection. The combined collections of these institutions offer visitors a practically unrivalled opportunity to discover and enjoy the work of the world's most famous artists. Van Gogh, J.M.W. Turner, Caravaggio, Manet, Seurat, Holbein, Velazquez, Bellini, Degas, Stubbs, Vermeer, Gainsborough, Monet, Michelangelo, Constable, Titian, Hockney, Raphael, Millais

and Bacon are all represented in museums and galleries in London.

Some of Britain's most famous modern artists have worked in and drawn inspiration from London including Damien Hirst, Lucian Freud and Antony Gormley. The Saatchi Gallery has played an important role in the development of the city as a global centre for modern art.

London is a major attraction for architects and designers due to its abundance of creative talent. Foster + Partners, Zaha Hadid Architects, Rogers Stirk Harbour + Partners, Thomas Heatherwick Studio, Alexander McQueen, Vivienne Westwood, Stella McCartney and Phillip Treacy are all based in London. Both the London Design Museum and The V & A Museum regularly organise design-related exhibitions. London also has a large number of small and independent art galleries.

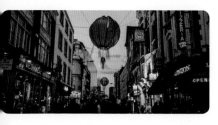

Culture

London is a mix of people from every corner of the globe and different areas have very different cultural influences. Immigration from the 1950s onwards profoundly changed London and brought new languages, foods and artistic influences to the capital. Today, there are hundreds of local communities spread out across the city, each defined by unique characteristics of location, history and people.

London's cultural scene is broad and vibrant. Home to theatres, galleries, concert halls, bookshops and some incredible museums, the city has a long historical connection with the country's greatest writers, musicians, poets and artists. London has hundreds of cultural events every week from poetry recitals to whisky tastings; curry clubs to talks with global celebrities.

London's most well known dialect is cockney and true cockneys have to be born 'within the sound of bow bells', a reference to the church of St-Mary-Le-Bow in east London. Cockney has its own vocabulary (usually rhyming slang) so don't be surprised if you encounter English speakers you don't understand. Charles Dickens immortalised some of the tough conditions in the East End during the 19th century through his books and these serve as a good historical and cultural starting point.

CATEGORIES

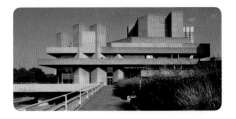

Entertainment

London's entertainment scene has moved on from the public executions, duels and cock fights of the 16th century to offer world-class musicians, actors, sportspersons and comedians. The capital's theatreland is world-famous and many well-known film actors started off 'treading the boards' in London. London was Shakespeare's inspiration and the Globe Theatre, rebuilt to the specifications of the original, stands on the South Bank.

Live music is a local favourite and there are many jazz clubs and other performance spaces that host musicians from all over the world every night of the week. Classical music fans can expect historic venues such as the Royal Albert Hall, St Johns, Smith Square and St-Martin-in-the-Fields; and the Royal Opera House and the Coliseum attract the world's greatest opera singers.

London is a focus for sport and includes the All England Club which hosts the Wimbledon Tennis Championships; Wembley Stadium, the home of English football; and Twickenham Stadium, the home of English rugby. The home of cricket is also located here at Lord's.

Category	#	Map
Film		
Electric Cinema	331	17 \| B4
Regent's Street Cinema	195	11 \| E4
Music		
100 Club	190	10 \| C5
Cargo	054	03 \| B7
Fabric	092	05 \| D4
Jazz Café	024	01 \| E7
King's Place	030	02 \| B3
Koko	026	01 \| E7
Ministry of Sound	119	06 \| E4
Notting Hill Arts Club	330	17 \| C5
The O2 Arena	138	08 \| D2
Pizza Express Jazz Club	234	10 \| C6
Regents's Park Open Air Theatre	020	01 \| D8
Ronnie Scott's	237	10 \| D6
Royal Albert Hall	319	15 \| C3
Royal Opera House	172	10 \| F6
Scala	031	02 \| B4
St-Martin-in-the-Fields	161	10 \| E8
Vortex Jazz Club	039	03 \| B2
Wilton's Music Hall	066	04 \| C4
Sport		
All England Lawn Tennis and Croquet Club	360	
Lord's Cricket Ground	018	01 \| B8
Twickenham Stadium	354	
Wembley Stadium	349	
Theatre		
Almeida Theatre	035	02 \| D2
Battersea Arts Centre	143	09 \| A4
National Theatre	155	06 \| B2
The Old Vic	151	06 \| C3
Piccadilly Circus	248	10 \| C6
Sadler's Wells Theatre	099	05 \| C1
Shakespeare's Globe Theatre	117	06 \| E1
Theatre Royal Drury Lane	171	10 \| G1
Theatreland	245	10 \| C2

Food & Drink

332

London has become one of the most exciting cities for food and drink in recent years. Global superstar chefs are queuing up to open restaurants in the city and there has been exponential growth in home-grown talents as well. London's cosmopolitan mix of people has brought both the knowledge of and demand for cuisines from all over the world.

There is a strong demand for Indian and Bangladeshi cuisine in London and Brick Lane is the curry capital of Europe. Europe is well represented with cuisine from France, Italy and Spain being particularly popular. Street food markets have exploded in recent years and can be found all over the city. Borough Market and Southbank Centre Food Market are two particularly popular ones, serving pulled pork, chorizo, paella and hundreds of other exotic dishes.

The pub is a staple of the London social scene and the city's residents can be found drinking a pint of ale after Smithfield Meat Market closes at 8am; negotiating an insurance contract in the City at lunchtime; after work with colleagues; and in pub gardens all weekend. The British craft beer market has grown significantly in recent years and there is now a huge amount of choice from small and independent brewers using hops from all over the world. Some pubs have gone upmarket, offering more complex and structured food

and in some cases garnering a Michelin star in the process (the Harwood Arms). London has a large number of old pubs as well, allowing the visitor to enjoy a drink in a place frequented by Dick Turpin, Charles Dickens, Lord Byron or even Jack the Ripper.

London has been a major player on the world cocktail scene since prohibition, when Harry Craddock left America and joined the American Bar at the Savoy Hotel. Today, London has 5 of the top 10 bars in the world, according to some rankings. The city is filled with cutting edge bars offering classic drinks and experimental libations in equal number. Bars are hidden in basements and behind fridge doors and not only offer excellent drinks but also exciting design and live music.

British food hasn't always had the best reputation, but today British chefs with global experience are reinventing British cuisine using local, seasonal produce and being recognized on the world stage for their efforts. Global competition has increased the quality of British food across the board and the good old fish and chips, pies, sausage rolls and pork pies have been brought into the 21st century.

CATEGORIES

threesixfive London

History

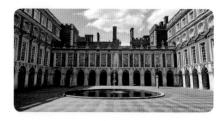

352

London was settled by the Romans in AD43 and the site was chosen for its location on the river. A bridge connecting the north and south banks effectively connected the city with Europe and trade thrived. The decline of the Roman Empire led to the virtual abandonment of the city, although the surrounding areas continued to be inhabited. The city fell into the hands of invaders until it was recaptured by King Alfred The Great. After this time, the city began to reorganise and set up a governance structure. The city became a focus for government activity and laws began to be issued from London. In 1042 English rule was again restored by Edward The Confessor and he commissioned the building of Westminster Abbey. Westminster increasingly became the centre of government in England.

Following the Norman conquest, William the Conqueror was proclaimed king at Westminster Abbey and sought to fortify the city. The Tower of London was built, the first stone castle in England. Westminster Hall was constructed by William's son and became the focus of the English Parliament. The Middle Ages saw increased trade and London grew as a result. The Black Death in the 14th century killed half the population, but London recovered and continued to grow.

The reformation profoundly changed London. Pre-reformation, half of London was owned by religious houses. The reformation caused most of this property to be transferred to the king and aristocratic connections. One such monastery, the Charterhouse, was dissolved and became a hospital and school on Charterhouse Square. The reformation severed the tie with Rome and the power of the pope in Britain, leaving the king with greater power and a growing parliament.

Britain's connections began to extend beyond Europe to Russia, the Middle East and the Americas. The economy grew based on mercantilism and London started to import skills and labour causing the city's population to swell. Culturally, William Shakespeare and Ben Johnson wrote plays that reflected the changing age and challenged people to think about what was going on around them. Along with the printing presses, this served the role of the modern media, to disseminate information, inform discussion and ultimately hold public officials and rulers to account.

During the English Civil War, the financial resources of the City of London supported the parliamentarians against the king and Charles I's eventual defeat led to his execution on a scaffold outside Banqueting House.

In 1666, London was burnt to the ground in the Great Fire of London. The city was rebuilt following the original designs. Wood was replaced with brick as the main building material to protect against future fires. New houses were built in the west close to The Palace of Whitehall and St James's developed as a residential area. Proximity to the king was an indication of power and wealth. After the fire, many churches were rebuilt including St Paul's Cathedral, rebuilt by Christopher Wren.

By the 17th century, the British East India Company was starting to have a large effect on trade. The Bank of England was founded to fund the Napoleonic Wars and Lloyds of London started operating as a mechanism for transferring risk of an increasing amount of seagoing cargo against loss.

The 18th century saw England and Scotland combine to form Great Britain, the Industrial

Revolution and the development of the British Empire based on naval technology, exploration and trade. This economic activity caused London to grow exponentially. New bridges were built and immigration increased as the need for workers increased.

The population grew from 1 million in 1800 to 6.7 million in 1900 and the largest city in the world. Charles Dickens' 19th century novels about London told the story of the underclass: inner city slums crammed with workers.

The 19th century also saw the Great Exhibition in Hyde Park and the construction of the railways, which connected London with the rest of the country and allowed quicker movement of people.

The 20th century saw the First and Second World Wars, when London was bombed (The Blitz) causing extensive damage to buildings and a large loss of life. London rebuilt again and hosted The 1948 Olympics. The swinging sixties saw London take the lead in fashion and music and the 1980's saw temples of commerce erected in the City such as the Lloyd's Building. The history of London has been tumultuous, but all of these events have created one of the most diverse and prosperous conurbations on the planet.

Item	#	Date	Map	
Petrie Museum of Egyptian Archaeology	186	5000 BC - *	10	C2
Cleopatra's Needle	158	1450BC	10	F8
London Wall	070	190-225	05	H7
Whitehall	279	Middle Ages	13	G3
Westminster Abbey	283	960	13	G4
Windsor Castle	351	11C **	13	I8
Tower of London	069	1078	05	I8
Southwark Cathedral	122	1106	07	B1
The Priory Church of Saint Bartholomew the Great	090	1123	05	D4
Charterhouse Square	089	1371	05	D4
Hampton Court Palace	352	1525		
St James's Palace	270	1536	13	D2
The Mall	254	17C	13	F2
Monument to the Great Fire of London	073	1677	05	G7
The Golden Boy of Pye Corner	091	Late 17C	05	D5
The Foundling Museum	183	18C	10	F1
Dr Johnson's House	109	1700	05	C6
Buckingham Palace	274	1703	13	C4
Pickering Place	265	1731	13	D2
Apsley House	272	1778	13	A3
The Royal Institution of Great Britain	220	1799	11	D6
Wellcome Collection	184	19C	10	C1
Dennis Severs' House	059	1800	03	B8
Charles Dickens Museum	181	1812-1870	10	G2
Sir John Soane's Museum	105	1837	05	A5
Highgate Cemetery	003	1839	01	D3
Brunel Museum	362	1843		
Cutty Sark	131	1869	08	B8
V & A Museum of Childhood	043	1872	03	E7
Jack the Ripper Tour	065	1888	04	B2
HMS Belfast	125	1939	07	D1
Imperial War Museum	118	1914 -	06	C5
Admiralty Arch	253	1912	13	F1
Churchill War Rooms	281	1939-1945	13	F3
Fashion and Textile Museum	128	2003	07	D3
British Museum	178	Various	10	E4
Grant Museum of Zoology	185	Various	10	C2
London Transport Museum	169	Various	10	F7
Museum of London	087	Various	05	E5
National Maritime Museum	133	Various	08	B8
Natural History Musuem	316	Various	14	A2
Science Museum	317	Various	14	A2
Victoria and Albert Museum	318	Various	14	A2

*Dates refer to the date of establishment or the date to which the item relates eg. Dennis Sever's House features replica interiors from the 1800's; The Jack the Ripper Tour relates to 1888, when the crimes were committed etc. ** C = Century.

Leisure & Nature

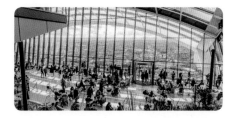

London is one of the greenest cities in the world and there are no less than eight royal parks within its boundaries. These landscaped spaces provide all sorts of activities and include Bushy Park, Green Park, Greenwich Park, Hyde Park, Kensington Gardens, Regent's Park, Richmond Park and St James's Park. Wildlife is a particular feature of London parks with St James's Park being home to pelicans and mallards; and Richmond and Bushy Parks being home to red and fallow deer.

London is filled with residential squares containing green spaces, some public and some private. Some of the grandest are in the centre and include Grosvenor Square Gardens. Major efforts are constantly being made to develop and improve green space in the city for local communities and examples include Duncan Terrace Garden, the Phoenix Garden and the Red Cross Garden.

London is home to Kew Gardens, which contains the world's largest collection of living plants; and Hampstead Heath, which offers a huge space for running, rambling and dog walking.

London is increasingly becoming a city of skyscrapers and as the city builds higher, the opportunities to view the city from elevated positions increases. Some of the best views of the city can be had from the Shard, Sky Garden and the London Eye.

London parks offer a range of different sporting activities. There are tennis courts in Regent's Park; an outdoor swimming club in Hyde Park, where they swim on Christmas Day; rowing clubs on the river and a polo field in Fulham.

Despite London's busy and crowded living space, the city is abundant with green spaces, both large and small; and exploring these spaces on foot is one of the city's most rewarding activities.

CATEGORIES

*Hyde Park and Regent's Park do not appear here because they are areas in their own right and have their own introduction. See Contents.

Shopping

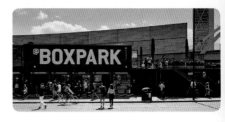

049

London is one of Europe's great shopping destinations. Some of the world's oldest department stores are here and these include Harrods, Selfridges, Liberty and Fortnum and Mason. Central London is filled with well established shopping streets, many of which focus on a particular product. Savile Row is the home of bespoke tailoring; Jermyn Street is home to shirt and shoemakers; and Bond Street is the London home of haute couture. Oxford Street is London's major shopping street and the busiest in Europe.

In the 1960s, London was famous for music and fashion and the King's Road in Chelsea and Carnaby Street played their part in the fashion movement. They continue to offer small and independent fashion retail.

In the 2010s, small and independent is back in fashion and London highlights include Persephone Books, Kristina Records, Couverture and the Garbstore, Hostem and the Goodhood Store.

London has something for everyone and for children, you can't do better than Hamley's, the oldest toyshop in the world.

Maps

Symbols:

⊙ London Underground Stations
☐ London Overground Stations

M1	North	001-020, 022-026
M2	North	027-036
M3	East	037-062
M4	East	063-066
M5	City	067-114
M6	South	115-119, 148-156
M7	South	120-130
M8	South	131-138
M9	South	139-147
M10	Central	157-191, 230-252
M11	Central	021, 192-204, 208-229
M12	Central	205-207
M13	Central	253-291
M14	South-West	292-294, 301-318
M15	South-West	295-300, 319-320, 328
M16	South-West	313-315, 321-327, 329
M17	West	330-347

HIGHGATE WOOD

001

HAMPSTEAD GOLF CLUB

HIGHGATE

HIGHGATE

0 500m

NORTH HILL

SOUTHWOOD LANE

ARCHWAY ROAD

HAMPSTEAD LANE

004

005

HAMPSTEAD LANE

002

003

HIGHGATE HILL

DARTMOUTH PARK HILL

NORTH END WAY

SPANIARD'S ROAD

HAMPSTEAD HEATH

006

HIGHGATE WEST HILL

HEATH STREET

HAMPSTEAD

HIGHGATE ROAD

JUNCTION ROAD

007

010

011

013

TUFNELL PARK

HAMPSTEAD

008

FORTRESS ROAD

009

FINCHLEY ROAD

MANSFIELD ROAD

FITZJOHN'S AVENUE

HAVERSTOCK HILL

012

MALDEN ROAD

BELSIZE PARK

TO 027 (MAP 02)

FINCHLEY ROAD

SWISS COTTAGE

ADELAIDE ROAD

CHALK FARM

CHALK FARM RD

014

015

025

016

KENTISH TOWN ROAD

PRIMROSE HILL

CAMDEN TOWN

024

ST. JOHN'S WOOD

ABBEY ROAD

FINCHLEY ROAD

AVENUE ROAD

CAMDEN

026

PRINCE ALBERT ROAD

023

MORNINGTON CRESCENT

ST. JOHN'S WOOD

019

OUTER CIRCLE

017

MAIDA VALE

018

REGENT'S PARK

022

TO 021 (MAP 12)

020

ST. JOHN'S WOOD ROAD

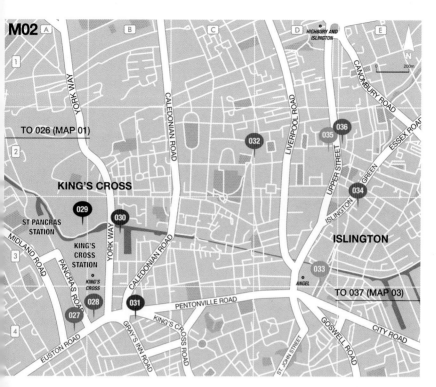

< Map 01: North

Highgate. Hampstead. Primrose Hill. St. John's Wood. Regent's Park. Camden.

Map 02: North

King's Cross. Islington.

Map 03: East >

Dalston. Haggerston. Bethnal Green. Shoreditch.

MAPS

threesixfive **London**

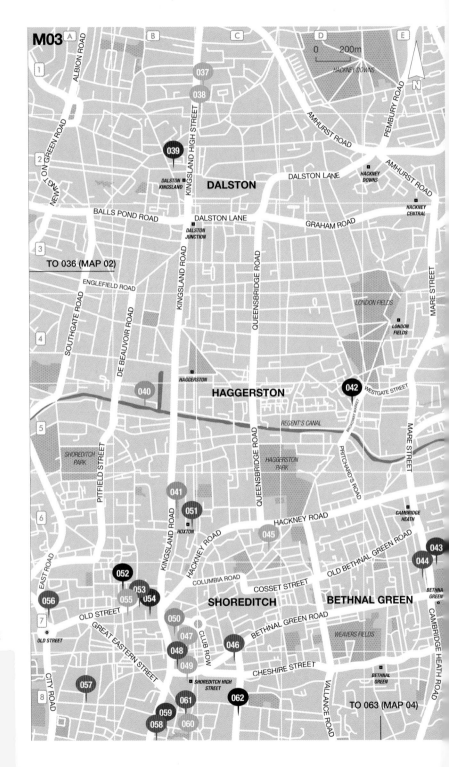

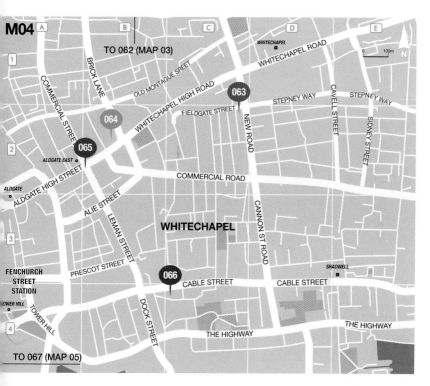

Map 04: East

Whitechapel.

Map 05: City >

Tower Hill. City of London. Farringdon.
Clerkenwell. Holborn. Temple.

threesixfive **London**

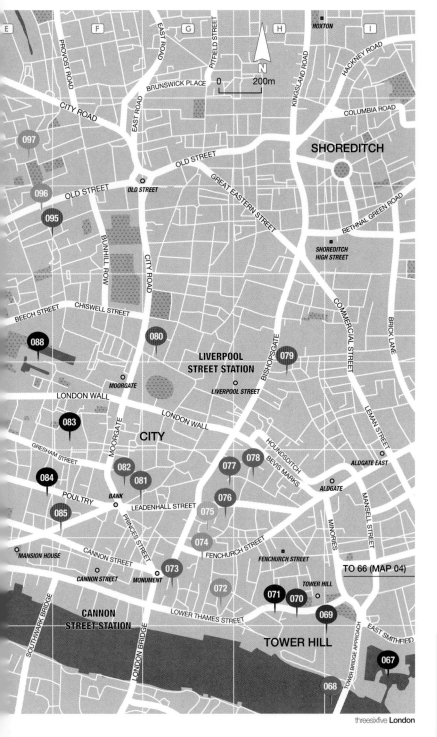

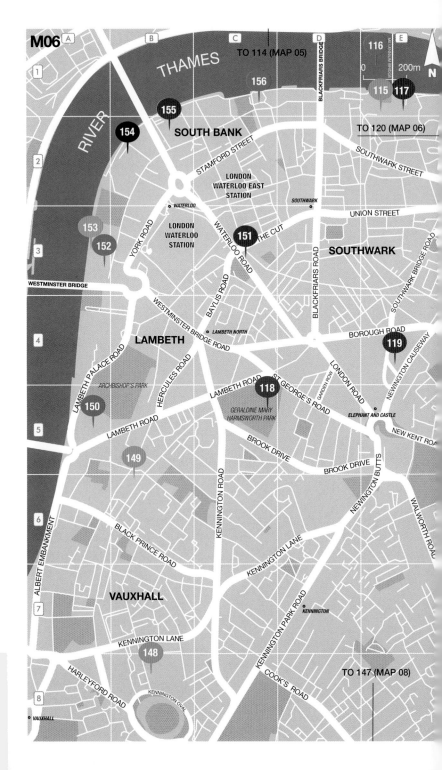

M07 A B 123 C 125 D E N

RIVER THAMES

TOWER HILL

100m

122

121

LONDON BRIDGE

124

LONDON BRIDGE STATION

ST THOMAS STREET

TOOLEY STREET

126

SOUTHWARK STREET

SOUTHWARK

120 UNION STREET

NEWCOMEN STREET

GREAT MAZE POND

127

BERMONDSEY

SNOWSFIELDS

CROSBY ROW

WESTON STREET

128

BERMONDSEY STREET

DRUID STREET

TOOLEY STREET

BOROUGH

BOROUGH HIGH STREET

129

TOWER BRIDGE ROAD

130

GREAT DOVER STREET

LONG LANE

TO 131 (MAP 8)

TO 119 (MAP 6)

ABBEY STREET

Map 06: South

Southwark. Vauxhall. Lambeth.
South Bank.

Map 07: South

Southwark. Bermondsey.

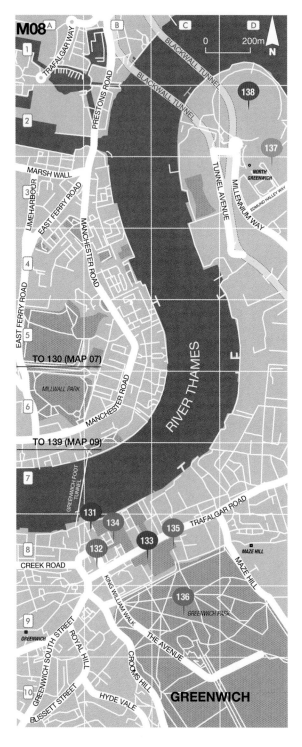

M08 ^A

Map 08: South

Greenwich.

131 Cutty Sark
132 Goddard's
133 National Maritime Museum
134 Old Royal Naval College
135 Queen's House Greenwich
136 Royal Observatory Greenwich
137 NOW Gallery
138 The O2 Arena

Map 09: South >

Clapham. Battersea.

139 The Exhibit
140 Northcote Gallery
141 The Dairy
142 Trinity
143 Battersea Arts Centre
144 Santa Maria Del Sur
145 Albert Bridge
146 Battersea Park
147 Battersea Power Station

MAPS

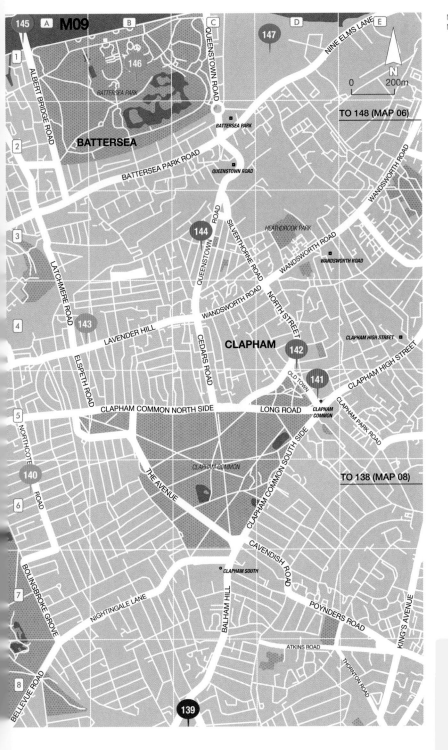

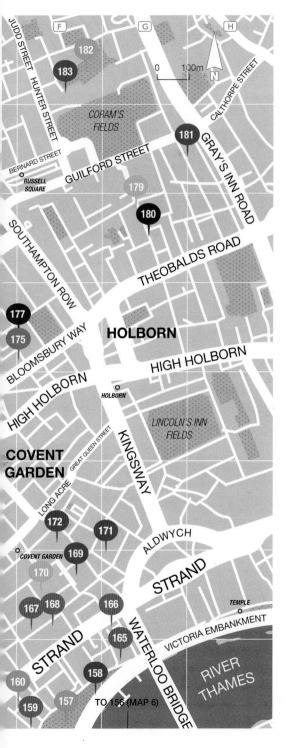

Map 10: Central

Covent Garden. Blooms-
bury. Fitzrovia. Soho.
Leicester Square.

M11 A

TO 205 (MAP 12)

MARYLEBONE ROAD B C D MARYLEBONE ROAD

PARK SQUARE GARDENS E

021

1

N

0 200m

2

MARYLEBONE

YORK STREET

BAKER STREET

GLOUCESTER PLACE

REGENT'S PARK

PARK CRESCENT

GREAT PORTLAND STREET

UPPER WIMPOLE STREET

HARLEY STREET

DEVONSHIRE STREET

204

202 203

201

200 199

198

WEYMOUTH STREET

192

NEW CAVENDISH STREET

GEORGE STREET

BAKER STREET

MARYLEBONE HIGH STREET

WIMPOLE STREET

HARLEY STREET

PORTLAND PLACE

NEW CAVENDISH STREET

GREAT PORTLAND STREET

208

PORTMAN SQUARE GARDENS

WIGMORE STREET

197

194

193

195

MORTIMER STREET

SEYMOUR STREET

PORTMAN STREET

ORCHARD STREET

JAMES STREET

WIGMORE STREET

WELBECK STREET

CAVENDISH SQUARE

MARGARET STREET

3

MARBLE ARCH

OXFORD STREET

209

196

OXFORD STREET

210

OXFORD STREET

OXFORD STREET

OXFORD STREE

4

PARK LANE

PARK STREET

NORTH AUDLEY STREET

BOND STREET

213

GROSVENOR SQUARE

DAVIES STREET

212 211

VERE STREET

NEW BOND STREET

OXFORD CIRCUS

229

GREAT MARLBOROUGH STREET

214

UPPER BROOK STREET

CULROSS STREET

GROSVENOR SQUARE GARDENS

228

MADDOX STREET

5

UPPER GROSVENOR STREET

GROSVENOR STREET

227

CONDUIT STREET

226

REGENT STREET

CARLOS PLACE

215

MOUNT STREET

225

6

PARK LANE

PARK LANE

SOUTH AUDLEY STREET

MAYFAIR

216

BERKELEY SQUARE

218

BRUTON STREET

219 220

BERKELEY STREET

221 222 224 223

HYDE PARK

CURZON STREET

CURZON STREET

PICCADILLY

ST. JAMES'S

7

PARK LANE

217

PICCADILLY

GREEN PARK

ST. JAMES'S STREET

PICCADILLY

PARK LANE

8

PICCADILLY

PICCADILLY

CONSTITUTION HILL

GREEN PARK

PALL MALL

TO 230 (MAP 10)

HYDE PARK CORNER

BUCKINGHAM PALACE GARDEN

MAPS

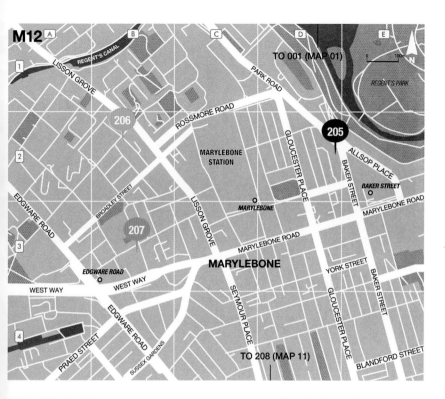

TO 001 (MAP 01)

TO 208 (MAP 11)

REGENT'S PARK

MARYLEBONE STATION

MARYLEBONE

MARYLEBONE

BAKER STREET

MARYLEBONE ROAD

< Map 11: Central

Marylebone. Mayfair.

Map 12: Central

Marylebone.

MAYFAIR

ST JAMES'S

GREEN PARK

GREEN PARK

ST JAMES'S PARK

BUCKINGHAM PALACE GARDEN

VICTORIA STATION

PIMLICO

SOUTH STREET
SOUTH AUDLEY STREET
HILL STREET
CURZON STREET
HERTFORD STREET
PICCADILLY
BERKELEY STREET
DOVER STREET
OLD BOND STREET
JERMYN STREET
PALL MALL
THE MALL
CONSTITUTION HILL
GROSVENOR PLACE
BIRDCAGE WALK
BUCKINGHAM GATE
PALACE STREET
VICTORIA STREET
VICTORIA
EATON SQUARE
BUCKINGHAM PALACE ROAD
FRANCIS STREET
ROCHESTER ROW
EBURY STREET
BELGRAVE ROAD
WARWICK WAY
VAUXHALL BRIDGE ROAD
ST. GEORGE'S DRIVE
PIMLICO

ST JAMES'S PARK

257 259 260 261 262 263 264 265 266 267 268 269 270 271 272 273 274 275 290 291

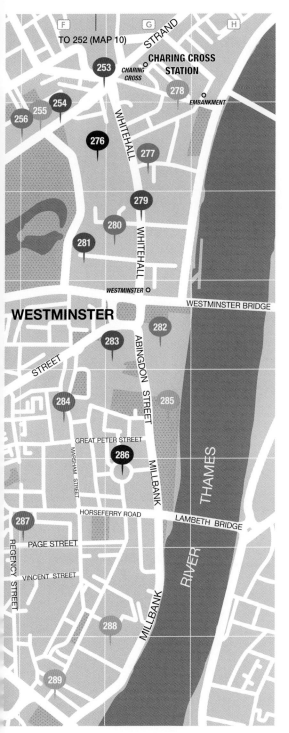

Map 13: Central

St James's. Westminster.
Pimlico.

Map 14: South-West >

Belgravia. Chelsea.

Map 15: South-West >

Knightsbridge. Hyde Park.

Map 16: South-West

Fulham. Kensington.

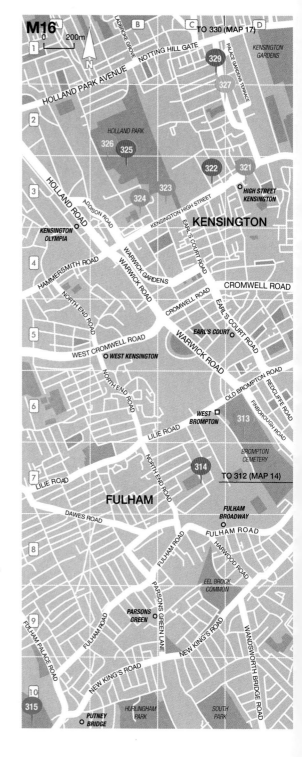

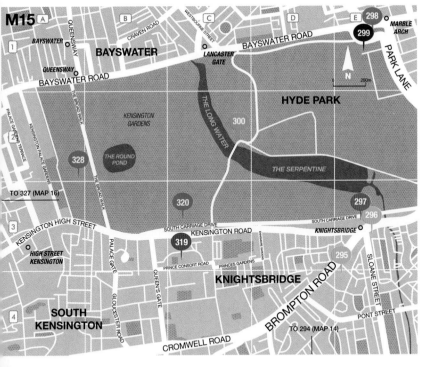

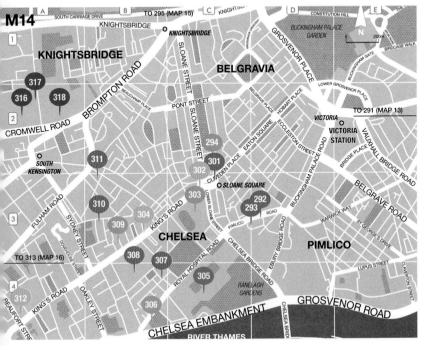

A B C

0 200m

N

PADDINGTON
RECREATION
GROUND

HARROW ROAD

1

KILBURN PARK ROAD

MAIDA VALE

CHIPPENHAM ROAD

SHIRLAND ROAD

ELGIN AVENUE

339

2

338

337

340 HARROW ROAD

SUTHERLAND AVENUE

LADBROKE GROVE

LADBROKE
GROVE

WESTWAY

WESTBOURNE
PARK

GREAT WESTERN ROAD

333

WESTWAY

3

WESTBOURNE PARK ROAD

CHEPSTOW ROAD

335

LADBROKE
GROVE

WESTBOURNE PARK ROAD

331

334

336

332

WESTBOURNE GROVE

347

346

4

LADBROKE GROVE

KENSINGTON PARK ROAD

PEMBRIDGE VILLAS

PEMBRIDGE ROAD

NOTTING HILL

5

NOTTING HILL GATE

330

NOTTING HILL GATE

HOLLAND PARK

TO 329 (MAP 16)

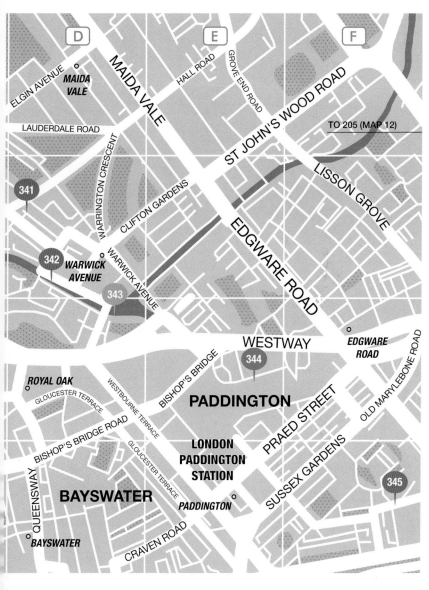

Map 17: West

Notting Hill. Ladbroke Grove. Maida Vale. Paddington. Bayswater.

threesixfive **London**

Language

English or American English?

Essentially the same languages, English and American English have some differences in grammar and vocabulary. Here are some of the them:

American	English	American	English
airplane	aeroplane	mailbox	postbox
aluminum	aluminium	math	maths
anise	aniseed	movie theater	cinema
apartment	flat	pacifier	dummy
appetizer	starter	parking lot	car park
bachelor party	stag night	private school	public school
bachelorette party	hen night	public school	state school
beet	beetroot	scallion	spring onion
candy	sweets	scalper	ticket tout
cart	trolley	second floor	first floor
cell phone	mobile phone	sedan	saloon
checkers	draughts	sidewalk	pavement
chips	crisps	sneakers	trainers
cookie	biscuit	snow pea	mangetout
counterclockwise	anticlockwise	soccer	football
diaper	nappy	sprinkles	hundreds and thousands
drugstore	chemist	station wagon	estate car
eggplant	aubergine	subway	underground/tube
elevator	lift	suspenders	braces
emergency room	casualty	sweater	jumper
expressway	motorway	tic-tac-toe	noughts and crosses
first floor	ground floor	truck	lorry
fries	chips	trunk	car boot
garbage can	dustbin	turtleneck	polo neck
gasoline	petrol	undershirt	vest
hood	car bonnet	vacation	holiday
jelly beans	jelly babies	vest	waistcoat
lawyer	solicitor	zip code	postcode
line	queue	zucchini	courgette
liquor store	off-licence		

Cockney English (A London Vernacular)

Cockney English is a type of London rhyming slang used in the East End of London.

English	Cockney English
cash	sausage and mash
curry	ruby murray
eyes	mince pies (mincers)
feet	plates of meat
hair	barnet fair
have a look	butcher's hook*
head	loaf of bread
lie	porker, porky (short for pork pie)
mate	china plate
money	bees and honey
rotten	bales of cotton
skint	boracic lint
stairs	apples and pears*
starving	hank marvin
suit	whistle and flute
sun	currant bun
teeth	hampstead heath
telephone	dog and bone
television	custard and jelly
thief	tea leaf
tie	peckham rye
urinate (piddle)	jimmy riddle
wife	trouble and strife
wig	syrup of figs

Cockney rhyming slang is usually abbreviated, removing the rhyming word, making it harder to connect with the original meaning. For Example:

English form: "I ran up the stairs to have a look".
Cockney long form: "I ran up the apples and pears to have a butcher's hook".
Cockney usage: "I ran up the apples to have a butcher's".

Itineraries

24 hour, 48 hour and 5 day itineraries to make the most of your trip to London.

	24 hours	48 hours
Breakfast	The Wolseley 256 **	Riding House Cafe 191 **
Morning	Burlington Arcade 222 \| Royal Academy of Arts 224 \| Fortnum and Mason 261 \| Jermyn Street 258 \| Green Park 271 \| Spencer House 269 \| Buckingham Palace 274	British Museum 178 \| St George's Bloomsbury 175 \| Covent Garden Market 170 \| Victoria Embankment Gardens 157 \| St-Martin-in-the-Fields \| National Gallery 250
Lunch	Regency Café 287 *	Andrew Edmunds 239 ** Bao 240 **
Afternoon	Tate Britain 288 \| St John's Smith Square 286 \| Victoria Tower Gardens 285 \| Westminster Abbey 283 \| Houses of Parliament 282 \| Churchill War Rooms 281 \| Banqueting House 277 \| The Mall 254 \| Trafalgar Square 252	Carnaby Street 231 \| Liberty London 232 \| Broadcasting House 193 \| Oxford Street 196 \| Selfridges 209 \| Wallace Collection 198 \| Marylebone High Street 200 \| Daunt Books 203
Dinner	Terroirs 162 ** Rules 167 ***	La Fromagerie 202 Bernardi's 208 **
Evening	London Eye 153 \| National Theatre 155 \| Oxo Tower 156 \| Jerusalem Tavern 094 \| Fabric 092	Wigmore Hall 197 \| Regent Street Cinema 195 \| Artesian Bar at The Langham 194 \| 10⊙ Club 190

* ≤ £15 pp. ** £15-£30 pp. *** £30+ pp. (food only)

The Wolseley 263

Bao 240

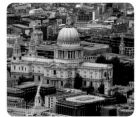

St Paul's Cathedral 086

Day 3

Beagle 051 *

The Geffrye Museum of the Home 041 | Hoxton Square 052 | Ace Hotel 050 | Boxpark 049 | Old Spitalfields Market 060

Galvin La Chapelle 058 *** Beigel Bake 046 *

Brick Lane 062 | Whitechapel Gallery 064 | Tower Bridge 068 | Tower of London 069 | London Wall 070 | All Hallows by the Tower 071 | Sky Garden 074 | Monument to the Great Fire of London 073

Sweetings 085 *** Angler 080 ***

St Paul's Cathedral 086 | Millennium Bridge 116 | Tate Modern 115 | Shakespeare's Globe Theatre 117 | Ministry of Sound 119

Day 4

Regency Café 287 *

Sloane Square 302 | Saatchi Gallery 303 | King's Road 304 | Royal Hospital Chelsea 305 | Chelsea Physic Garden 306 | Michael Hoppen Gallery 309

Bibendum 311 *** Tom's Kitchen 310 **

Natural History Museum 316 | Victoria and Albert Museum 316 | Royal Albert Hall 319 | Albert Memorial 320 | Kensington Palace and Gardens 328 | St Sophia's Cathedral 346

Hereford Road 347 ** The Cow 333 **

Electric Cinema 331 | Portobello Road 336 | Notting Hill Arts Club 330

Day 5

The Pavilion Café 001 *

Highgate Cemetery 003 | Kenwood House 004 | Hampstead Heath 006 | 2 Willow Road 010 | Keats House 011

The Holly Bush 007 ** The Hampstead Creperie 008 *

Camden Arts Centre 009 | Abbey Road Studios 017 | St John's Lodge Gardens 022 | London Zoo 023 | Camden Market 025

Plum + Spilt Milk 028 *** The Albion 032 *

King's Place 030 | Scala 031 | Almeida Theatre 035

Transport

BICYCLE

London's network of cycleways has improved markedly in recent years and there are now over 60 miles of dedicated cycle routes. One of the best ways to experience the city is to rent a 'Boris Bike', named for the London mayor who implemented the scheme. Bikes cost £2 per day and can be used for 30 mins at a time without additional charge. Just get the bike back to a bike station within the allotted time. You can then take another bike for another 30 mins. Be aware that if the bike is kept for over 30 mins, charges apply and the longer the time, the quicker the charges increase.

NB. London can de dangerous for cyclists, especially when cycling behind lorries turning left. Additional care should be taken when riding in the city.

BUS

London has an extensive fleet of buses that run 24hrs per day. The classic Routemaster bus has been updated by Thomas Heatheriwck and can be seen all over the city. An Oyster card costs £5 deposit and gives you access to the whole London bus, tube and train network. Alternatively, you can use a contactless debit card. Bus journeys cost £1.50 and you cannot use cash. There is a maximum daily limit of £4.50 on the London travel network.

TAXI

London's famous 'black cabs' are all over the city and you can just flag one down and hop in. They offer speed and comfort. Uber is another option for the city and can be used by downloading the app. There are many unregulated taxis in London, especially at night time and these should be avoided. A short black cab ride in the city centre may cost less than £10 but airport transfers can get very expensive.

TUBE

The London Underground Network is the oldest in the world and one of the most extensive. Fares can be paid by oyster card or contactless debit card. There is a daily cap of £4.50 per day and one week travel cards can be purchased using the Oyster card to get a discount.

TRAIN

Apart from the tube, London has an overground network and a large network of National Rail trains across the city. Some of these can be used with Oyster and contactless, but generally trains leaving London require a separate ticket to be purchased. The Heathrow Express offers a quick service from the airport to London Paddington.

More information on London travel is available from the Transport for London website: tfl.gov.uk

Notes

Index A-Z

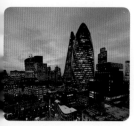

30 St Mary Axe 078

Bao 240

Dover Street Market 249

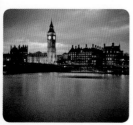

Houses of Parliament 282

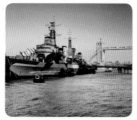

HMS Belfast 125

The Grill at The Dorchester 216

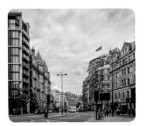

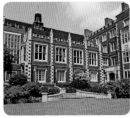

Harvey Nichols 296

Columbia Road Flower Market 045

Inner Temple Gardens 114

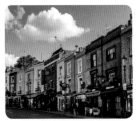
Portobello Road 336

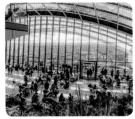
Sky Garden 074

Victoria Embankment Gardens 157

Picture Credits:

Editors:	Henry Wilkins
	Leo Edwards
	Xiaoyin Zhang

| Publisher: | Threesixfive Content ltd |

| Design: | Threesixfive Content ltd |

Contributors:	Geraldine Bekenn
	David Cairns
	Sharon Cairns
	Claire Fairbairn
	Tim Fairbairn
	Adam Green
	Satoko Green
	Marie-Louise Lucas
	Nicholas Lucas
	David Nicholson
	Christine Vayssade
	James Wilkins
	Peter Wilkins

The publisher would like to thank all of the establishments who have kindly given permission to reproduce their images.

threesixfive books can be ordered directly from the publisher at www.threesixfivecity.com

ISBN 9780993285264

9 780993 285264